#25

MORRICE

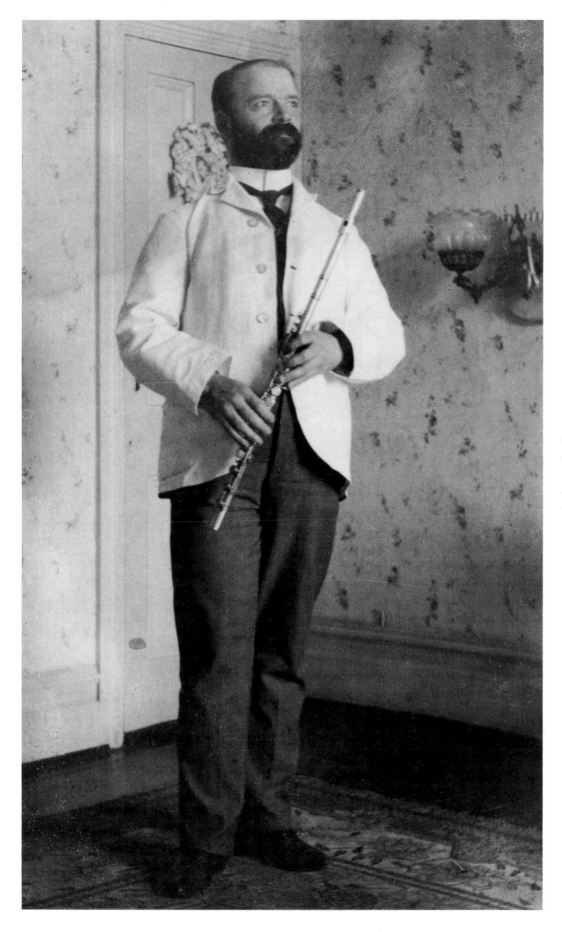

Original photograph signed on the back: "J.W. Morrice, Paris, 1897." Anonymous untitled photograph. Gift of Miss F. Eleanore Morrice and of David R. Morrice. Montreal Museum of Fine Arts.

MORRICE

A GREAT CANADIAN ARTIST REDISCOVERED

G. BLAIR LAING

WITH AN INTRODUCTION BY JEAN SUTHERLAND BOGGS

MC CLELLAND AND STEWART

The Canadian Publishers
McClelland and Stewart Limited
25 Hollinger Road, Toronto M4B 3G2

CANADIAN CATALOGUING IN PUBLICATION DATA

Laing, G. Blair, 1911–
 Morrice : a great Canadian artist rediscovered

Includes index.
ISBN 0-7710-4567-0 (limited ed.). – ISBN 0-7710-4568-9
(trade ed.)

1. Morrice, James Wilson, 1865–1924. 2. Painters –
Canada – Biography. I. Morrice, James Wilson,
1865–1924. II. Title.

ND249.M67L34 1984 759.11 C84-099505-9

Printed and bound in Canada

Every effort has been made to ascertain ownership and acknowledge copyright for quoted excerpts. Information would be welcomed that would enable the publisher to rectify any error.

DESIGN: Brant Cowie/Artplus Ltd.

CONTENTS

INTRODUCTION

THE PAINTINGS OF James Wilson Morrice attract our attention so quietly and so discreetly that our discovery of their quality seems to become a creative act in itself. It is natural that this should lead to the kind of obsession about their acquisition which Blair Laing describes as having informed his life and his career as one of Canada's premier art dealers. That obsession can be supported by the knowledge that such leading institutions of contemporary art throughout the world then as the Carnegie International in Pittsburgh, the Luxembourg Museum in Paris, the Musée des Beaux-Arts in Lyons, should have bought Morrice's paintings during his lifetime. Such a devotion to the work of this artist would certainly not be suppressed when a Canadian visitor feels pride in discovering his paintings on the palatial walls of the Hermitage in Leningrad or in the bolder company of the Barnes Collection near Philadelphia. It can even be stimulated by learning that James Wilson Morrice, the man, was the source for characters in novels by Arnold Bennett and Somerset Maugham. But it is finally the undoubted quality of the work that leads to the kind of pilgrimage into the career of Morrice that Blair Laing describes.

What could make Laing's odyssey such a surprise is that Morrice's is an art of understatement. His works are not large. He painted in oil, enjoying the fact that it is creamy and opaque. Although his colours do vary from his canvases on grey days in Paris or Quebec to the intensity of bright foliage in Jamaica or Tangiers, his palette and his handling of paint are never as assertive as his contemporaries in Paris such as Picasso (admittedly sixteen years younger) and the fauves, including Matisse (four years younger). The

human figures in his paintings – even within a circus or a bullfight – seldom move or, if they do, saunter languorously. Wherever or whatever he chose to paint, snow scenes in Quebec, the Quai des Grands Augustins in Paris, a street in Cuba, or a beautiful woman, it is as if he had been reflecting upon the scene, recording it somewhat wistfully – certainly tenderly – but as if it might not survive other than in his painting. Finally Morrice is always the expatriate – he spent thirty-four of his fifty-nine years abroad – seeing things, savouring them, but never possessing them in the manner of more aggressive artists like Picasso, Matisse, or Tom Thomson and the Group of Seven. It is, however, the very delicacy, the very tentativeness, the very sensitivity of his vision that give Morrice's paintings their enduring appeal and make him one of Canada's greatest artists.

JEAN SUTHERLAND BOGGS

PREFACE

IT IS TIME a fresh look were taken at James Wilson Morrice, who left Montreal in 1890 to study art in Paris, and who went on to become Canada's first Post Impressionist painter.

His paintings, as much as those of any other artist working in France during the first decade of the century, caught the reality and flavour of Edwardian Europe. They still convey to us a distinct feeling of nostalgia. He painted the kiosks and the streets of Paris, the battlements of St. Malo and Concarneau, and the canals, churches, and palaces of Venice. He was a painter genius who created an art for posterity. He captures the essence of a period and makes it as real for us today as it was three-quarters of a century ago.

Although he painted primarily in Europe, North Africa, and the West Indies, some of his Canadian works are among his finest. As early as 1896, after six full years of study and practical painting experience in France, he began to return regularly to Canada, for several weeks each winter, to visit his family and to sketch and paint along the St. Lawrence North Shore. He was an early and original interpreter of the Quebec winter landscape – horses and sleighs entering a habitant village, ferry boats and ice floes in the St. Lawrence, and jaunty winter scenes in Montreal and Quebec City. He brought to Canada a new technique and fresh approach to art in the manner of Post Impressionism, and his style had a lasting effect on a generation or more of Canadian artists that followed him.

For precisely half a century I have enjoyed, studied, bought, sold, and collected the pictures of James Wilson Morrice. It all began with an impres-

PLATE 1
Prow of a Gondola
c. 1897, Panel 12½″ × 9″

The black prow of a gondola surmounted by a white ferro juts into the centre foreground of a wide expanse of the Grand Canal, Venice. Across the water glows the pink façade of the Doges' Palace.

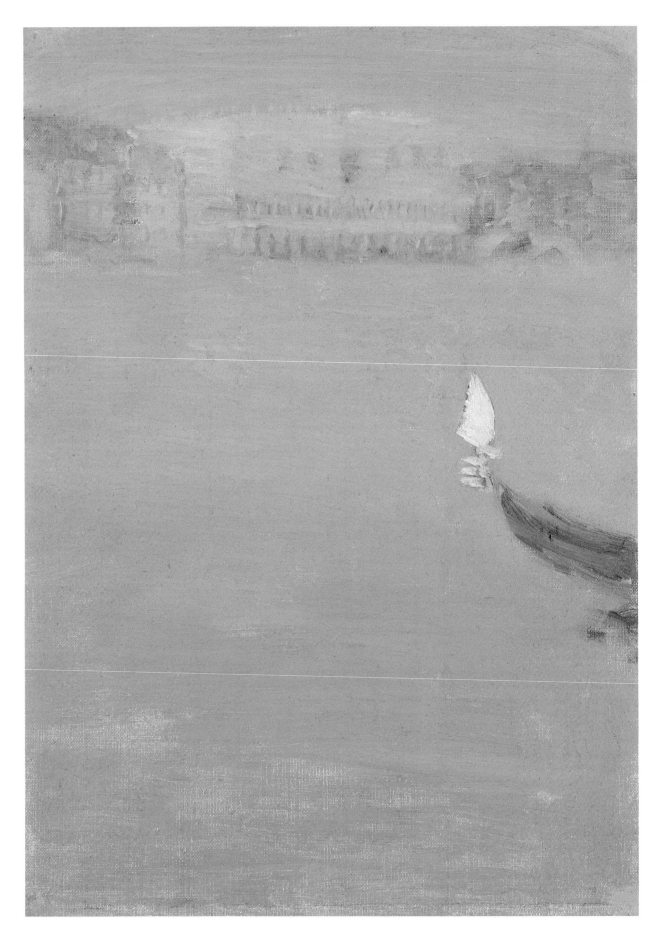

PLATE 1

sive exhibition of his paintings at our galleries in 1934, and today I find myself more intrigued than ever with the painter and his work. He was during his lifetime truly one of the most fascinating figures in the international art world. And as a Canadian, he is all the more significant for us.

I have wanted to write a story of his life for some time now. I did not wish to do so in the form of an academic biography, which too often gathers the facts, but misses the spirit; for, above all, it is the spirit and personality of Morrice as a man and as a painter I have been seeking. How then to proceed? First, I decided it was important to see and resee as many of his pictures as possible. Second, I planned to make leisurely visits throughout the artist's painting world and other haunts, if they still existed. Perhaps that way I could find a Morrice that few of us really know.

In France, I visited several times the village of Bois-le-Roi in the forest of Fontainebleau, and the little hamlet, Dennemont, on the Seine, near Monet's water-lily garden at Giverny. I have been to Normandy ports like Dieppe, and Brittany's ancient St. Malo with its medieval ramparts. These provided favourite painting places for Morrice, as did St. Malo's adjoining seaside resorts, Paramé and St. Servan. I know the fishing port of Cancale, famed for its oyster beds, where he also painted. Brittany's rugged south shore appealed to Morrice and he made wonderful sketch panels and canvases at Le Pouldu, Douarnenez, and the walled town of Concarneau.

I have stopped at Cagnes-sur-Mer in the Alpes-Maritimes, where Morrice bought a villa for his mistress, Léa Cadoret, in 1922. Other trips, including a visit to Cuba and the Caribbean, helped to further illuminate some of the artist's painting paths.

There have been no recent books written on the artist (although there are any number of Canadian art history students working on segments of his life and work, as theses). The truth is that Morrice and his paintings have been overshadowed by the pervasive and warm-hearted acclaim accorded by Canadians to Tom Thomson and members of the Group of Seven. Large colour reproductions and romantic documentaries have all added to their lustre and popularity. But Morrice has not yet received his proper share of recognition. Painting mainly in France from 1890 to 1912, he produced only some thirty Canadian subjects, perhaps a little more than ten per cent of his total output of canvases. This is not very much when you compare it to the impressive total number of pictures produced by Lawren Harris and A.Y. Jackson. However, one of Morrice's pictures, *The Quebec Ferry*, is now as famous as some of Tom Thomson's great Algonquin Park canvases and certain examples of the Group members' most eloquent works.

PLATE 2

The Flower Market, St. Malo
c. 1901, Panel 9¾" × 7"

A medium-small panel shown at the Canadian Art Club in 1915 and illustrated in the catalogue. It depicts the old St. Malo flower market held by the white-capped Breton women under the trestle bridge leading to the St. Malo station. Here again one experiences Morrice's skilful handling of the surfaces of the grey granite buildings, heightened by the reflected accents on the windows that seem to echo the whites of the women's caps.

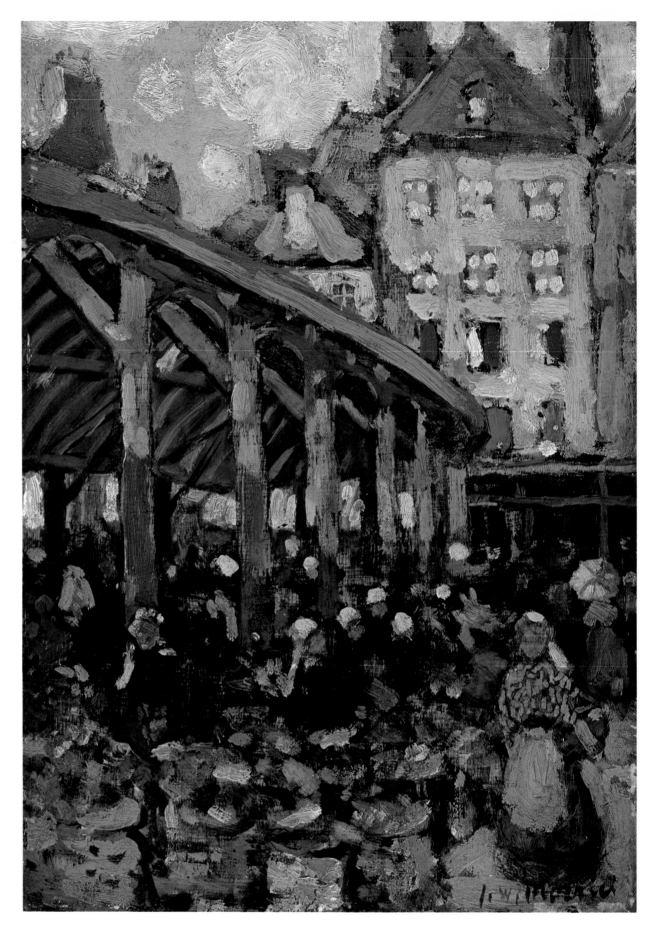

PLATE 2

During the undisturbed and serene quarter-century in Paris before the First World War, Morrice moved within the contemporary art scene and was held in highest esteem by the most knowledgeable members of that community. He was a hyphen-figure who straddled the nineteenth and twentieth centuries as a major entry into the international art world. His is the story of a transplanted Canadian, a man frail in body but profoundly talented, who in the mid-1890s found himself, as if by chance, among the flesh pots of Toulouse-Lautrec's Montmartre. A year younger than the little dwarf genius Toulouse-Lautrec, whom he knew, and whose lithographs of Paris night-life he admired, Morrice also shared a common love with Lautrec of the Montmartre circus. Later, he became a nomad wanderer who, in 1910, 1912, and perhaps 1913, went as far south in native dress as Marrakesh, Morocco, where he created some of his most colourful and spellbinding works. During the war years, in 1915, we find him painting in Cuba and Jamaica.

One contemplates the circumstances upon which the third child of a family of seven boys and one girl, born to the strictest of Presbyterian parents in old Montreal, went to Paris and ultimately became Canada's most interesting painter. Just what was it that allowed this man, who sprung from Presbyterian roots, to later move so easily among the haunts, cafés, and bistros of Paris, and become so creative and unique?

It is hard to imagine two people more different in character than David Morrice, Montreal's nineteenth-century omnipotent merchant prince, and his sometimes highly irreverent artist son. But that, I think, is not an uncommon occurrence in large families where the father is a highly success-ful individual. The fact is that right at the start of the James Morrice story there is David Morrice. And it is impossible to understand the life of the artist without a careful look at his father and family. The success story of David is certainly extraordinary, though not unparalleled at that time; a man who rose from modest beginnings to lofty pre-eminence in the cotton and wool industry – not to mention the distinction he gained as a patron of Presbyterianism and Scottish Montreal. He is like a merchant prince right out of Principal George M. Grant's *Picturesque Canada*. Indeed, George Grant, principal of Queen's University, the illustrious editor and author, was a friend of David Morrice, and was present at the dedication of Morrice Hall, Montreal, in November of 1882.

In business David Morrice was certainly a man of vision. But it must have been a soul-searching decision for him to accept his son's resolve to study art. And above all to study art in Paris, that sinfully wicked city and certain

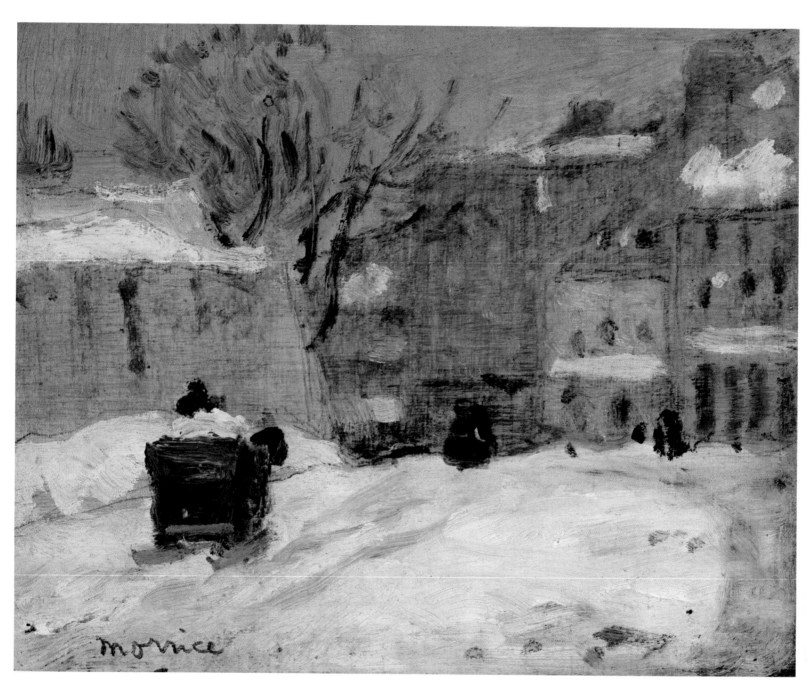

PLATE 3

destroyer of young manhood. This was the conventional thinking of the time and an attitude that long persisted. Paris and young Morrice must have been a source of constant gossip in the drawing rooms of upper-class Montreal.

And yet, astonishingly, David Morrice not only tolerated his son's wish, but fully supported and encouraged him; and for twenty-five years provided him with a generous living allowance. There is no doubt that James, a freshly crowned lawyer, knew exactly what he wanted in life and was totally committed to achieving these goals. Not only did he convince his parents that his ambition in life was to become an artist, but he also won their approval to study abroad and departed for Europe with the family's blessing.

To fully know James Morrice it is necessary to appreciate not only his work, his stamping ground, and the scope of his nomadic travels, but also to understand the lasting significance of the strong Presbyterian background of his youth.

MORRICE

1

DAVID MORRICE,
PATRIARCH AND
MERCHANT
PRINCE

IT WAS A COLD WINDY DAY in mid-December 1982, with snow and ice on the ground, when I stood contemplating the inscriptions on the Morrice tomb in the old Protestant cemetery in Montreal. It could have been on a similar afternoon, just over sixty-eight years earlier, that David Morrice's funeral cortège halted at this very spot. Here he was laid to rest beside his beloved wife Annie, who predeceased him by three weeks. The lavish neo-renaissance tomb stood out in silhouette against the chill milky sky of a late winter afternoon.

Here in the cemetery, high on the slopes of Mt. Royal, is an historic record of many of the entrepreneurs, railway builders, bankers and business-men who came from Scotland in the nineteenth century and became highly successful in Montreal, the city of their adoption. The David Morrice family monument is a striking reminder of this fact.

Here is the place where the entire Morrice clan is buried. It was a dynasty that endured for just under one hundred and thirty years after James Morrice's father David originally arrived in Canada. Carved on four sides of the granite tomb, in areas contained by small Greek columns, is a capsule history of the Morrice family's years in Montreal. Besides David and his wife Annie, six of their seven sons are buried here as well as the wives of the two who were married. James's name appears as well, but the inscription records that he died and was buried in Tunis on January 23, 1924.

It seems eminently appropriate that James Morrice's parents and brothers should all have been put to rest among Montreal's Presbyterian elite, and not James. Though he could quote long passages from the Bible when it

PLATE 4

Winter Street with Horses and Sleighs

c. 1905, Panel 6″ × 4⁷/₈″

This is the Art Gallery of Ontario's excellent small panel of horses standing in a square. It is mid-winter, possibly at Montreal's Bonsecours Market, and the horses, protected from the cold with thick blankets, are patiently waiting for the return of their drivers. Morrice's horses have a special charm, and look much the same whether on the Quebec ferry dock in winter, the Quai des Grands Augustins, Paris, carting sand on a Brittany beach, or performing at the circus.

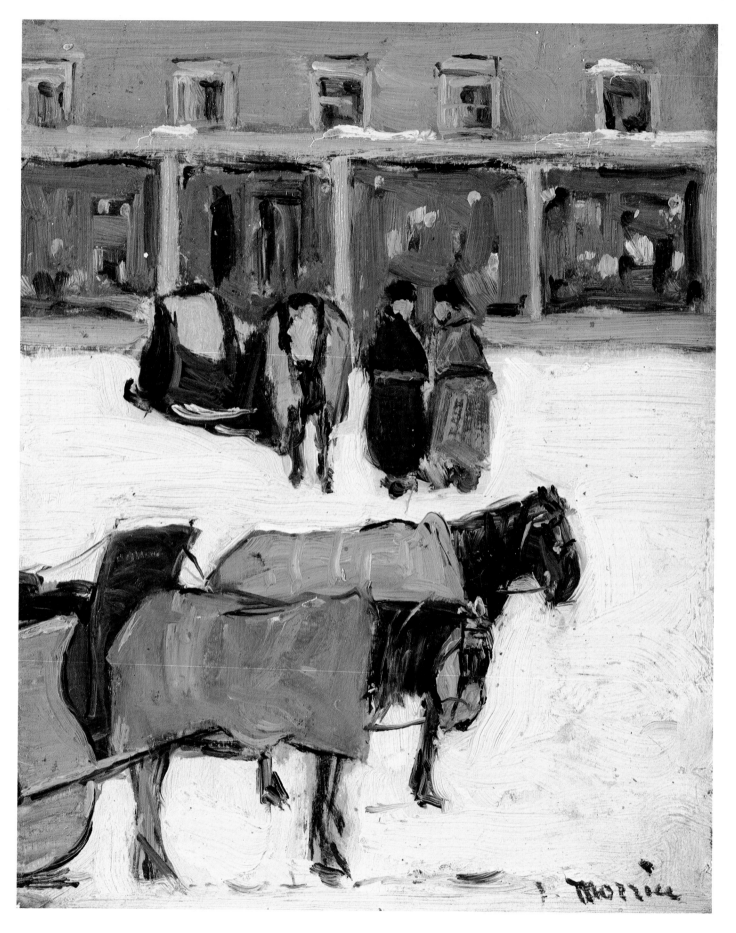

PLATE 4

applied to certain wayward aspects of his own life, he was a non-believer. It is fitting indeed that he should be buried within sight of the rounded mosques of Arabic Tunis, where death claimed him while he was in futile quest for his lost health.

The names of the final two descendants of the family are also chiselled in the plinth: David Rousseaux Morrice (d. 1978) and his sister Eleanore (d. 1981). They were the children of Arthur, James's second youngest brother and his wife, Florence Ethel Rousseaux.

David and Eleanore, the last of the Morrice clan, are important to our story because, following their mother's death in 1962, they inherited some one hundred panels and canvases painted by their uncle "Jim," as the artist was affectionately known to them. With few exceptions, the pictures had come down to them by succession from their father's estate. About forty examples from their collection were later distributed to public galleries throughout Canada. Then, on the death of Eleanore Morrice, a further gift of fifty works went to the Montreal Museum, which greatly strengthened their Morrice collection.

The father of Eleanore and David, Arthur A. Morrice (1873-1931) joined the family textile business about 1900, and became manager of its Toronto office. His two children were born in Toronto.

I met Ethel Morrice, Arthur's widow, in about 1948, at her Pine Avenue home in Montreal. The reason for my visit was to get some idea of the scope of her J.W. Morrice collection. Perhaps, I thought at the time, some of the pictures might be for sale.

Her home was a virtual gallery of paintings by her husband's brother James. The downstairs entrance hall, dining room, and living room were all hung with his canvases, including the *Blue Umbrella* a charming *plein air* study of James's mistress Léa Cadoret. On the second floor, in David's large studio (for he was an artist in his own right) were dozens of his uncle's small panel paintings hanging on the walls or casually resting on table easels. At one time too, he possessed twenty-four of his Uncle Jim's sketch books.

Like his mother, David was adamant about keeping all of his uncle's work he had in his possession, though he received enticing cash offers from dealers and collectors all over Canada.

My visit with the dowager lady came to nought. She had no desire whatsoever to part with any of her paintings, and I never saw her again.

Yes, Ethel Rousseaux was the magnificent matriarch who for thirty years firmly controlled the family fortune and held her attractive children at home in close bondage. The family fortune, being substantial, was enough to

PLATE 5
Lady in Brown
c. 1895, Canvas 34″ × 20″

This is possibly Morrice's only full-length figure study. The young woman, one of the artist's models, is wearing a distinctive hat, gloves of fine chamois, and is holding a folded umbrella. She stands tall with an elegant and imposing bearing, her long dress falls in graceful folds and the picture is a study in harmonious browns.

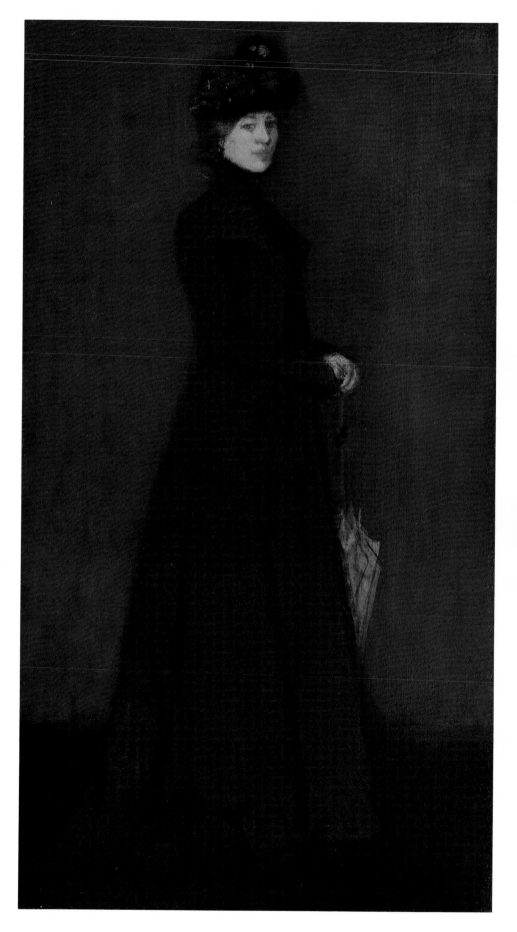

PLATE 5

allow them to live in luxury and enjoy travel in North America and abroad, whenever they pleased.

By 1982, as I stood in the snow at the Morrice tomb, the original family fortune, like the family itself, had disappeared.

Over the years their former thriving family textile business had been swallowed up by sale and mergers. The original family mansion on Redpath Street had been obliterated for construction of a high-rise apartment building. Ethel and Arthur Morrice were long dead and now their two children were gone too.

I gazed past the tomb, down the mountainside from the vast graveyard towards the commercial core of the city with its tall modern buildings and pondered. Who was this David Morrice, the patriarchal Presbyterian who resided for more than fifty years in his adopted city, and amassed a fortune before dying in 1914, five months after the Great War broke out? In what sort of environment did his son, the young James, grow up, and what kind of town was Montreal in those days?

David, the founder of the Morrice dynasty, and Canada's most munificent nineteenth-century Presbyterian church benefactor, was born in St. Martin's Parish, Perthshire, Scotland in 1829. His father's name was also David and his mother was Christina Wilson. It was a venerable Scottish custom to name the children after parents and grandparents, and David II's artist son enjoyed the same birthright. Born in 1865, and destined to become Canada's most illustrious artist, he was baptized James Wilson after his paternal grandmother.

The family did not spell their name in the conventional Anglo-Saxon way, Morris; it had been changed years earlier in Scotland to the Celtic version, Morrice. Actually, people today still think of the name as French, but it is not, though in the current Paris telephone directory there are several columns of Morices.

In Perth, David Morrice received the usual solid grammar school education for which Scottish schools were noted, and afterwards worked briefly in his native city. We are told that he visited Ireland and stopped off in Dublin and Cork, but business opportunities were negligible there in the wake of the potato famine.

He then travelled to London, Manchester, and Liverpool, Great Britain's fast growing manufacturing and shipping centres. It was during these adventure-filled years before mid-century that he gained insight into the commercial potentials of the burgeoning textile trade. His experience gained

PLATE 6
The Old Holton House
c. 1909, Canvas 24″ × 29″

Painted shortly before construction began of the Montreal Art Association at this site. A horse-drawn sleigh, with the driver and passenger all bundled up, passes in front of the house.

26

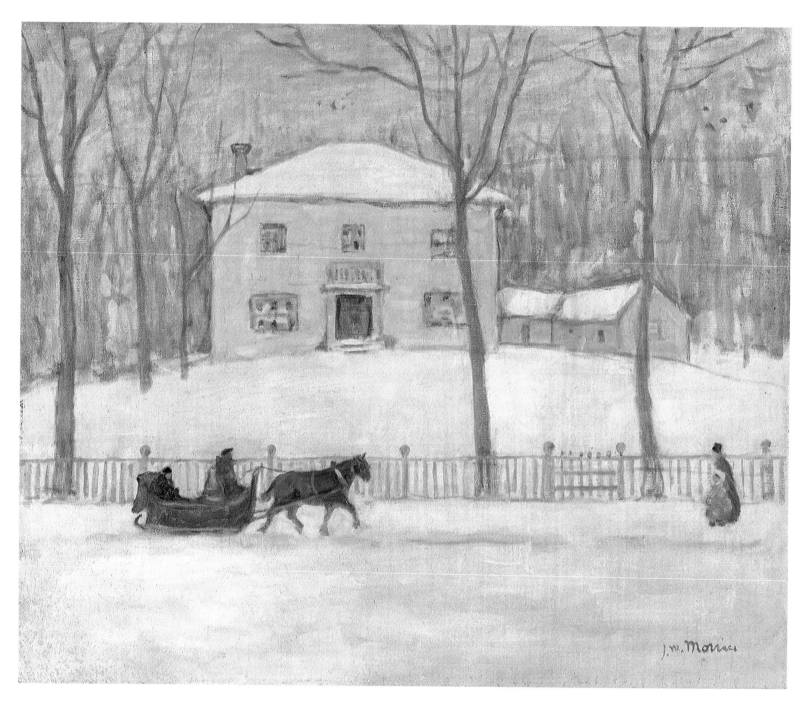

PLATE 6

while working in the factories as a young man was exceedingly useful during a notable business career. Years later in the early 1880s, remembering the great value of his own practical apprenticeship, David sent his two eldest sons William and David Jr., to Manchester to learn the dry goods business. Manchester was then known as the great metropolis of "Cottons, Twists, and Twills." According to contemporary accounts the two brothers resembled their father, and were commended as "chips off the old block" in ability and enterprise.

David Morrice lived in Canada from the 1850s until his death in 1914. And his life spanned those historic years which saw the country grow from a British colony to nationhood. Detailed data of David's early days is imprecise. But he was said to have landed in Montreal in 1852, at the age of twenty-three. After a brief stay in Montreal he moved to Toronto, Canada West, where he worked as a salesman at a wholesale textile establishment. Apparently he continued with the Toronto firm for several years.

The first record we find of David Morrice living in Toronto is in the June 16, 1860 issue of George Brown's very Grit and very reliable *Globe*. It was an announcement of his marriage on the 14th of the month at the residence of the bride's uncle, William Mather, to Annie, the willowy, winsome eldest daughter of James Anderson of Brampton. The Rev. Dr. John Taylor officiated.

John Taylor, a fellow Scot, was a medical doctor as well as a clergyman. From 1853 until he returned to Scotland in 1861, he was minister of Toronto's Gould Street Church. Just how long prior to the above date David Morrice had lived in Toronto is unknown. However, a church association was so important to him that he would have joined John Taylor's congregation almost as soon as he got off the stage-coach or boat.

The January 13, 1861 Toronto census records that David and Annie Morrice were living at number 4 Church Street, in a three-storey brick house. By then, David Morrice was doing quite well as he was able to afford the services of a full-time maid, Fanny Davies. His occupation is recorded as salesman, his religion, Free Church – Presbyterian.

In October 1862, about six months after becoming an elder at Gould Presbyterian Church, David Morrice abruptly reported to the Session that he had decided to leave Toronto to take up permanent residence in Montreal. Apparently business in the Upper Canada capital was not growing fast enough to satisfy the aspirations of this ambitious young man. Canada's booming commercial metropolis, Montreal, was the place to be in order to take advantage of the greater business opportunities that Montreal then offered. He became immensely successful in Montreal over the years, and remained there the rest of his life.

PLATE 7
Winter Scene, Quebec
c. 1905, Panel 4¾" × 6"

The artist visited this Quebec village during the early years of the new century. The scene is lit by reflections of a full moon on freshly fallen snow. Some large snowflakes are still falling. It is one of a series of panels the artist completed of Quebec village subjects.

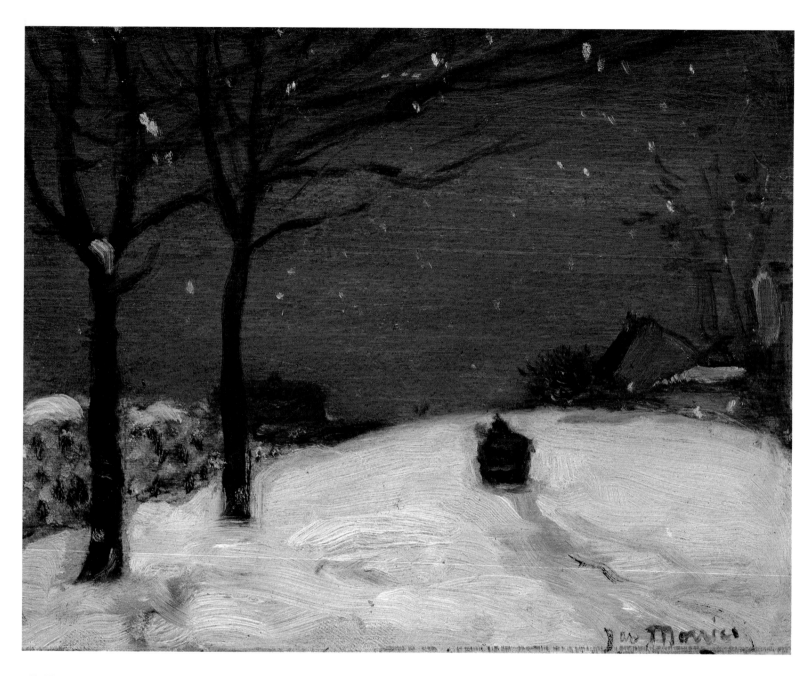

PLATE 7

Annie and David left Toronto some time before the end of December 1862 with their infant son William, who was born there in 1861. No sooner was David in Montreal than he joined the Côte Street Church whose minister was D. H. MacVicar. David Morrice was appointed Superintendent of the Sunday School, an office he held for twenty-five years. When he retired, the kirk elders created for him the office of Honorary Superintendent. They also expressed the hope "that he would long be spared to see the school prospering above his highest anticipations." Pompous words indeed in the high Victorian manner, yet they do reflect the extraordinary respect held for this man by his church peers.

Sometime before July 1863, David Morrice moved into 30 Aylmer Street in Montreal. We know he was there earlier, but directories then as now are often slow in picking up the exact arrival dates of newcomers. He lists his vocation as merchant and commercial agent. After June 29, 1864 he moved again, this time to Gibraltar Cottage, St. Luc Road. It was at Gibraltar Cottage on August 10, 1865 that his third son, James Wilson, was born.

It was about this time that David Morrice, after consultation with his wife, decided it was time to provide a more gracious home for his young growing family. Also, he genuinely felt that a fine house would enhance his own status in the city as an important citizen and businessman. But what kind of house should he provide? One of the ample older homes that already graced Montreal? Or would he build himself a new one? And if so, he knew the right architect.

From the mid-1860s onward, many of Canada's most lavish houses were located on the inclines of Mount Royal. Some rivalled in affluence the brownstone mansions of New York's Manhattan Island. It was a form of deep-rooted nostalgia that caused many Montrealers of Scottish and English background to show great pride in their heritage. It was natural therefore that men like David Morrice, who had achieved prestige and wealth in a distant colony, should have felt a certain sense of gratitude and loyalty towards the motherland, while retaining a deep attachment to the land of their adoption.

Montreal's Presbyterian Gothic architecture of the 1870s and 1880s was brilliantly practised by the Scottish-born architect John J. Browne. Browne had travelled extensively in the British Isles and Continental Europe, returning with sketch books filled with drawings of many great classical buildings of the old world. Hence it was not by chance that, in 1871, David Morrice selected him to design and build the new David Morrice family home, an imposing three-and-a-half-storey cut-stone edifice at 10 Redpath Street. Its

PLATE 8

Quebec Farmhouse
c. 1910, Canvas 32″ × 24″

In a style reminiscent of art nouveau the bare branches of a tree emerge from the right foreground, creating a strong pattern against the grey walls of the farmhouse. A single horse draws a pink sleigh on a snowy road. It carries a solitary figure bundled in furs. A group of houses and barns appear in the mid-distance and a cold blue sky, cloudless and dull, highlights the lighter tones of the foreground.

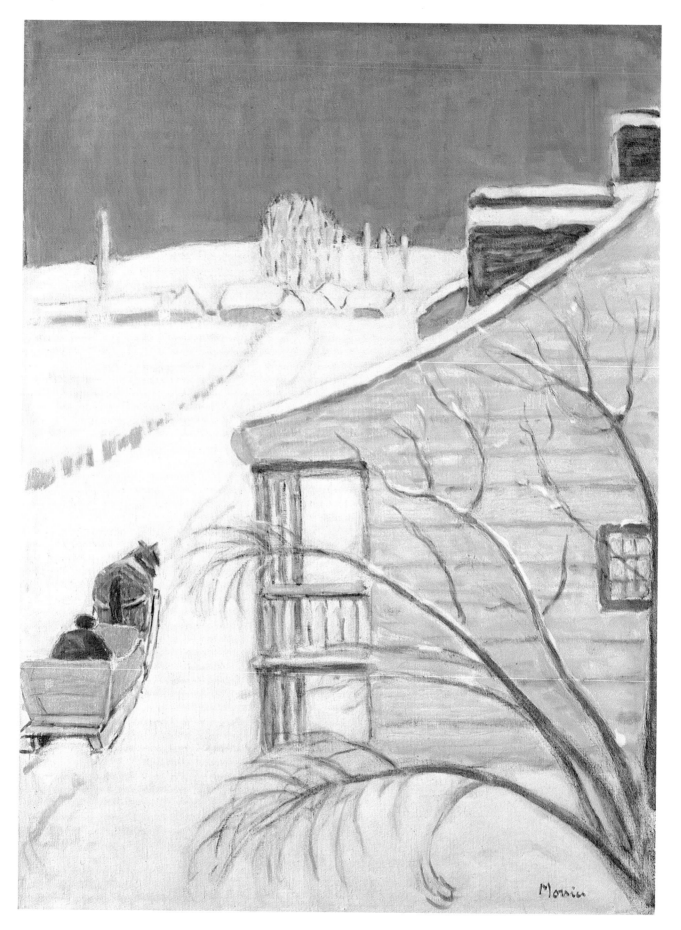

PLATE 8

façade boasted Grecian columns with an ample portico reached by five steps. The window shutters were hinged and hooked flat against the adjoining walls, and the slate roof was surmounted with small Gothic-like towers; a decorative wrought-iron perpendicular grill enclosed the entire perimeter of the roof. The whole structure reminded one of similar mid-century high style Victorian houses in Edinburgh or St. Andrews. The Morrice mansion, however, surpassed nearly all of them in opulence. David Morrice's close business friend, Andrew F. Gault, who was also a cotton magnate, was so impressed with the Morrice house that he too retained Mr. Browne to build his own Gothic style mansion, "Rokeby," on nearby Sherbrooke Street.

Years later, in 1909, an illustrated issue of the Montreal Board of Trade magazine noted that the Morrice house was "prominent among the handsome homes of this fashionable section of the city." In the same issue, Montreal is grandiosely referred to as "The Imperial City of Canada, Metropolis of the Dominion." A boastful statement, perhaps, but certainly an accurate assessment of Montreal's status as a Canadian city at the time.

By 1871, the David Morrices were the proud parents of five sons, the eldest of whom was ten years of age. Two more boys were born later, Arthur Anderson in 1873, and Edward MacDougall in 1875. The latter died at the age of twenty-three, and the grieving parents established a memorial fund in his name. Finally, there was Annie, born in 1879 and named after her mother. She was the only girl in the Morrice family, and a sister the artist mentions in later letters with great affection. Annie loved to travel and James anticipated with pleasure his sister's visits to Paris. In her younger years he painted some charming studies of her.

By 1863, David Morrice was not only a highly successful wholesale merchant, but he had also become more and more involved in the cotton industry. Manufacturing was then making steady progress in Canada and, after 1861, textile production began to rise dramatically. During and after the American Civil War (1861-65), a demand arose in the United States for Canadian textiles, needed by the Americans to replenish their own depleted stock.

Unfortunately, the Canadian cotton industry over-expanded during those boom years. Inefficient production methods and lack of capital made the industry highly vulnerable to business slumps. Profits fell off and nineteen of the country's twenty-six cotton mills found it necessary to amalgamate. Two companies were formed: the Dominion Cotton and the Canadian Coloured Cotton Mills. The Bank of Montreal, long a banker to the govern-

PLATE 9
Le Pavillon de Flore
c. 1902, Panel 5″ × 6″

Carriages drive by and ladies with parasols stroll down the wide avenue approaching the palace. It is a sunny day and fluffy white cumulus clouds are floating high in the sky. The scene is painted in heavy impasto with bright colours. It was exhibited in 1937 at the National Gallery's Morrice Memorial Exhibition, and was one of three panels lent by Jacques Dubourg of Paris.

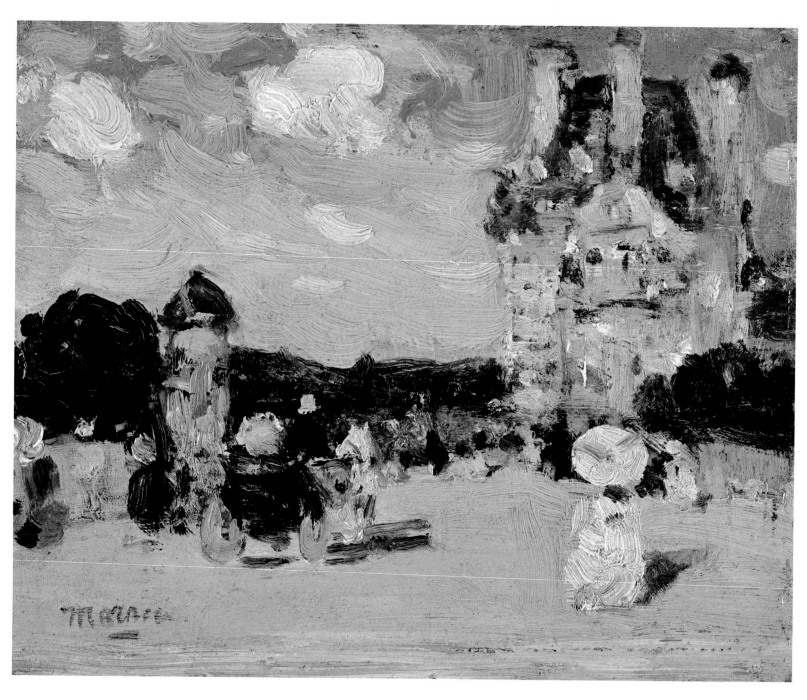

PLATE 9

ment and as well a supporter of the textile industry, supplied the necessary funds for the mergers. And David Morrice was the man who controlled the Canadian Coloured Cotton Mills. He was also one of the first to recognize the significance of newly discovered aniline dyes for colouring.

By the mid-1870s, David Morrice's business was firmly established, and the three dominant interests in his life were his church, family, and business.

Undoubtedly one of the strongest influences of David Morrice's earlier life in Montreal was that of the forceful theologian and educator, D.H. MacVicar, first as his minister and later, in 1868, as principal of the Presbyterian College in Montreal. MacVicar had a talent for rallying enthusiastic supporters to the cause of his church, and David Morrice was one of them. He became chairman of the college board and was credited by the clergy with bringing to the office a "business-like approach and selfless dedication." So closely involved was he with the affairs of the church that he decided to personally pay the entire cost of erecting an essential addition to the college's theological facilities.

It was a foregone conclusion that Mr. Browne, who had designed so many splendid Victorian Gothic structures in Montreal, should be chosen as architect for the new Morrice Hall, as it was to be called. It turned out to be Browne's noblest effort. Completed in 1882, it still stands and is now part of McGill University. With its fine spires and Gothic windows, it looks as stern and stable today as it ever did. It is possibly the finest example of Victorian Presbyterian architecture that remains standing in Canada. No wonder the college fathers received the original gift with such enthusiasm.

The public opening of the hall took place on the afternoon of Tuesday, November 28, 1882. During this occasion David Morrice was eulogized for his princely gift.

It is almost certain that all the members of the Morrice family, including James, were present during this highly emotional occasion – the dedication of a great cathedral of higher learning, built by his father, as a gift to his church.

This was truly an apotheosis, the crowning triumph for the merchant prince, and it brought him the utmost joy and satisfaction.

Young James would have watched with awe this virtual canonization of his father. He was eighteen at the time, and his father must have seemed like a prophet figure out of the Old Testament, a leader of his people. But there is another side to it too. James had grown up with years of strict observance of the Sabbath, and the Presbyterian morality of everyday life was stern. Now there was this ceremony at the opening of Morrice Hall. Perhaps it was

PLATE 10
Overlooking a Lagoon in Venice
c. 1902, Panel 7″ × 9¾″

Four young ladies in long dresses and hats are sitting at a table overlooking the dark waters of the Grand Canal. The glow from the tall lamps along the edge of the canal lights up their hats and faces. The soft play of moonlight from a summer evening enhances the shapes and surfaces of this delightful Venetian subject. Gerald Kelly acquired the picture from Morrice about 1902. It was apparently one of the artist's favourite paintings of Venice. Morrice also painted a medium-sized canvas of this subject that was either lost or destroyed.

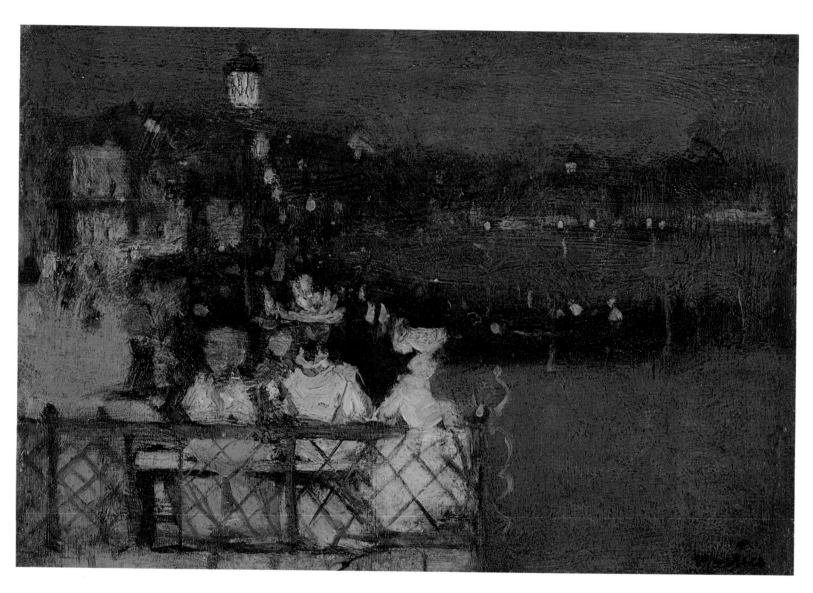

PLATE 10

just too much for James, perhaps it started his flight from church and religion, and also from Montreal itself.

But the donor of the Morrice Hall wasn't exaggerating or crying wolf when he intimated to his elders that his gift would result in considerable financial sacrifice. He must have had some kind of warning that his business affairs were not going well at the time, but apparently he had no inkling that anything as serious as a possible bankruptcy was imminent.

Soon after the dedication of the hall, in November 1882, there was a cotton crisis which led to a serious collapse of prices. By 1884, the cotton industry was in serious difficulty following the virtual bankruptcy of David Morrice.

Despite the market crises of 1883-84, Sir John A. Macdonald's "National Policy" of high protective tariffs finally rescued the Canadian cotton industry. No wonder the entire Morrice family were such staunch followers of Sir John.

By 1885, David Morrice was in his mid-fifties, a man in his prime. He set to work with zeal and it did not take him long to pay off his debts and have his credit fully restored by the banks. Over the next few years he earned his fortune back, and then some. And in so doing he became more respected than ever.

David Morrice shunned the sybaritic pleasures that could easily have been his as a rich man. He preferred the life of a family man and active church leader. He was also a generous philanthropist, and worked to make a better life for his employees. In today's idiom he was a man of social conscience.

David Morrice was also considered an art connoisseur, but the collection of paintings at his Redpath home, except for those by his son James, were conventional works of French nineteenth-century Realist and Dutch-Hague schools, and could hardly be termed distinguished.

As vice-president of the Art Association, he helped choose the site for the new Art Association building, today known as the Montreal Museum of Fine Arts. In 1909, his son James painted a scene of the old Holton House and its grounds on Sherbrooke Street, after a snowfall. This was the property that was soon to become the location of the new Montreal Art Association.

A better time could hardly have been chosen to raise money for the construction of a new half-million dollar art museum than the year 1910. Montreal was full of wealth in those palmy pre-war years, and there were many patrons who were honoured and delighted to make substantial contributions to the building fund. The 1912 report shows David Morrice to have

PLATE 11

A Brittany Girl Knitting
c. 1898, Canvas 21⅛" × 13⅛"

There are several old Notman and Fraser photographs of interiors of the Morrice family home on Redpath Street, Montreal. Of particular interest is a photograph that shows this canvas prominently displayed on the sitting-room wall. It was one of Mrs. Morrice's favourite paintings, a gift from James to his mother in the late 1890s.

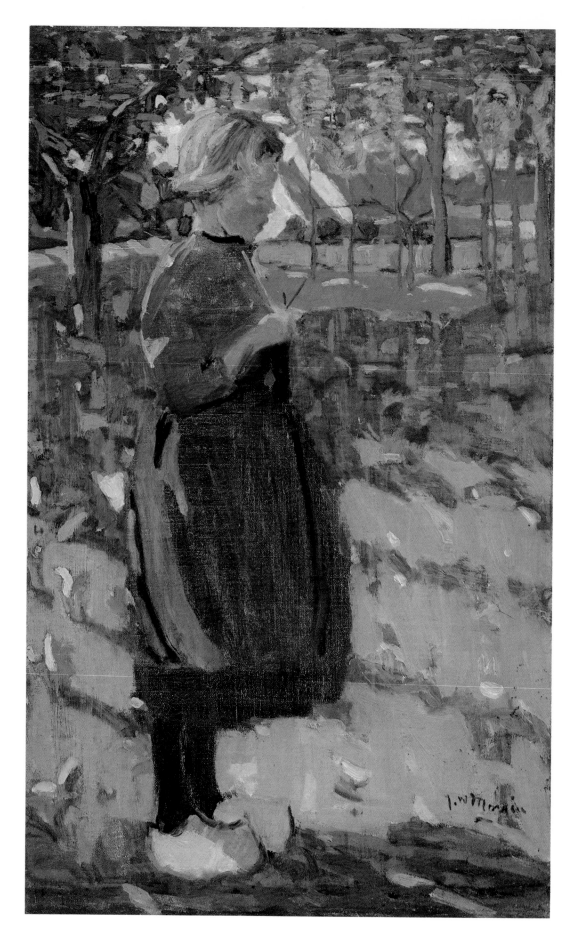

PLATE 11

been one of them. This was the world of generous giving that David Morrice supported, and these stern and mighty titans of industry and finance were all his friends as well as fellow Scots. When the opening of the new gallery actually took place, he felt proud to see several examples of his son James's work on exhibition.

In 1911, the *Montreal Star* rated David Morrice a millionaire, and by the time he died three years later, he probably was one several times over.

Throughout his life David Morrice's health remained uncertain, but he seemed to cope and was able to call upon a reservoir of inner strength when he needed it. On more than one occasion he talked about making trips or taking holidays abroad, but seldom did. He lived past his eighty-fifth birthday, remaining active in commerce at all times. He was considered the father of Canada's cotton industry, and it was reckoned that he knew more about the cotton business than anyone else in the land. He was also a director of some of the most powerful financial institutions in Canada, including the Bank of Montreal.

When he died in 1914, he was mourned by his family, missed by his business associates and lamented by his elders and friends in the Presbyterian Church.

I could not help but reflect, as I scanned the names of the Morrice family tomb a year or so ago, that Mr. David Morrice was still alive when I was born in Westmount, the English-speaking section of Montreal, in 1911. Indeed, some of my early years were spent in the community where the elder Morrice had reigned.

Westmount at that time was a town of some fifteen thousand, built on the side of Mount Royal, and a place totally Anglo-Saxon in population and character. Life went on entirely in English. My birth certificate notes that I was baptized at the MacVicar Memorial Presbyterian Church. Besides the presence of my parents, the baptism was witnessed by my Presbyterian grandfather, Robert Laing, and the document bears his signature. I remember him as a fanatical bible-reading, white-bearded autocrat who died at the age of ninety-seven. Indeed, looking back, I feel I can now understand James Morrice's determination to escape the grip of Canadian Presbyterianism.

My parents left Montreal in 1914, but returned just after the War; my father was in those days involved with one of his brothers in the oil business, but somehow the partnership foundered and he turned to other things. We lived on Côte St. Antoine Road and I attended the nearby Argyle Street Public School where all subjects were taught in English. For me, French as a language hardly existed.

PLATE 12

The Surf, Dieppe
c. 1904, Canvas 23¾″ × 28¼″

Exhibited in the Canadian Art Club exhibition of 1914, this picture was originally called A Dutch Pier, *but Morrice corrected the title in a letter. At some point after its first showing the artist removed from the composition the figure of a Breton woman carrying a basket of seaweed up from the shore. This picture was bought just before the First World War by Colonel Hamilton Gault of Montreal, who knew the artist and his family well.*

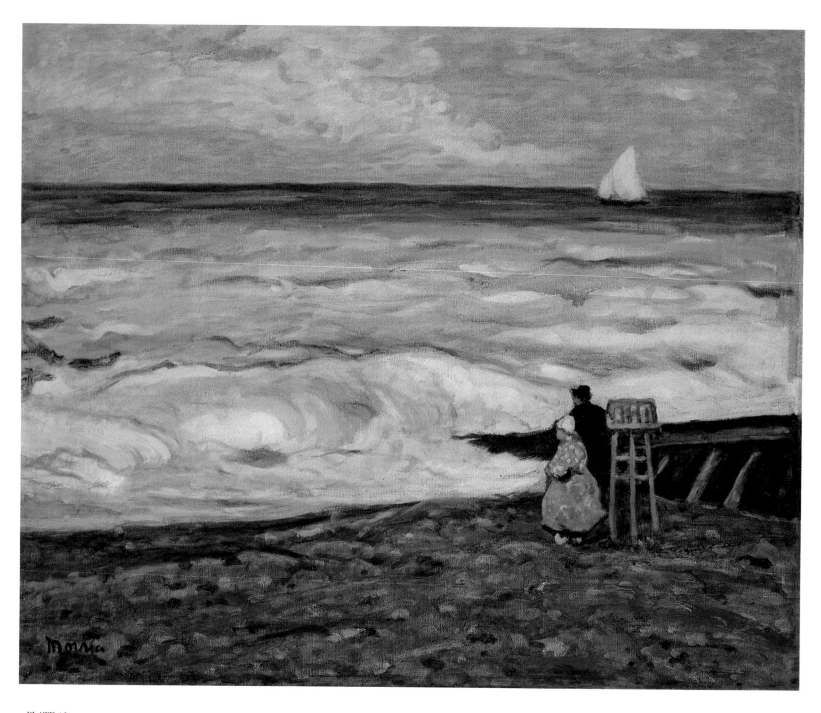

PLATE 12

My family left Montreal for good in the early 1920s, but as a young art dealer, particularly from the mid-1930s onwards, I revisited the city of my birth many times to look for suitable works from dealer colleagues, artists and private owners, to exhibit and sell in Toronto. We had no French Canadian customers in those days. Our Montreal buyers were members of the old established English and Scottish Canadian families, such as the Dawes, Refords, Websters and Pillows. From 1932 on, we worked closely with the Montreal art firms, Scott and Sons, William Watson, Sydney Carter, and later the Stevens Gallery, Scott's short-lived successor. In the late 1940s, we acquired many pictures by Morrice in Montreal, including some of his Harpignies-influenced Normandy landscapes, from the Austrian immigrants Joseph and Vilma Shima who had established the Continental Galleries in the late 1930s. They had many works by Morrice for sale from the estate of F.R. Heaton, Wm. Scott and Sons' successor.

From the mid-1860s, Canada had entered a period of economic prosperity, and the political realization of Confederation created a general euphoria and spirit of optimism. Montreal was already the metropolis of Canada and in 1871 had a population of 115,000. By 1901, the population had reached over 367,000, which far out-distanced the population of any city in Canada. The fast growth of Montreal could be attributed to the large influx of French Canadians leaving the villages and farms for the city.

By 1900, Westmount had become the home of a strong Scottish core of English-speaking people. This was the district where many of the brilliant risk-taking Scottish and English immigrants, the Canada builders, lived. They were the merchants, industrialists, owners of steamship lines, international traders and railway builders – members of the freewheeling enterprising elite of the new world. This was the milieu of that extraordinary Presbyterian patrician, David Morrice, and this was the society into which his brilliant son James was born.

As my gaze shifted from the tomb in the old cemetery to the slopes of the mountain, I became aware that the Morrice family's stay in this world had ended. The family fortune and the remaining clan members were now gone. And if not for the sublime works of art which David's son James painted, this cemetery monument would be all that survived. There is no doubt that these paintings are sufficient to perpetuate the family name, and assure James Wilson Morrice the place he warrants in modern art history.

PLATE 13

The Flower Seller
c. 1901, Panel 5″ × 6″

Among the most pleasing and colourful street sights in Paris are the flower vendors' markets. This one is located in front of the elegant midtown buildings on the rue Royale, or perhaps on an avenue near the Madeleine. A figure on a first-floor balcony casually surveys the scene. A closed double door beneath leads to a courtyard. The vignette is painted in Morrice's most sumptuous colours. The building façade is in rich earthy greys and olive greens while a corner of the little market stand glows with the crimson of roses and carnations.

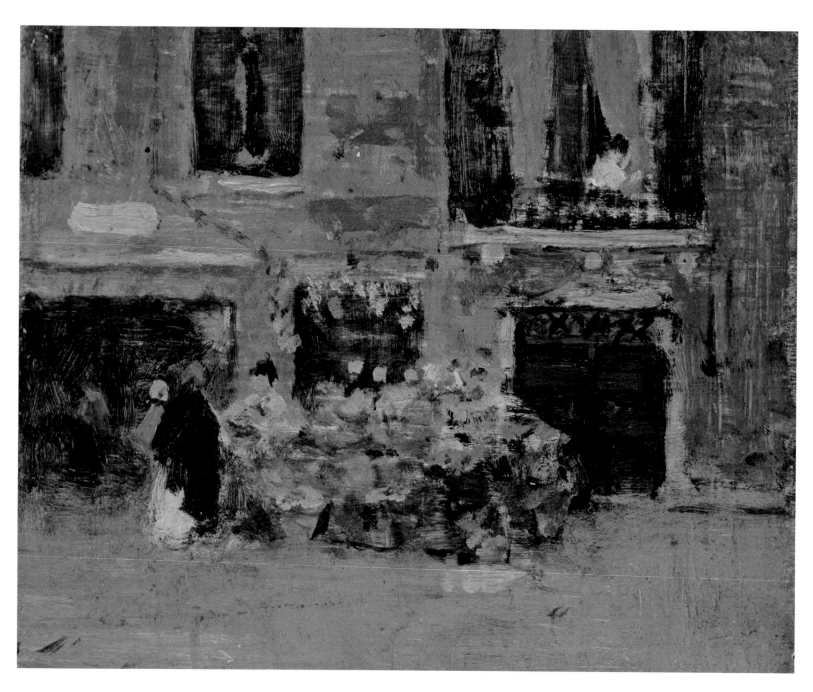

PLATE 13

JAMES'S
STUDENT DAYS
IN TORONTO

WHEN JAMES W. MORRICE took the Grand Trunk train to Toronto in early September 1882 to begin his university studies, he had just turned seventeen and it would be his first long absence from home. Toronto was by then an easy overnight journey from Montreal and he must have greatly enjoyed the adventure of travelling by himself in a first-class railway coach. He also looked forward to the personal freedom he would soon enjoy as a resident college student.

Of course he had with him his fine new flute. The young Morrice was deeply interested in music, and as a reward for passing his university entrance examinations at the nearby Sherbrooke Street private school he attended, his parents had given him a silver flute. It was a splendid hand-wrought instrument that replaced a less expensive flute on which he had long and faithfully practised. The flute, manufactured in three sections, fitted into a purple velvet-lined leather case, and an engraved silver plaque read, "James W. Morrice, 1882, Montreal." Throughout the rest of his life he was never long separated from his cherished flute.

About 1934, I well remember my artist friend, Curtis Williamson, who knew Morrice in France, telling me that the only time Jim's flute was missing was when he had reluctantly surrendered it to a Paris pawnbroker to raise some quick easy cash. Such temporary embarrassments seldom occurred as, in spite of a generous family allowance, Morrice was extremely frugal in his spending habits. He also could be careless and forgetful about money and leave bank drafts and cheques for months uncashed in bureau drawers.

PLATE 14
A Town in Brittany
c. 1896, Panel 9¼″ × 13″

This is a small inland town. Black-garbed Breton women in contrasting white hats are preceded by three children in azure-blue dresses walking towards a fiacre drawing up to the curb. Morrice traded the panel to Robert Henri in 1896. It marks a turning point in Morrice's career as by now he had developed into a truly original painter.

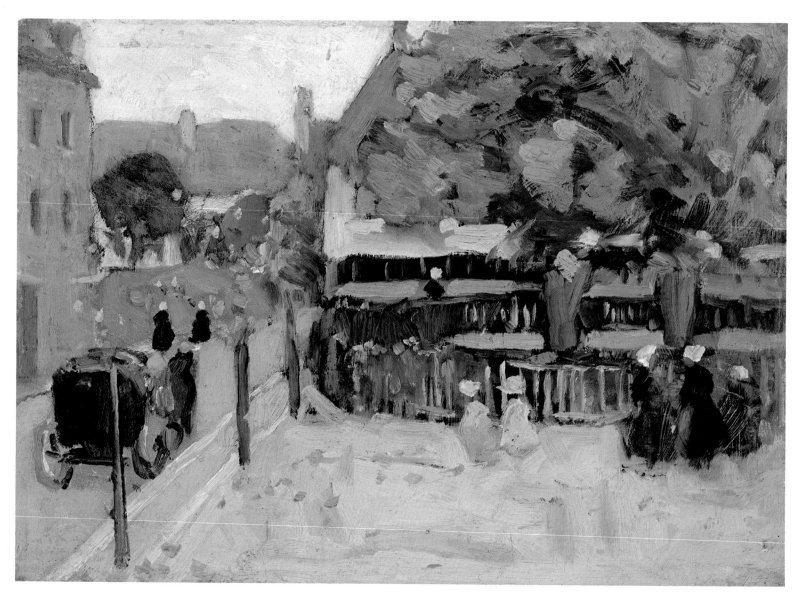

PLATE 14

Just why the University of Toronto, rather than Montreal's renowned McGill, was selected for James's higher education, is not known. For whatever reason, his father decided that the former was the proper choice for James. After all, David Morrice knew the city of Toronto well, having begun his own business career there some twenty-five years previously, and the D. Morrice firm still conducted an active branch office on Toronto's Bay Street. Moreover, the Toronto of 1882 was a much smaller and more conservative place than Montreal. Morrice Sr., the strict Presbyterian churchman, likely felt there were fewer temptations to lead a young man astray in the Ontario capital.

David favoured a legal education for his son. In the back of his mind he hoped that one day James would join the family firm; no doubt a legal training would be helpful in administering their extensive textile interests. However, then as now, it was a lengthy course of study for any young man because, after an arts degree, a further three years at Toronto's Osgoode Hall was necessary.

James began college life as a freshman at University College. He spent the next seven years as a student in Toronto, before being called to the Bar in the autumn of 1889. James was not a brilliant scholar who achieved high marks in his examinations, though his intellectual capabilities were considerably higher than his college grades would suggest.

When James Morrice arrived in Toronto in 1882, the city had a population of about eighty-five thousand and by 1885, enjoying considerable expansion through immigration and amalgamation of its suburbs, the population rose to 104,000. Toronto became the principal market-town for central Ontario farmers and others living in numerous surrounding villages.

A concern of citizens of Toronto at the time was the health risk involved in drinking the city's water, and the Medical Officer of Health warned of the dangers of a typhoid epidemic, the water in the harbour being badly contaminated by raw sewage.

Other citizens claimed that bad water was not the most serious of Toronto's drinking problems. People who shunned the polluted city water could drink to their heart's content in about three hundred licenced taverns, saloons, hotels, and dives of various kinds in the city. It is possible, and indeed it has been suggested, that James Morrice first acquired his taste for strong drink in some of these pubs during his university days.

We know that James lived at various addresses during his student days in Toronto: a boarding house at 64 Wellington Street West; in residence at University College in 1887; and in 1888 and 1889, rooms at 629 Yonge Street.

PLATE 15
Boat Building, Brittany
c. 1896, Canvas 15″ × 18″

In June 1896, Morrice wrote to his American artist friend Robert Henri urging him to come and spend a month with him in Brittany because "it is frightfully slow being here all alone." "At present I am at Cancale," he says, "a small fishing place near St. Malo. The boats here are interesting to paint. Now you had better come and join me at St. Malo — I am sure you will like it. There are no artists but plenty of billiard tables — expenses per day about five francs or less."

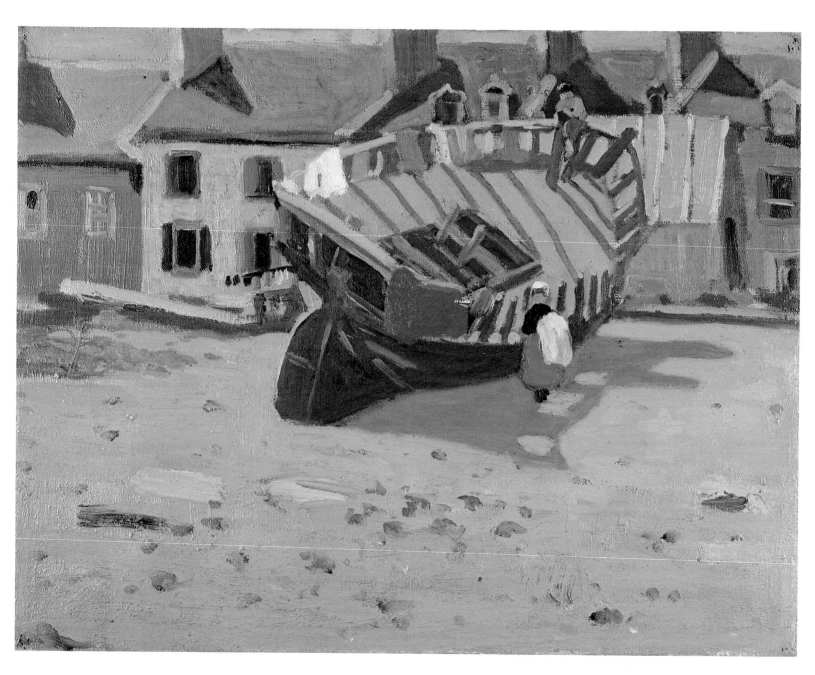

PLATE 15

He was invited to join Zeta Psi, for years the most exclusive private club on the campus. But there is no record of him having actually lived in the fraternity house. At one point, the fraternity possessed one of his early paintings, though it was never considered of any importance. James as a "Zete" does make one wonder. He was quiet, retiring, and inclined to art and flute playing, whereas the "Zetes," as they were called, were inclined to be noisy, social, and athletic. Perhaps it was with the "Zetes" that James developed a liking for alcohol.

At some point during the early Toronto years, he acquired a set of watercolours and made excursions into the countryside, especially around the bucolic Don Valley. These pastorals, depicting sheep and cattle quietly grazing near the river flats, were hesitant, tentative beginnings of his painting efforts, but one could already detect a sincerity in the workmanship and a definite feeling for paint quality. Another young man who had drawn there in the 1880s was Ernest Thompson Seton, later famous as a naturalist and writer of animal stories. Indeed, at least one of Seton's stories is set in the Don Valley that Morrice liked so well.

During summers, he did some watercolours in the Adirondacks and at Cushing Island on the Maine coast, where his family holidayed. But like Tom Thomson's early work some twenty-six years later, the paintings were inherently dull. It would take a few more years before James's exceptional artistic gifts would begin to show.

James returned home to Montreal from Toronto in the autumn of 1889 with his flute and his law degree. There were many family discussions about his career, but James had become firmly convinced that his future lay in art and that he must go to Europe to study in order to reach his goal. His father, surprisingly, was not entirely against the idea. Apparently two of his influential friends, Sir William Van Horne, collector of fine paintings, and E.B. Greenshields, who published a book in 1906 on modern Dutch artists, urged him to support James's cause. Both of these individuals later bought J.W. Morrice paintings.

The twenty-four-year-old James, now a fully qualified lawyer, was considerably older than the average art or music student beginning a concentrated training course. He realized that there was little time to lose before getting on with the serious study of art or music, and his instincts pulled him like a powerful magnet in the direction of an art career. Paris was then the one place in the world where it was possible to get the professional training he needed. An added incentive would be the opportunity of seeing great art, and meeting and working with students from many other parts of the world.

Artist's brushes and palette decisively won the day.

PLATE 16
A View of Tangiers
c. 1913, Canvas-covered board
9¼″ × 12½″

Looking down the roadway from the Hôtel de France into the town of Tangiers one sees a white English church and, beyond, the sea. Palms and other trees form graceful arches over the paths. The buildings are all white, many tiled with red roofs.

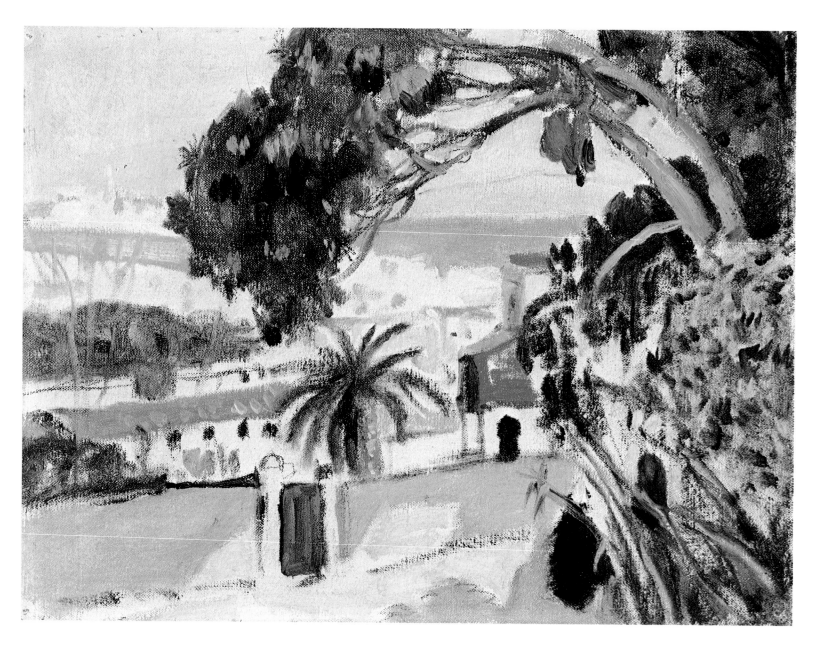

PLATE 16

3

THE EARLY
PARIS YEARS

ALTHOUGH HIS EXACT DEPARTURE date from Montreal remains unknown, James packed up his steamer trunk, making sure of the company of his flute, his watercolours, and some books to read, and sailed down the St. Lawrence for Europe in the late autumn of 1889.

He spent several months of that winter in England around London, with brief trips to Wales and the Midlands. He lived a short time at 87 Gloucester Road, South Kensington, in a modest one-storey building offering "Bed and Breakfast" to lodgers. James was well located then to visit London's many galleries, and he did so regularly.

By the spring of 1890, Morrice was off to Paris, and settled with his belongings in the inexpensive but adequate Hôtel Moderne, in the Place de la République. At that time Paris was probably the most civilized and beautiful city in the world. He liked the city immediately and soon felt at home there. It was to remain his artistic and spiritual home for the rest of his days.

France had undergone massive political upheaval from the 1860s on. The 1870-71 war with Prussia had ended in total disaster and disgrace for France. Some French artists had had paintings confiscated by the enemy, and during the war, Claude Monet and Camille Pissarro fled to England as voluntary exiles. While in London, they painted some masterpieces. Pissarro produced his *Dulwich College* and *Road to Sydenham* canvases, and from Monet's brush came a series of wonderful river views of the Thames and its bridges.

Besides losing her sense of national pride in an ignominious defeat, France had been forced to cede her fair and productive provinces, Alsace and

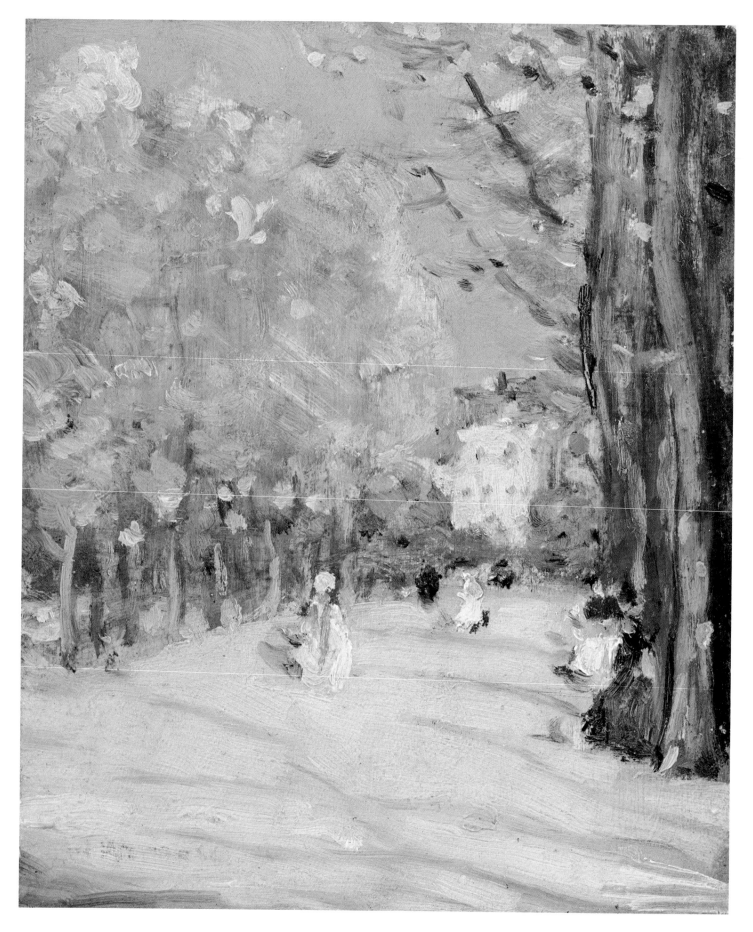

PLATE 17

Lorraine to the hated Bosch. But slowly, during the next twenty years, the country had regained its spirit of optimism, and the Paris that greeted Morrice in 1890 was a vital and stimulating city.

By the 1890s, a new style of painting appeared in the work of Edouard Vuillard and Pierre Bonnard, two of the "Nabis" group, or prophets, as they called themselves. Vuillard was painting his richly coloured domestic interiors: his mother sewing, or the family taking tea in the drawing room. There were also Bonnard's interiors and brilliant compositions of horse-drawn carriages and figures moving along busy Paris streets.

Van Gogh had died from self-inflicted wounds in 1890, and Seurat had died the following year at the age of thirty-two, the latter being one of the most gifted of all the nineteenth-century French artists. But there were many other great names, some of whom, like Degas, Cézanne, Redon, Gauguin, Toulouse-Lautrec, Monet, and Renoir, lived on into the twentieth century.

The world of art surrounded and excited Morrice and he regularly attended exhibitions by these artists at the many private galleries that were springing up in Paris. Later, his own work was included in various salons with many of the modern French masters.

A number of Canadian artists had previously studied in Paris, including Blair Bruce, Paul Peel, and George A. Reid. But with the exception of Paul Peel, who died there at the age of thirty-one, Morrice was the only important Canadian artist of his time to remain abroad so long as a willing exile, though no matter where he found himself, or how much he travelled, he always thought of himself as a Montreal-born Canadian.

Paris totally accepted the young Morrice, and while there he was transformed from a rich provincial man's son, albeit one with a law degree, into a major painter in a mere six or seven years. In Paris artists were judged strictly on their abilities, and it wasn't long before Morrice was accorded full acceptance by his fellow painters and almost unanimous praise from the art critics of his day.

The Paris in which Morrice found himself was not only the arts centre of the western world, but a city of light-hearted gaiety. It was a place of downright hedonism and sybaritic pleasures. In spite of the self-righteous warnings or gentle supplications from relatives and friends concerning the immoral aspects of the city, budding artists from all over the world continued to flock to Paris in order to study.

Paris is a city of public parks and gardens, which are a source of pride to its citizens. Over the years, Morrice was attracted to them – the Tuileries, the

PLATE 18
A Café, Paris
c. 1900, Panel 5⅛" × 6½"

A subject Toulouse-Lautrec might have painted in a Montmartre bistro. The restaurant is crowded with people sitting at closely spaced tables. All the figures are wearing hats, the moustached male a black one and two of the female figures most elaborate eye-catching yellow bonnets.

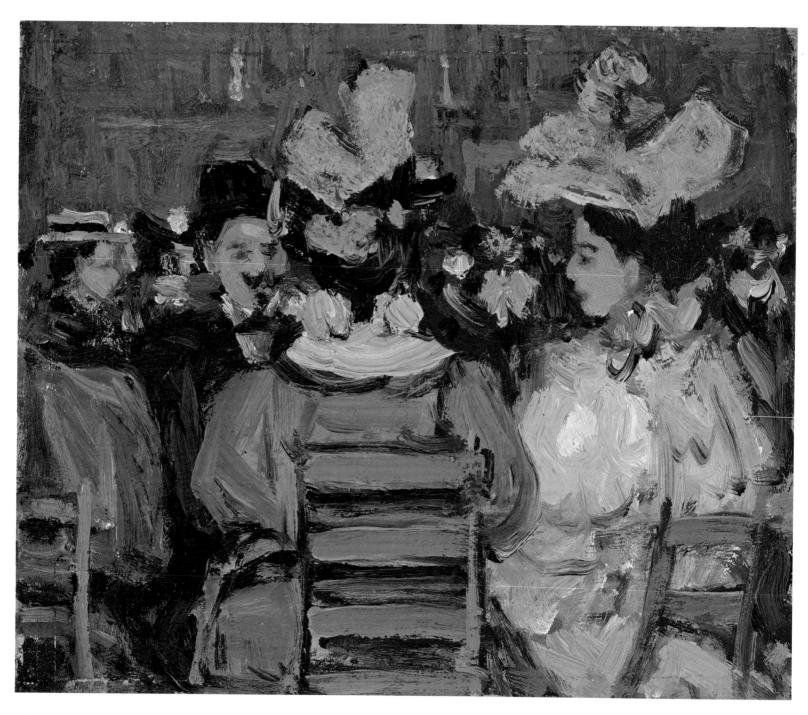

PLATE 18

Bois de Boulogne and the nearby Luxembourg Gardens. They appealed to him, and there he drew and painted studies of children at play, nurses pushing prams, or young couples strolling hand in hand along gravelled paths. Paris is the only city I know where the roofs, with their turrets, balconies, and sculptured friezes, are often as interesting to see as are the buildings at street level. Morrice enjoyed painting the Paris buildings, often using them as a background for the figures and horse-drawn vehicles he found on the boulevards.

Morrice made the first of his many sketching trips to St. Malo in the summer of 1890, and a watercolour of this date exists, depicting a panorama of the town from the outer harbour. Throughout the years, the artist became greatly attached to the province of Brittany and its people. He also made occasional visits to England, but it was France that held him closely in her artistic embrace. However, one must not forget another place in Europe that captured Morrice's imagination, and that was the old city of Venice.

It appears that the palaces, bridges, canals, and gondolas of Venice cast a spell over Morrice just as they have done with so many other painters throughout the ages. He probably made his first trip to Venice in 1894, with his close friend, the American artist, Maurice B. Prendergast.

In the summer of 1897, Morrice visited Venice with Maurice Cullen, having originally met him in January of that same year while sketching along the North Shore of the St. Lawrence including the village of Ste. Anne de Beaupré. In 1901, he was again in Venice with Cullen, and painted a series of palace façades bathed in sunset colours and reflected in the dark waters of the lagoons. In 1904, he visited Marseilles and did some drawings in a sketch book of a bullfight arena. He then went on to Venice, where he painted during the summer with the American etcher and biographer, Joseph Pennell.

In a letter to Edmund Morris dated July 1, 1907, Morrice apprises the former that he is leaving for a fortnight's stay in Venice and then on to Siena where he would stay for some time. Whether he ever reached Siena is uncertain, and I have never seen any pictures he may have painted there. That year was probably his final painting trip to Venice.

Over an intermittent period of some thirteen years, Venice spoke to Morrice with a sincere and spontaneous voice. This is evident in his Venetian works which are so harmonious. His paintings of twilight and evening views of the city, outdoor café scenes and wispy female figures seated on benches or strolling beside lagoons, remain among his best and most appealing works.

Morrice was far from alone as an expatriate North American. Gertrude Stein, for one, was making her way into the *avant-garde* studios and lives of

PLATE 19
Wet Day on the Boulevard
St. Germain
c. 1896, Panel 7¼″ × 8¾″

This is the district where Morrice spent the greater part of his Paris painting days. The artist was fascinated with the play of light from the gas lamps on the wet boulevard. A year or so later he enjoyed using the same effect in his Venice night scenes.

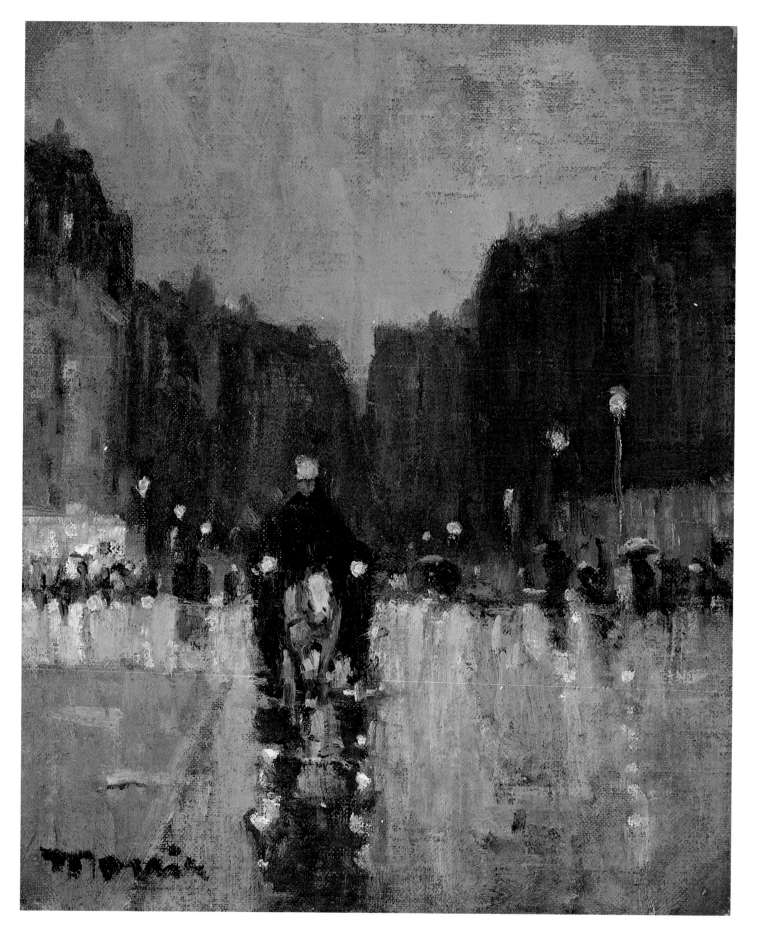

PLATE 19

such innovators at the time as Picasso and Matisse. And across the channel, near London, another expatriate was spending his meticulous life trying to discern just what it was that made London and Paris so amenable to culture and the arts. Clearly, Morrice, the patrician's son from Montreal, shared with that other patrician, Henry James, the feeling that society in North America was unfavourable to art and literature.

Henri Matisse had a studio a hundred yards or so along the Quai des Grands Augustins on the fifth floor of a building at the corner of the Place St. Michel. It had windows that looked straight down from his unheated atelier onto the channels of the Seine. This was a similar view to the one enjoyed by Morrice, only it was a little further upstream and closer to the towers of Notre Dame. Here Matisse began to produce as early as 1903 his revolutionary "fauve" paintings saturated with brilliant clashing colours. Like Morrice, Matisse also had an early training in law, but unlike Morrice abandoned early his formal studies.

During his early years in Paris, Morrice lived at several different addresses. About 1891-92, he occupied 9 Campagne-Première in Montparnasse. The five-storey stone house still stands, occupied. In the spring of 1896, Morrice moved to 34 Notre Dame des Champs, near the Luxembourg Gardens. This building, a shopkeeper informed me during my search for his old addresses, had been demolished many years earlier to make way for the extension of the Boulevard Raspail.

By 1897, Morrice was living at 41 rue St. Georges, on the fringe of Montmartre and the five-storey building is still there. Nearby, where the rue Laffitte reaches up the slopes of the butte, was Ambrose Vollard's little print and picture shop. Vollard, renowned for his astute taste in advanced art, became one of France's fabled dealers and art publishers. He was born on the Island of Réunion in 1865, the year of Morrice's birth. Vollard arrived in Paris in 1893 and opened a shop on the rue Laffitte. It soon became a street of commercial picture dealers, and James Morrice, who lived just around the corner for more than two years in the late 1890s, would have known Vollard, as well as the work of many of the artists he handled.

By mid-1899, Morrice had moved into a flat in an old house at 45 Quai des Grands Augustins, which he furnished sparsely. It may have been bare and simple inside, but it comprised one floor of a fine eighteenth-century building which still exists today on one of Paris's most ancient streets. Here he spent some fourteen of the most productive years of his life, painting up cigar-box-size panels into canvases and larger wooden panels which he later exhibited in Europe, the British Isles, and North America. The three win-

PLATE 20
Entrance to the Village of Ste. Anne de Beaupré
c. 1900, Canvas 16" × 22"

This was in the heart of the Quebec countryside for which Morrice had such deep affection. His pictures had nothing in common with the village scenes Cornelius Krieghoff painted two or three generations earlier or with the work of Horatio Walker who was seven years Morrice's senior and lived on the Ile d'Orléans, where Morrice also painted. He was the first Canadian artist to use the French Post Impressionist technique to paint his unique Quebec winter scenes. His work had a lasting influence on younger artists like Clarence Gagnon, Albert Robinson, and A.Y. Jackson.

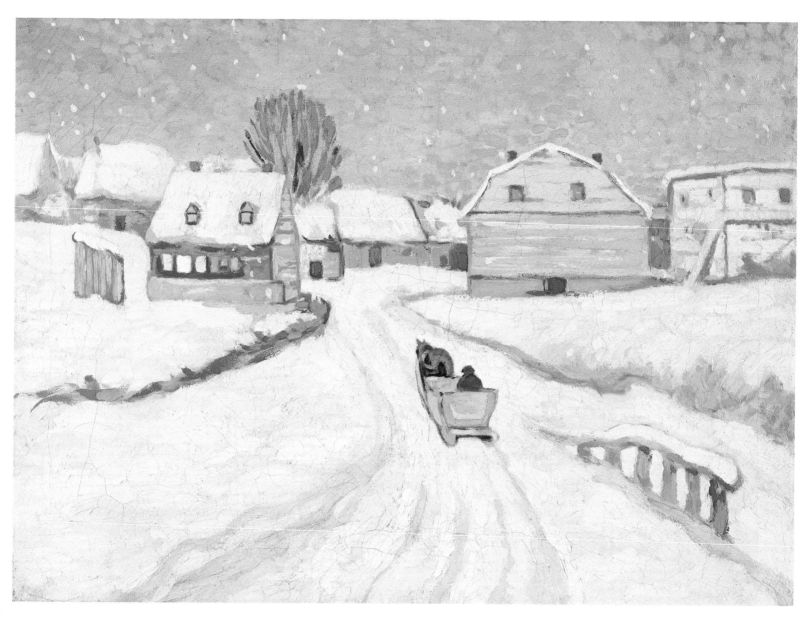

PLATE 20

dows of his studio, with their decorative iron grillwork, provided a sweeping view of the Seine from the Pont Neuf on the left to the twin towers of Notre Dame upstream on the right. Few cities in the world could offer such a glorious architectural view. And twenty or more of his memorable canvases painted from those windows confirm this fact.

It was on a mid-September morning of 1982 around mid-day that I found myself on the Quai des Grands Augustins in front of number 45. The large front door leading to the entrance hall was wide open and the building apparently more or less vacant. No one seemed to be on the premises except a lone workman enjoying a noon siesta. Like many other old houses on the Quai at this time, Morrice's former studio-home at 45, was also in the midst of extensive renovations. As I walked inside and stood in the lower hallway meditating for a moment, I imagined I could hear floating down the stairwell snatches of a melody from the Bach Suite for Flute and Strings in B Minor that the artist loved to play.

I climbed the winding stairway to the third floor and walked into the artist's former studio, the door being wide open and the flat vacant. I stood near the windows where Morrice used to stand and imagined him looking across the river with its busy barge traffic towards the historic buildings of the Ile de la Cité. Here was the Palais de Justice, which spreads virtually across the whole of the island, including as it does the Conciergerie and the thirteenth-century Gothic Sainte-Chapelle, with its lacy towers and stained-glass windows. Morrice would have known that it was here on this island during the French Revolution that such personages as Danton, Robespierre, Marie Antoinette, and Madame du Barry, the favourite of Louis XV, were imprisoned before their deaths.

During the first fourteen years of the century before the war broke out, there were amazing new discoveries in the fields of science and medicine; it was also an age of social upheaval, and Victorian values were gradually losing their hold. Morrice resisted the changes; he preferred peace and quiet to the noisy new automobiles that began to clatter along the boulevards and quais. But most of all, he enjoyed relaxing in the old style and sipping an absinthe with such friends as Charles Conder, the Australian artist, and Joseph Pennell, Whistler's biographer. Morrice was a good hand at billiards, having learned the game at home in his father's billiard room or at one of his father's clubs. If, in Montreal, he was never allowed to play the game on Sundays, in Paris he could enjoy playing any day of the week at the nearby Café de Versailles with Robert Henri.

During the early years of the century, Clarence Gagnon, an art student, sought out Morrice in Paris and painted with him in St. Malo. Gagnon's

PLATE 21
Early Snow on the Quai des Grands Augustins
c. 1905, Canvas 18″ × 14½″

From his third-floor studio on the Quai des Grands Augustins, Morrice looked out on one of the most interesting views in Paris. In this scene, two female figures, each holding a black umbrella, are walking along a slushy sidewalk by the bookstalls fronting on the river. Long barges anchored on the far side of the channel and buildings can be seen on the Ile de la Cité. The trees are bare and the atmosphere of the picture cold and damp.

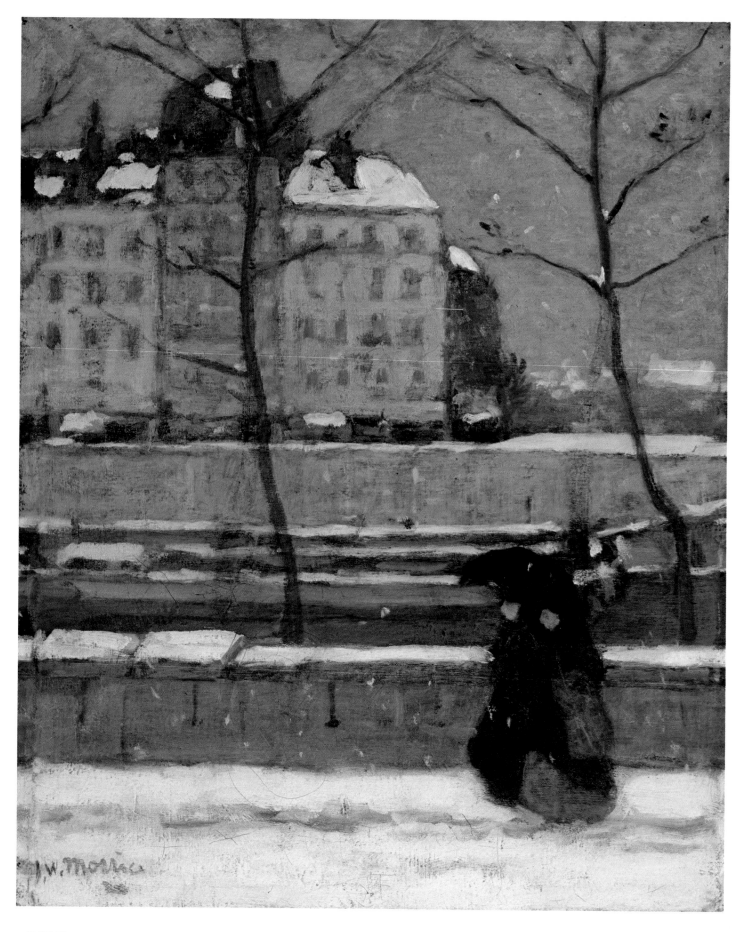

PLATE 21

French subjects were highly influenced by the Morrice painting style. However, a short time after his return to Canada in 1909, he found his own personal touch and began to produce those dramatic and colourful landscapes of the Baie St. Paul region of Quebec. Morrice admired Gagnon's etchings and in 1910 recommended that they be exhibited at the Canadian Art Club's annual Toronto exhibition.

In a 1935 letter, Gagnon recalls sketching at Giverny in 1905. He liked the country so much that he later spent several summers there. (The gifted Gagnon wrote the most readable and informative letters in English, a language he learned from his literary mother.) Gagnon and his wife Katherine were admirers of Morrice and we possess a small panel of the beach at Le Pouldu which Morrice gave them, and which Gagnon's second wife Lucille sold to me in 1953.

Lucille Gagnon had also owned the Morrice canvas *Pont Louis Philippe* since the early 1950s, and it had always held a special place in her affections, as well as being a view of one of her favourite Paris subjects. She could never be persuaded to sell it, but I finally acquired it years later from a niece to whom it had been willed.

In one of his notebooks, Morrice mentions the Giverny railway station. Giverny was the site of Claude Monet's garden-estate and lily pond where, on the graceful Japanese bridge, the courtly artist received visitors from time to time. Morrice knew Monet and visited his home and gardens with his companion Léa on several occasions when they stopped off at Giverny on the way to Dennemont.

It was in June 1982 that I visited Giverny for the first time. I found the Monet property magnificent, especially the lily pond. The latter is formed from a tributary of the River Epte and is approached through a short tunnel cut under the highway. What also heightened my interest in the water garden was that we had bought, years before in Paris, an important 1906 Monet canvas of this same lily pond.

A gentle rain began to fall during this warm June day and everything seemed tranquil and serene. The Monet estate, complete with its lily ponds, rose gardens, and Japanese bridge, has been restored to its former glory. It now belongs to the French State, a gift from the Monet family and international admirers.

Dennemont was a favourite rendezvous spot for Morrice and his young mistress Léa Cadoret. When Morrice and Léa got off the train at the Vernon-Giverny station in the early 1900s, it was but a short trip to Dennemont. Dennemont is a small village lying along the banks of the River Seine

PLATE 22
View of Paramé from the Beach
c. 1901, Canvas 24″ × 32″

This is a panoramic view of Paramé with part of the adjoining beach, St. Malo. In general Morrice painted few panoramic vistas, preferring instead more intimate subjects and close-up scenes. The extensive beach includes figures of children, women with umbrellas and some blue-striped beach tents. The white buildings on the coast, and the sky, account for more than one-half of the composition.

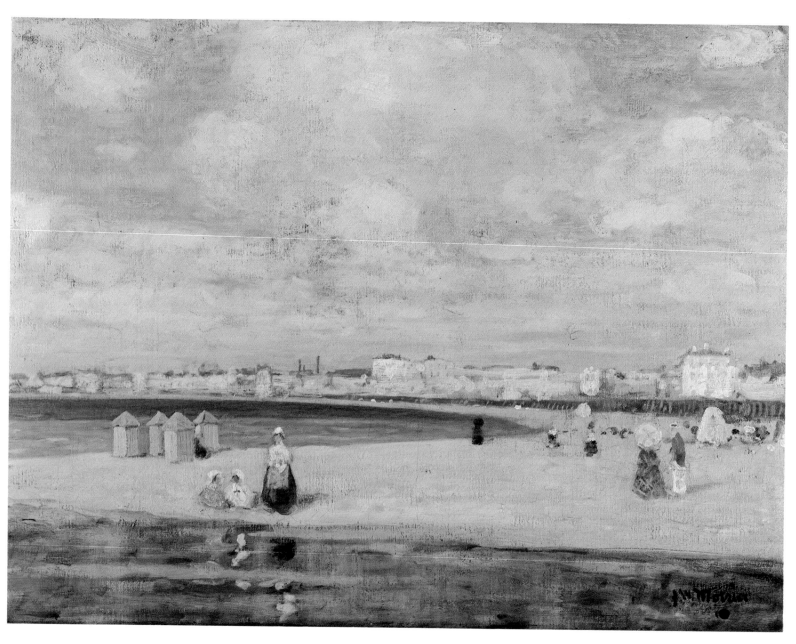

PLATE 22

opposite Mantes. On a quiet backwater of the river, there was at one time a small hotel with a mill and covered wooden bridge built over the water.

I twice visited Dennemont during 1982. It consists of perhaps fifty houses, some built on chalky hills to the left, others by the river's edge on the right. A single road bisects the village, and hard by the stream is a pathway just wide enough for a horse-drawn carriage to pass along. The eighteenth-century stone dwellings had small gardens resplendent with flowers which extended to the very edge of the quiet river waters.

On my last visit, I parked the car just off the main road in order to look around. In a minute or two, an old woman in a dark kerchief appeared at her door, and in a questioning and slightly hostile manner wanted to know what I was doing in her back garden. I explained that I was looking for the Old-Mill Hotel on the river. She told me that it had been blown up during the war by a stray bomb intended for the Mantes bridge. I asked if she had any photographs of the old building, and she nodded a vague affirmative. Then the old lady disappeared inside her house and a moment later re-appeared with a younger woman, who was probably her daughter. Now she showed no further agitation at the intrusion and allowed me to photograph her garden on the river to my heart's content. She suggested further that I should call on the village mayor, whom she said had a collection of early photographs of Dennemont.

About fifty paces down the hill, I found his office. After a brief wait, Monsieur le Maire emerged to greet me. He was fair-skinned with sandy-coloured hair, and you could tell from the crinkles at the corners of his eyes that he was a man of good humour.

I asked if he had any photographs of the original Old-Mill Hotel. He said he did, and after rummaging in an old desk for a minute pulled out a package of early twentieth-century hand-coloured postcards. As it happened, he had been collecting photographs of old Dennemont for years. Two in particular, dated 1905, interested me as they were typical Morrice subjects. One depicted the Old-Mill Hotel with its covered bridge. Another showed a group of peasant women washing clothes nearby on the river bank. When I inquired if I could purchase them, he just smiled and handed them to me as a gift. I was struck by the geniality and friendliness of the man.

Even though the Old-Mill Hotel has disappeared, the village still retains a certain atmosphere that must have appealed to Morrice and Léa those many years ago. It was probably here, about 1902, that Morrice produced his nostalgic (and now missing) painting of peasants washing clothes by the riverside.

PLATE 23
Venetian Girl
c. 1900, Canvas 18¾″ × 13⅞″

A young Venetian woman dressed in a long pink kimono-like robe decorated with flower petal forms is slowly strolling along the paved footpath of a lagoon. Her elegant coiffure is auburn coloured. The water reflects in shimmering pinks the walls of a palace opposite featuring a series of exquisite Gothic windows.

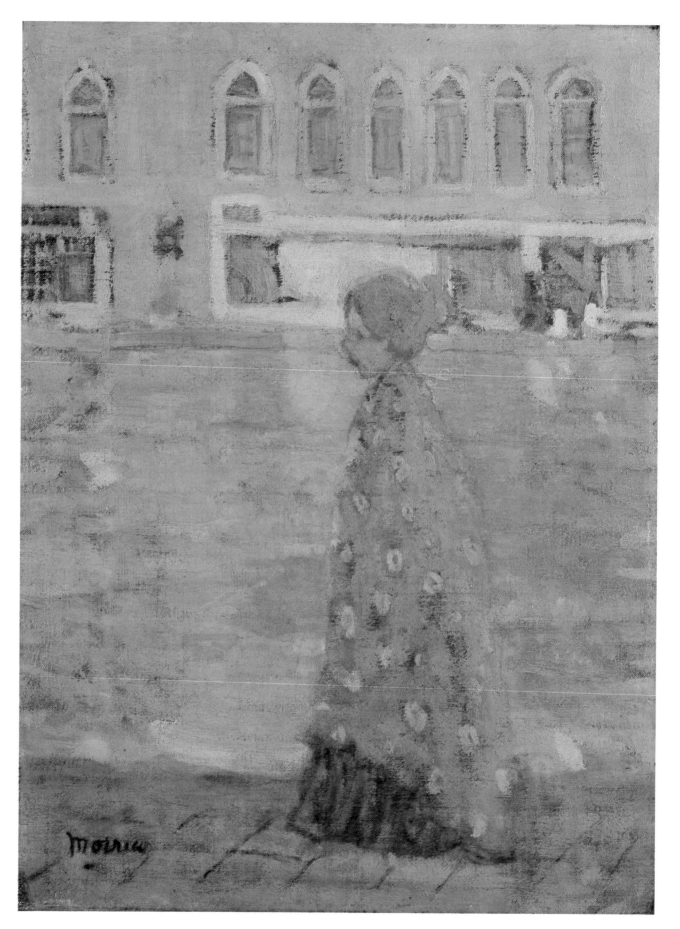

PLATE 23

On another trip, I visited the village Bois-le-Roi (Brolles) on the edge of the Fontainebleau Forest. It was in the valley of the upper Seine and the Fontainebleau Forest that the great Camille Corot (1796-1875) and fellow Barbizon artists, Charles F. Daubigny and Theodore Rousseau, worked on landscapes. Indeed, until well into the new century, Barbizon and its environs remained a popular place for painters. Brolles had an inn that was very popular among artists for its amenities, modest prices, and friendly proprietor in the late eighties and nineties.

In late June 1982, I set out to see if the hotel still existed. It was an easy hour's drive from Paris to the village. The countryside was fresh and green with a myriad of flowers in well-kept gardens, many joined by brick walls with field-stone headers. It was a pleasant surprise when, suddenly in a turn of the narrow road, I saw a two-storey building with fresh white-washed walls. In large block letters was a sign with the name "Hostellerie de la Forêt." Here indeed was Morrice's old Fontainebleau Forest Hotel. I drove into the courtyard, and walked through the open door to the friendly greeting by the patron, just in time for lunch.

Imagine my delight and astonishment when I found, fixed to the walls in the two dining rooms, nearly thirty murals. These had been painted by artists who had enjoyed their stay during those halcyon days between 1889 and 1901. One, a double mural painted on two panels, was a marine view of fishing boats off the French coast by the American artist Edward W. Redfield. Morrice knew Redfield through his friend Robert Henri when they went painting together in nearby Fontainebleau. It was then popular to pose nudes in woodland settings for an *en plein air* or impressionist effect, and Morrice painted several of these outdoors subjects.

The most attractive mural in the collection depicts a girl on a swing. A young lady with a flower pinned to her blonde hair is enjoying a garden swing. Her legs are clad in black stockings and her white lace petticoats are gaily flying in the breeze. In the lower foreground of the painting are the figures of two dapper artists at a table: one a moustached fellow holding a glass of beer; the other, sporting a Van Dyke beard, is smoking a pipe. Their felt hats are raffishly pulled down over their foreheads. The present proprietor, M. Hude, insists that the girl on the swing, then in her mid-teens, was the daughter of a Madame Délegant, who owned the hotel in the 1890s. Legend has it that the young woman married one of the American artists who used to frequent the Hôtel de la Forêt and returned with him to the United States. But unfortunately we don't know who painted the picture.

Many of the murals are unsigned and some that bear signatures are quite indecipherable. One shows a Paris dandy talking to a show girl from the

PLATE 24
View of the Beach and Ramparts, St. Malo
c. 1899, Panel 5″ × 6″

A view of the beach, bathing tents, granite buildings of the town and a corner of the ramparts done in the artist's most colourful painting manner. When the picture was exhibited in the Champs de Mars Salon, it was hailed by the critics as "full of the accent of truth and harmony . . . Mr. Morrice is certainly a painter with a new and powerful way of seeing nature. . . ."

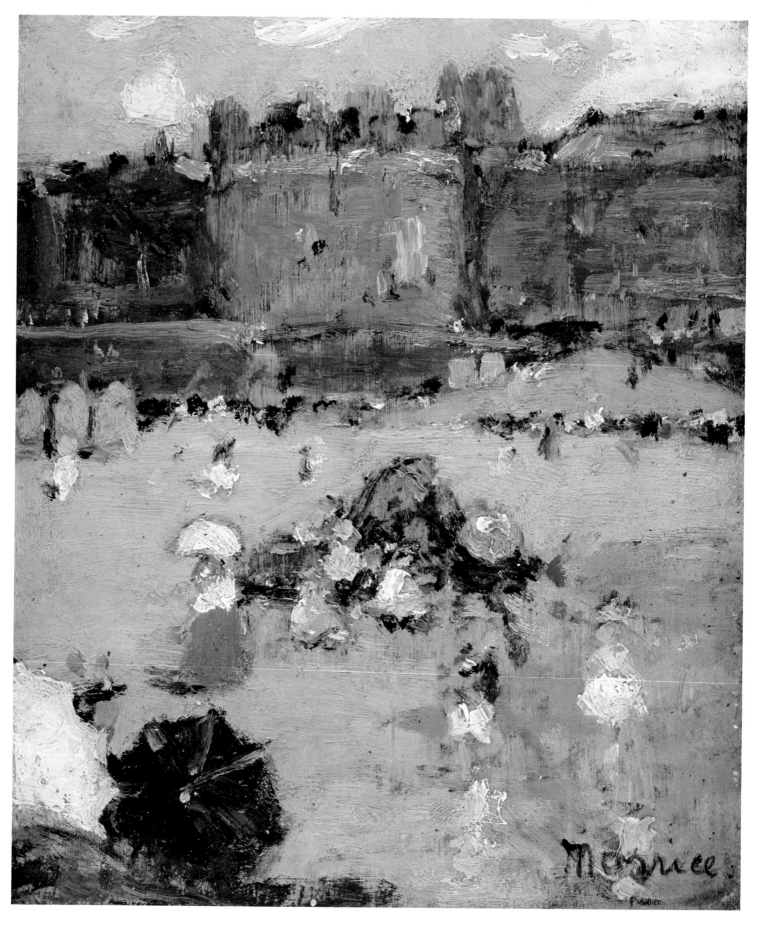

PLATE 24

Moulin Rouge, highly reminiscent of a Lautrec music-hall character. Another is a study of a dancer in a Balinese costume, and yet another a Montmartre cancan dancer. The subjects are a curious combination of rural respectability and a *joie de vivre* bordering on the erotic.

The early 1890s were great learning years for Morrice. First, he briefly attended the Academy Julian where nearly all the foreign students enrolled on arrival in Paris. As a youth, Rudolphe Julian set out for Paris hoping to become an artist. He soon realized that in Paris there was a lack of painting schools, so he founded an academy of his own. The academy became famous, and Julian proved to be a better businessman than artist. He remained active until 1907. Morrice probably attended a class or two presided over by Bouguereau, or perhaps Jean-Paul Laurens, and then fled its noisy confusion to take lessons from the landscape painter Henri Harpignies, who, in 1884, had opened his studio at 14 rue de l'Abbaye. Morrice accompanied the master on sketching trips to the Normandy countryside.

Harpignies' work was well respected in the art world of his time. Père Harpignies, as he was affectionately known, was a solid, if not an inspired painter. His niche lay in the nineteenth-century French art spectrum somewhere between Barbizon artists like Daubigny and Corot, and the early work of Monet and Pissarro. He lived to an incredibly old age and painted all over France, spring and summer landscapes in the Normandy basin of the Seine, seashore scenes of the Atlantic coast, and the valley of the Oise. Relatively inexpensive to buy, our gallery acquired many of his pictures throughout the years. We also had at one time or another a significant collection of small canvas-covered boards by Morrice, painted in the early nineties. These were attractive and well painted, but clearly reflected Harpignies' influence on the younger artist. They came from F.R. Heaton of Scott and Sons, the artist's long-time Montreal dealer and distributor of his estate pictures. However, Morrice soon dropped Harpignies' prosaic approach, and by the late 1890s he had found a style that would remain pure Morrice for the rest of his painting days.

PLATE 25
The Grand Canal, Venice
c. 1904, Panel 5″ × 6″

An attentive gondolier has just assisted two ladies, splendidly coiffed and attired, disembarking from his gondola. They are walking towards a square. Across the light-blue waters the dome of St. Mark's and other buildings appear indistinctly through a slight haze.

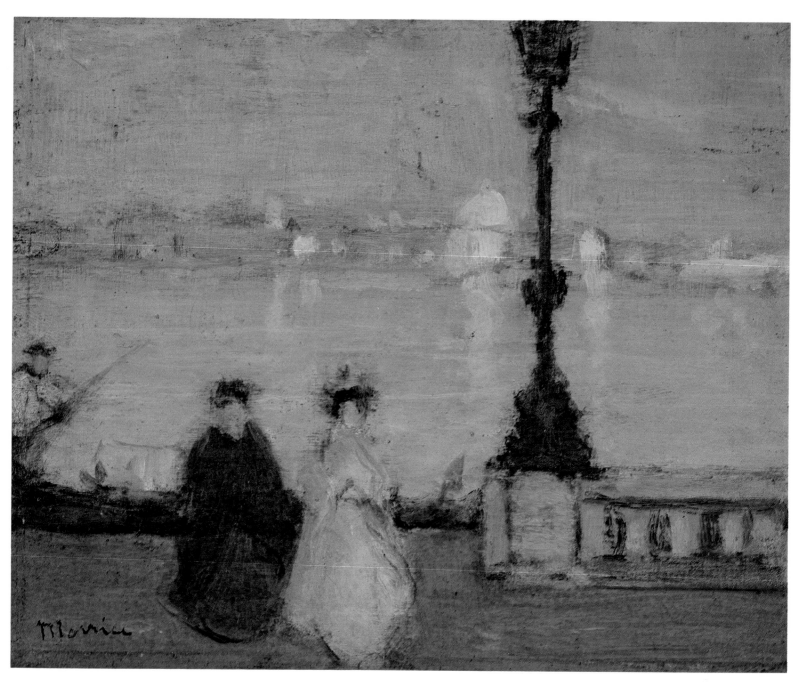

PLATE 25

4

THE
PARIS SALONS

By 1896, MORRICE WAS BECOMING the complete painter, confident and powerfully original. His showings from 1896 to 1913 in various Paris salons were an important part of his artistic life and helped place his name in the forefront of the international art world.

In 1889, a fierce struggle was emerging in Paris in the name of art and aesthetics. The war was primarily being waged between the established Salon des Artistes Français and the leaders of a proposed additional academy. The new organization had the long and awkward title of Salon de la Société Nationale des Beaux Arts, au Champs de Mars. It soon became known as the Salon National, or simply the Champs de Mars.

The jealousy and ill will that existed between the two factions and the disputes that took place, delighted the journalists and the press who revelled in the controversy.

The salon revolt was led by the most unlikely of men, the great Meissonier who, in 1889, opened the war against the official Salon des Artistes Français.

Jean Louis Ernest Meissonier (1815-1891) was, in his day, probably the world's most illustrious realist. In fact, public adulation of his work grew to a passion. He possessed strong patriotic sentiments, and his brush glorified the exploits of Napoleon and other stirring events in French history. These works were often painted on small polished wood panels, which seemed to highlight his superb draftsmanship and sumptuous use of colour.

Although in no way a modernist himself, Meissonier tolerated the new art and also felt that the older salon was out of date and not progressive enough. He was certainly successful in mobilizing important names to his side.

PLATE 26
Girl in Bonnet
c. 1900, Panel 9″ × 9″

A young girl from Le Pouldu district in Brittany is standing in an apple orchard. She wears an enormous wide-brimmed straw hat decorated with a red ribbon. Her facial features are so subtley modelled that the artist might have wished on the paint by magic rather than used his brushes.

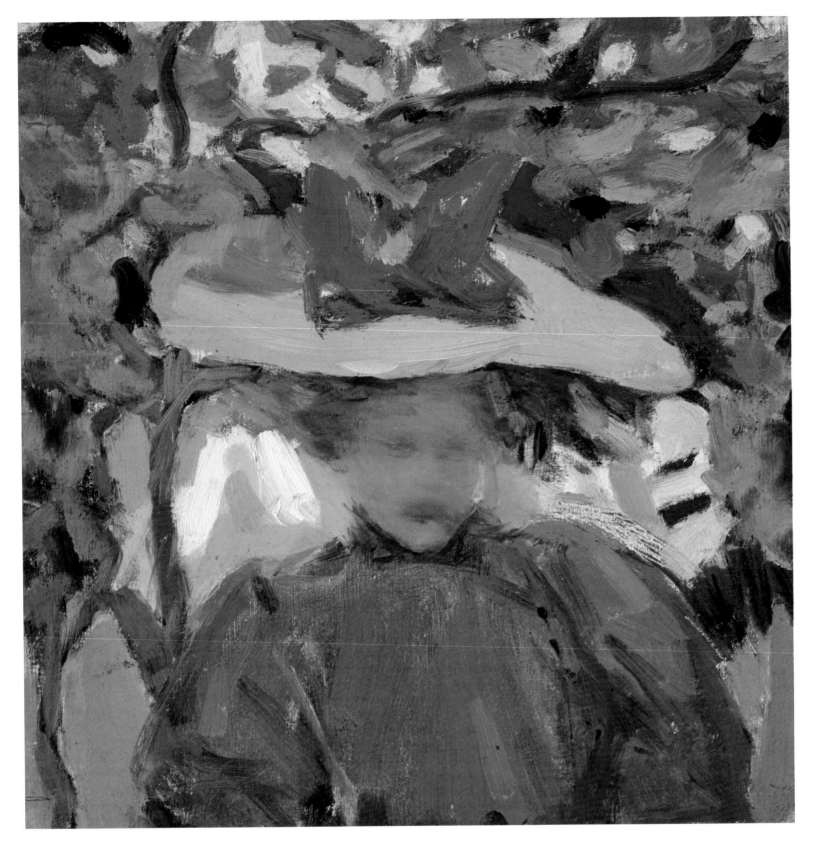

PLATE 26

Artists like Puvis de Chavannes, Rodin, Rafaelli, and the controversial American expatriate James McNeill Whistler, rallied to his cause.

The first exhibition of the newly established Salon National took place in 1890 in the Champs de Mars Salon. In 1896, just six years after his arrival in Paris, James Morrice was invited to participate in the annual Salon National exhibitions. This was his first important public showing in France, although he had exhibited some early watercolours at the Art Association, Montreal, several years earlier. This invitation was a personal triumph for the artist and gave him a new feeling of confidence.

From perusing the catalogues, it is quite impossible to determine which of the exhibited works were small cigar-box panels (*pochades* as they are commonly called today), medium-sized panels, or canvases. We do know that Morrice considered his little panels important enough to show in any public exhibition, and their quality did not escape the critics' sharp eyes. They also sold well.

In the October 1902 issue of the English publication *Truth*, its critic had this to say about Morrice's paintings, on view at the salon of that year.

> *Room 12 – A young Canadian Mr. Morrice of Montreal sends four pictures to the Champs de Mars Salon, which may not attract much notice among the general public but which are the best things in this room – two views of St. Malo and an evening and night at Venice. This is indeed painting combining taste and workmanship of the highest order.*

Indeed, Morrice's work was almost unanimously praised by the French writers in art publications. In 1905, Maurice Hamel in *Les Arts*, wrote:

> *The Canadian, Morrice, seems to me so "French" that I place him among ours. For frankness and firmness of tone, the richness of harmony, the corrida, the circus are pure wonders. The Quai des Grands Augustins, under snowy weather is a thing made of nothing and singing with delicious values.*

In 1906, Paul Jamot, writing in *La Gazette des Beaux Arts*, referred to Morrice as an "exquisite Whistlerian." It was a sincere compliment, but Morrice disliked the Whistler designation. In fact, he was highly sensitive when meaningless labels were used by critics to describe his art. Jamot went on to say:

> *The remembrance of the master could not prevent me from tasting these little harmonious landscapes, these fine notations of connections between a blue turquoise flecked sky and the warm whiteness of snow crossed with patterns of a*

PLATE 27
Rowboats on the Seine
c. 1898, Panel 4″ × 6″

A sketch probably made at Dennemont on the Seine where Léa Cadoret and her aunt often holidayed in the late 1890s. It is a colourful painting of rowboats on a quiet backwater of the river in the height of summer.

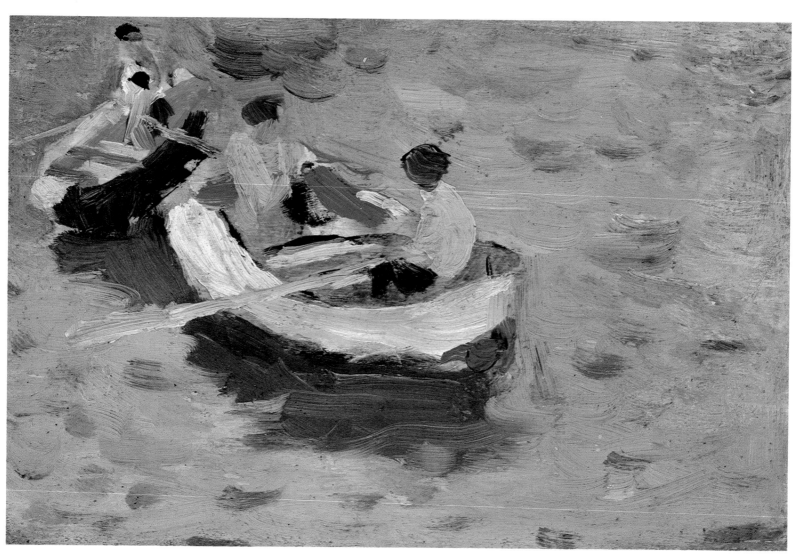

PLATE 27

horse-drawn sleigh, or a delicious twilight harmony in white, grey and salmon on this snowy street fringed with small shops.

In 1909, a critic discussing the salon of that year in *L'Art et les Artistes*, asserted:

The little things of M. Morrice are more and more "trifles" by the size, but also the painting is more and more exquisite.

By 1911, another critic writing of Morrice's paintings in the salon stressed that he reached the highest point of subtlety in his art as he restricted the sizes of his works.

No other Canadian painter abroad up to this time had ever received such universal acclaim by the critics.

In the controversy between the established Salon des Artistes Français and the Société Nationale, Morrice had supported the upstart Salon National. Now there was to be a third salon.

In 1903, the Salon d'Automne was founded by Franz Jourdain. He was an exceptionally alert and dynamic figure in the Paris art world of his time. He was a fervent champion of the Impressionists, and also an enthusiastic supporter of Morrice. Jourdain was the architect of the Samaritain department store in Paris, and an art adviser to Gabriel Cognacq, the owner. With Jourdain's help, Cognacq assembled one of the finest private collections of Impressionists, Post Impressionists and Old Masters in France. You could judge the excellence of Franz Jourdain's taste in art when you experienced the magnificence of the pictures in the Cognacq collection. Cognacq's paintings were sold at public auction in May 1952, at the Galerie Charpentier in Paris. It was the greatest art sale I ever attended. Looking at this event in retrospect, the Cognacq auction, although not the largest in the number of pictures offered, possessed a collection that was probably the finest in quality to be sold under the hammer during the twentieth century.

With the founding of the Salon d'Automne, it was now the turn of the Salon National to be jealous of a rival. In fact, the latter made determined efforts to block the opening. One critic wittily suggested there were enough salons already in Paris, but if an autumn salon, why not a winter, spring, and summer one too?

Despite dire threats of expulsion from the Salon National, many of its artist members dared to face the possibility of retribution, and happily exhibited at the more progressive Salon d'Automne. The initial exhibition was scheduled for 1903, but at the last moment Petit Palais officials claimed safety conditions were inadequate and cancelled the opening.

PLATE 28
A Street Scene, Paris
c. 1902, Panel 5½" × 6⅜"

A governess in a white cap and apron is escorting small girls wearing bonnets, walking by a street café. Across the boulevard is a five-storey building. The ground floor is fitted with red-striped awnings. The trees are bare of leaves but otherwise the picture is lively and colourful.

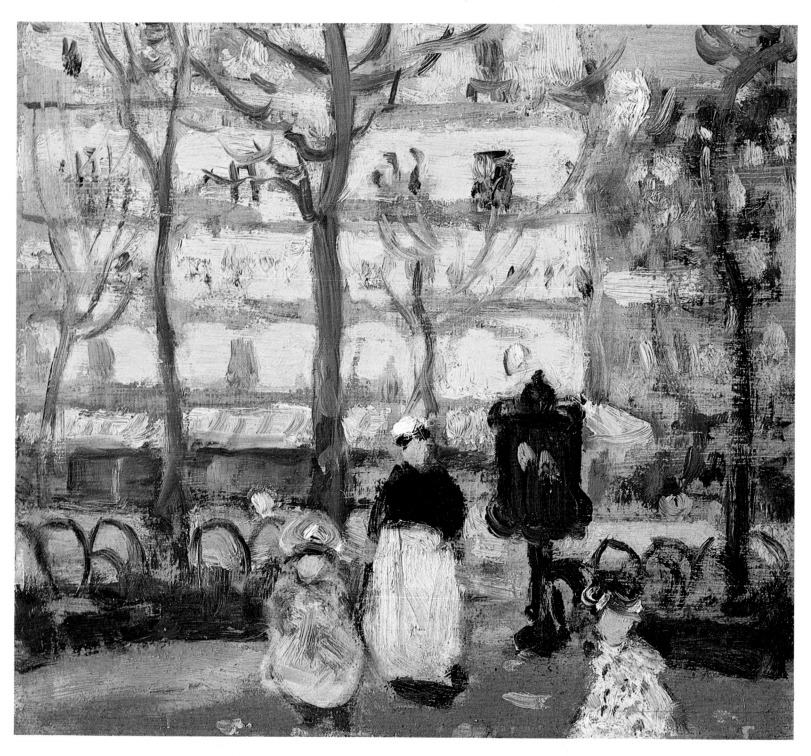

PLATE 28

Another powerful friend of Morrice's, who was involved in art, was the distinguished official Louis Lépine, who was appointed Prefect of Paris police in 1899. As a friend of Franz Jourdain, the Prefect intervened and authorized the opening of the Salon d'Automne on condition certain safety measures were carried out. The work was completed in a single day and the salon opened its doors on schedule.

In addition to showing in the Salon National, Morrice also exhibited a total of thirty-nine pictures at the Salon d'Automne from 1905 to 1913.

But survival problems were far from over for the new Salon d'Automne. The year after its launching in 1903, certain bureaucrats thought they detected revolutionary tendencies among artists like Henri Matisse and Georges Rouault. They refused permission for the opening. Franz Jourdain then appealed to Henry Marcel, Fine Art Director for the State, for personal help. Marcel was an erudite man with a fine collection of books and paintings. Later in 1908, he bought Morrice's magnificent painting, *The Port of St. Servan*. In the same year, on the opening night, he also arranged the purchase of the artist's *Le Quai des Grands Augustins* for the French State.

Marcel suggested that Franz Jourdain organize the exhibition in the Grand Palais and, thanks to Marcel's help, the 1904 salon was launched on schedule. Predictably, the success of the Salon d'Automne had been stimulated by the threat of boycott by the older salon. All the public controversy and publicity contributed to its great success.

The Salon d'Automne of 1905 was a huge exhibition and showed many *avant-garde* pictures. 1905 was also the first year James Morrice exhibited there, and as late as 1909, we know from his letters that he still considered it "the most interesting exhibition of the year, somewhat revolutionary at times but has the most original work." There were two big retrospectives within the 1905 salon. One was devoted to the classicist Jean Ingres and the other was a one-man show by Edouard Manet—the first retrospective of the artist whose flat, broadly brushed forms had long impressed the young Morrice. Cézanne, the master from Aix-en-Provence, sent up ten paintings including landscapes and a study of Madame Cézanne. Renoir sent some work from the south of France, and Odilon Redon, the leading symbolist, was given a place of honour. Vuillard and Bonnard represented the Nabis. And in addition, there were canvases by the popular primitive painter Henri Rousseau. Morrice showed four small *études*, three of Venice and one of the Tuileries.

In 1908, Morrice joined the Société Nouvelle which held annual exhibitions under the presidency of the great sculptor Auguste Rodin. The exhibi-

PLATE 29
Blanche in Blue and Green
c. 1912, Canvas 24″ × 20″

The painting was exhibited in 1912, at the Salon d'Automne, under the title Blanche, *along with four Tangiers subjects. The sitter is Blanche Baume, Morrice's attractive model whom he painted several times during this period wearing elaborate hats, long gowns, and sometimes in lavish Oriental costumes.*

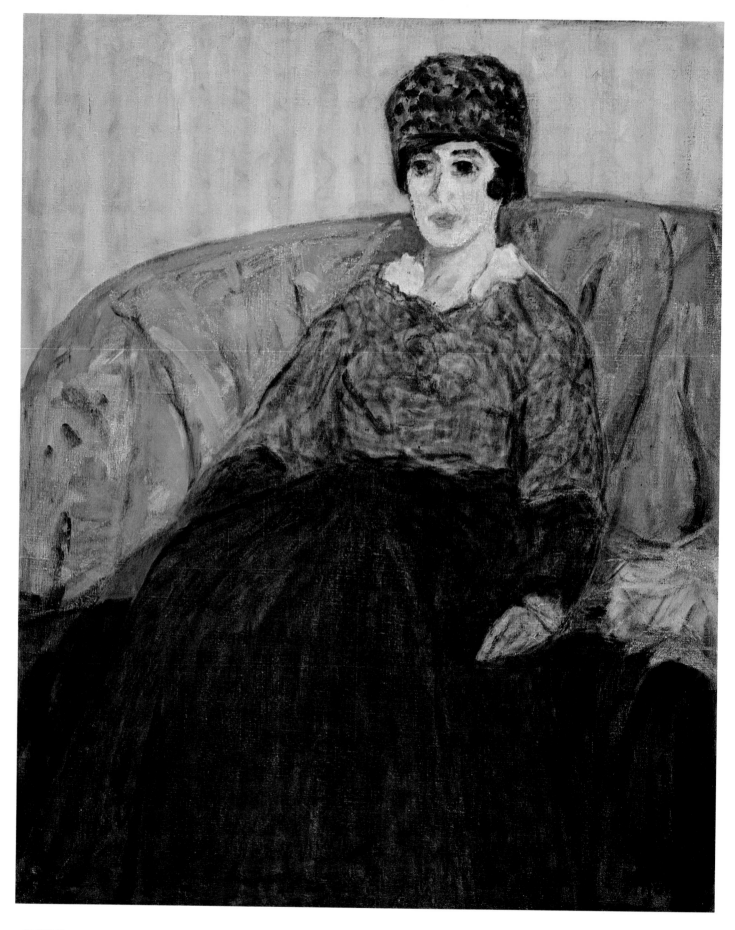

PLATE 29

tions were held in the ornate Edwardian premises of Georges Petit. Morrice exhibited there until 1913. André Schoeller, who joined the Georges Petit Gallery in 1904, and who was a friend and patron of Morrice, organized these exhibitions.

The principal members of the Société Nouvelle, according to Morrice, were Jacques Emile Blanche, Charles Cottet, Lucien Simon, André Dauchez, and Gaston La Touche. They are not names to excite the imagination today, but during their time they were extremely well-known French artists. Morrice's close friend, the Australian Charles Conder, was also a member of the Société Nouvelle.

It is clear that Morrice did not lack invitations to exhibit in public salons and, as well, enjoyed his share of private patrons. He continued to exhibit in the Salon d'Automne in 1912 and 1913 when, as a result of his North African visits, a powerful new dimension to his colour sense occurred. The bright Moroccan sun had enhanced his palette. In 1912, he showed some of his Moroccan subjects for the first time in Paris. A stunning study of his model Blanche Baume done in the same year also revealed the North African colour influence. In 1913, there was a canvas of Gibraltar and four Tangiers subjects. Some of these were significant works, *Tangiers la Fenêtre* was one, painted when he was staying with his friend Henri Matisse at the Hôtel de France.

One of the art critics who particularly admired Morrice's work was Louis Vauxcelles. A professor at the Sorbonne, he wrote reviews for the *Gil Blas* and other art publications. He wrote enthusiastically about the "fauves," having coined the expression in 1905, and was a great defender of the art of Cézanne. He also invented the expression "Cubism" when he pointed out in a review in 1908 that "Braque paints small cubes." In 1909, Newton MacTavish's *Canadian Magazine* carried a long, glowing article that Vauxcelles wrote on Morrice. Vauxcelles concluded his review thusly:

J.W. Morrice is neither a portraitist nor a landscapist, simply a painter and one of the best of the day.

In September 1912, Vauxcelles again wrote about Morrice's pictures in the Salon d'Automne:

Room XXII contains six small paintings where the Canadian Morrice put his indolent distinction and his science of harmony of colours.

Indolent is just as much a comment about the man as it is about his pictures. But although Morrice was often indolent in his manner, he was scarcely indolent with his brush.

PLATE 30
Barge on the Seine
c. 1896, Panel 9¼" × 6½"

A Seine barge plys the river opposite the Ile de la Cité. Trees and buildings fill the opposite shore but the artist artfully draws the eye to a full moon in glowing pink.

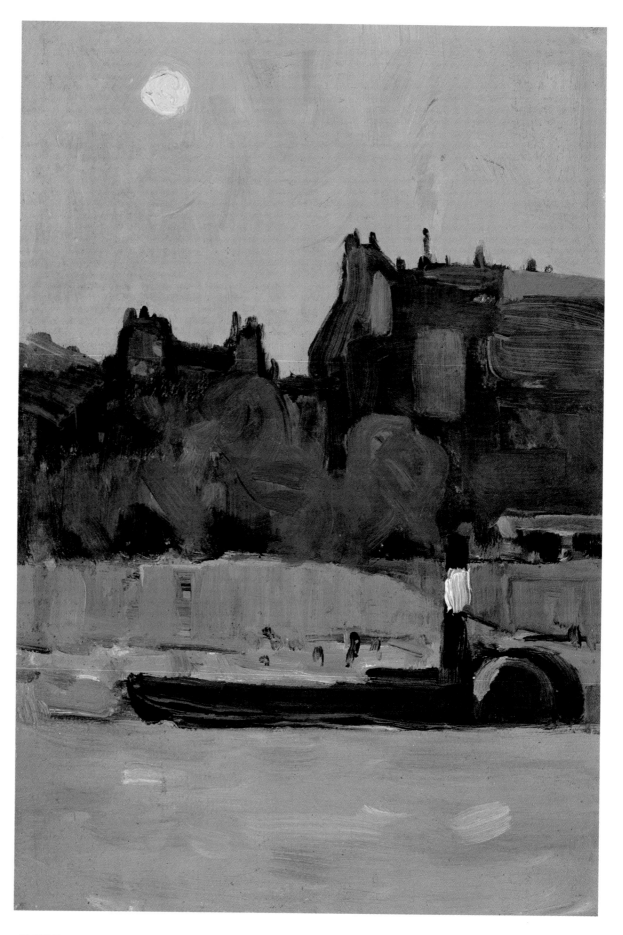

PLATE 30

Besides his various salon exhibitions in Paris, Morrice showed in London, Brussels, and Glasgow. In the United States he sent works to the Carnegie Institute in Pittsburgh and to Buffalo, Philadelphia, and the American Artists exhibitions in New York. Occasionally, he showed at the Art Association of Montreal. He showed regularly at the annual exhibitions of the Canadian Art Club from 1908 to 1915, when the club was disbanded because of the war. Over the eight-year period he exhibited a total of forty-six pictures. He appears to have sold only two canvases in Toronto throughout those years, one to the club's honorary President D.R. Wilkie, and one to Senator A.C. Hardy of Brockville. Newton MacTavish bought two or three of his panels. In addition, he showed at the private French Gallery, London, England. The manager, a certain Lawson Peacock, used to bring large collections of Dutch art to Montreal to exhibit with Scott and Sons. These collections of Dutch art were then in high fashion among wealthy Montrealers. Morrice despised the pictures.

The truth is that, early on in his Paris years, Morrice perceived the folly of proceeding in his painting career along academic lines. Certainly, his record with the new salons proves he was abreast of the times and, if he was not always *avant-garde*, at least he was in touch with the best of contemporary work. Within five or six years after his arrival in Paris, he had developed a personal style that would last for the rest of his life.

Nor did he lack money. With his picture sales and allowance from his family, Morrice's income would have probably approached $5,000 a year, which in those days was a lot of money. The exact amount of his paternal allowance remains unknown. But what is certain is that as his reputation grew, buyers in Europe were gladly paying the equivalent of $400 or $500 for his canvases. Even Matisse referred to him, in a slightly jealous moment, as a rich man.

Although Morrice was a member of the important Paris salons, he did not spend all his time in Paris. One place he loved was Brittany. The rugged coastline of Brittany was fully explored in the last quarter of the nineteenth century by hundreds of artists, and three of Morrice's fellow members of the Société Nouvelle. Simon, Dauchez, and Cottet, painted extensively in Brittany during the 1890s. Simon was born a Breton, and his two painter friends shared with him a great affinity for the province. Strong suggestions of the harsh qualities of the Brittany landscape and the poverty of the people emerge in some of their large salon works. These paintings reflected a fatalism brought on by a bitter struggle for survival.

For several years in the late 1880s Paul Gauguin painted Breton life. A leader of the Pont-Aven group, he applied his pictorial symbolism and rich

PLATE 31
Brittany Girl in White and Green Headdress
c. 1896, Panel 13″ × 9½″

A striking study of a young sad-faced Brittany girl. In general Morrice did not express sentiment in his art, but in this study he has let us glimpse the quiet air of resignation and the sad demeanour of his subject. It was a trait which characterized the peasants and fishermen of France's remote and ancient province.

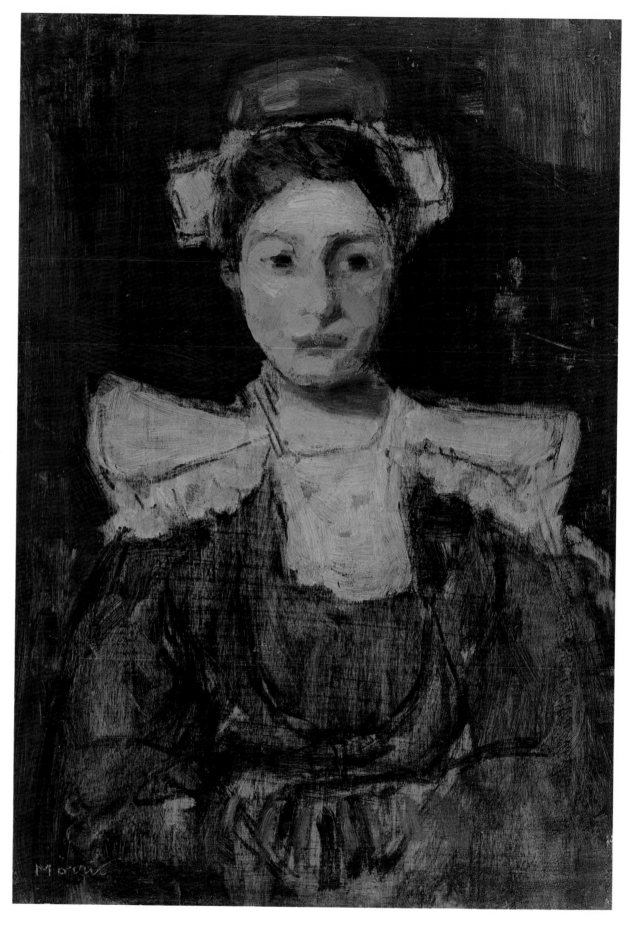

PLATE 31

colour sense with great success to the subject of Breton women in their traditional costumes. As Bretons were deeply religious Catholics and strict in their beliefs, he could never get a Breton girl to pose for him in the nude.

Written in one of Morrice's sketch books was the allegorical title of one of Gauguin's paintings, his famous 1897 Tahitian canvas, *Where do we come from? What are we? Where are we going?*

Morrice recorded the selling price for the picture in one of his notebooks: 150,000 francs, or $30,000. This masterpiece was probably offered for sale by Vollard, and Morrice was half-tempted to buy it, but decided against spending the money. More than likely the title of the picture struck a highly personal chord within the artist. Like Gauguin, Morrice was intrigued by questions about the meaning of life, and he was fond of writing ironical quotations about them in his notebooks. His pictures too pose some similar eternal questions.

Although Morrice knew the painters of the Breton group, having exhibited and dined with them, his work was quite different from theirs. Some commented on the social struggles and the harsh life of Brittany, and Morrice in his own work made few such social comments. He was a painter in the classical or French meaning of the term, and his paintings are entirely devoid of sentimentality. Instead, his figures possess a strange and placid immobility mixed with his own curious blend of magic. He sought out the mood of his subjects in an intuitive and subjective way, and his paintings are not merely illusions nor altogether reality.

Morrice could fix the transience of fashionably dressed ladies wearing bonnets with ribbons promenading along a sea jetty or in a park. He made painterly interpretations of what otherwise would never have been preserved, even by the camera. With deft touches, he could integrate figures near a city kiosk or on a beach. His figures and faces remain subtle, elusive, yet the total effect of his work is complete and satisfying.

Morrice was a member of numerous Paris salons, which allowed him the opportunity to exhibit widely. It was not typical for French artists to become members of every artist organization, but Morrice, with his North American background, considered it important. These exhibitions contributed significantly to building his reputation as a painter.

Although Paris was an important centre in terms of salons and other exhibitions, the artist eventually felt the need to travel to a sunnier and warmer climate. What he was after was light and bright colours, which would stimulate his palette.

PLATE 32

The Promenade, Dieppe

c. 1904, Canvas 19¾" × 24¼"

Morrice captures elegant ladies in long summer dresses and large bonnets; some are walking, others sitting with companions at tables under red striped umbrellas. Dieppe was the famous French-Anglo watering place of the early days of the century. Here the artist has assumed the role of a detached observer suspending the figures of the tableau in timeless immobility. This picture has an important historical background being Morrice's personal contribution to the Royal Canadian Academy's travelling exhibition in aid of the patriotic fund, 1914–1915.

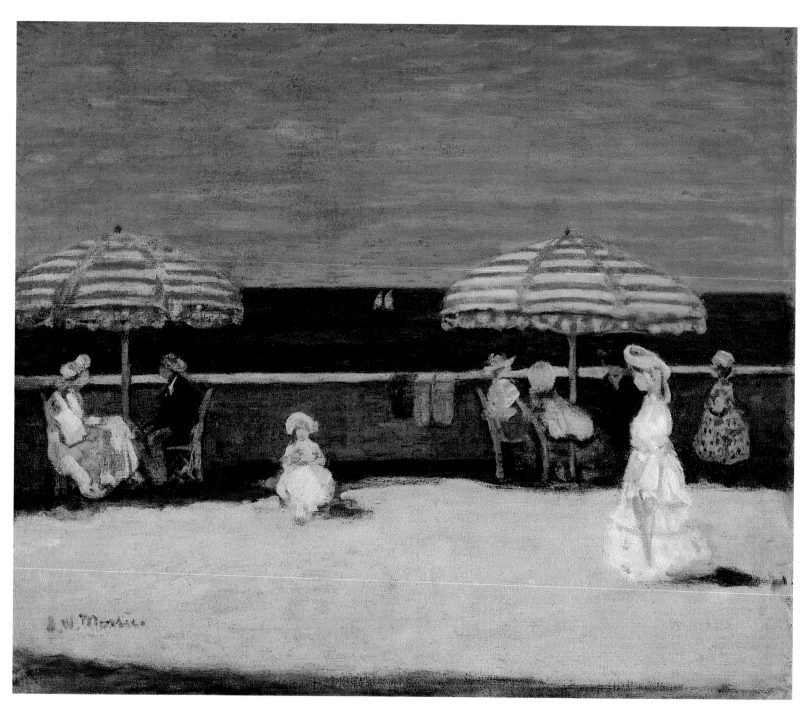

PLATE 32

The biographer of the New England artist Robert Logan (1874-1942) states that James Morrice was on a trip to Morocco with Logan in the spring of 1910, when they penetrated as far as Marrakesh, wearing Arab dress. Obviously they both had an adventurous spirit as southern Morocco was scarcely the safest place to visit in 1910. In fact, Lyautey, the first and greatest French proconsul of Morocco, only got to Marrakesh in 1912.

Late in February 1912, Morrice again crossed the Strait of Gibraltar to Tangiers and took a room with balcony at the Hôtel de France. Henri Matisse was already wintering there and painting some of his lovely Moroccan window views and figure pieces. Morrice and Matisse were congenial companions and spent much time together outside of working hours. Morrice had known and admired Matisse's work since 1905, when the Salon d'Automne first exhibited the fauves.

By January 1913, the artist was beginning his second winter trip to Morocco. This was Morrice's final and prolonged painting trip there and it lasted nearly two months. His palette reflected more and more the sun of North Africa.

For both productive winter stays of 1912 and 1913 in Morocco, Morrice took along a generous supply of his diminutive 5″x6″ blond wood panels. These were easy to pack and took up little travelling space. The edges were chamfered, which allowed them to slide more easily into a small wooden case which he carried in his jacket pocket. It included a made-out palette and several fine sable brushes.

These two winter sojourns in Tangiers and Marrakesh produced paintings of harmony and beauty. He developed a new colour vision during his Moroccan visits and succeeded in transferring it wondrously to his little wood panels and canvases.

Morrice didn't lack for painting companions. Besides Matisse, his colleagues Marquet and Camoin were also painting in Tangiers. Camoin wrote a tattling letter to Matisse in the spring of 1913, complaining of Morrice's noisy behaviour in his hotel apartment after some morning drinks. At this stage of his life Matisse was already something of a legendary character and Camoin was always ready to pay him homage.

I hope you've now arrived in Marseilles after a good trip. We have often thought of you here! Since your departure the weather suddenly turned to rain and Morrice unexpectedly took to the whisky. It simply begins with a few glasses of rhum at breakfast. Therefore you can imagine what a racket I can hear by mid-day, not to mention in the evening! He must leave on Friday, and in spite of my isolation I believe I won't miss him. He is a nice guy though but the whisky

PLATE 33
A Procession, Marrakesh
c. 1910, Panel 5″ × 6″

Morrice is seated in the corner of an outdoor café in Marrakesh, perhaps in Arab dress. At the table to the left is a Moroccan wearing a red fez. There is a religious procession in progress preceded by a figure in white robes riding a donkey and carrying a blue and white banner. In the mid-distance is a Moorish archway with a white façade and a low roof painted in Egyptian red.

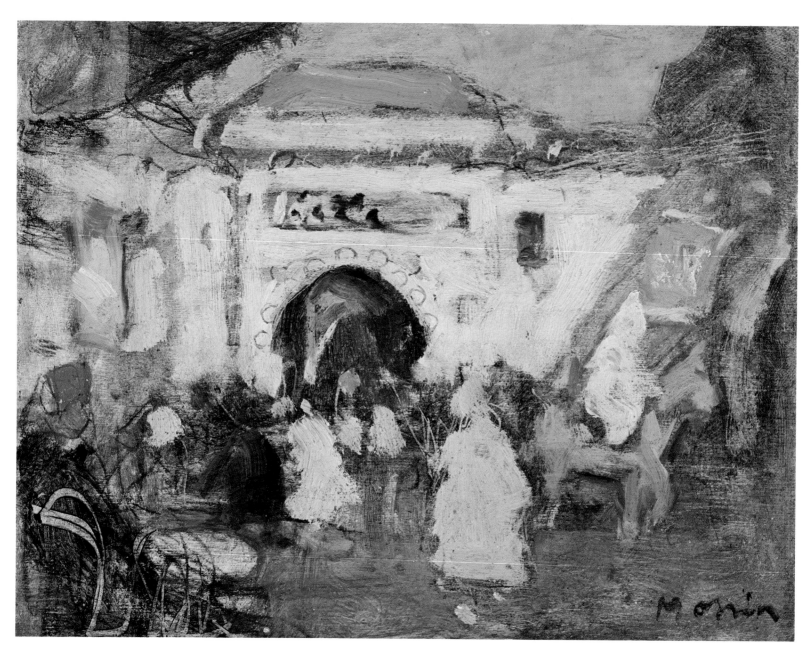

PLATE 33

makes him very tiring especially when you're alone with him. . . . Morrice, between two whiskies in a moment of lucidity, spoke to me a bit of painting, explaining me the opposite of what you believe, he appreciates very much what you do. He asked me to see my paintings and I was a bit surprised by his preference. . . .

Perhaps Camoin was jealous of Morrice's painting capabilities and his friendship with Matisse, and used this letter to disparage him.

But Morrice, always the gentleman, must have still felt kindly towards Camoin, because on March 4, 1913, he sent him a postcard from Gibraltar addressed to the Hôtel de France in Tangiers. It read: "Weather superb here. Am leaving for Spain tomorrow!" A postscript added, "Be kind to yourself" – another of Morrice's little witticisms.

The following extract, from a letter written by Henri Matisse in 1925 to the French art critic Armand Dayot, shows the high esteem in which Matisse held James Morrice:

About fifteen years ago I passed two winters in Tangiers in company with Morrice. You know the artist with the delicate eye and so pleasing with a touching tenderness in the rendering of landscapes of closely allied values. He was, as a man, a true gentleman, a good companion, with much wit and humour. He had as everyone knows, an unfortunate passion for whisky. Despite that we were, outside of our hours of work, always together. I used to go with him to a café where I drank as many glasses of mineral water as he took glasses of alcohol I do not know what else to tell you. He was a Canadian of Scottish origin, of a rich family, himself very rich, but never showed it. He was always over the hill and dale, a little like a migrating bird but without any very fixed landing place.

In one of his final letters during a long correspondence with his artist friend Edmund Morris, dated April 1, 1913, Morrice writes:

I spent two delightful months in Tangiers with lovely weather all the time. I came back to Spain and stayed a week in Gibraltar and am now working on a picture of the "Rock" which promises well. In Spain what inspired me most were the pictures of Greco at Toledo. Van Horne has one of the best I have ever seen. You have probably seen some of my things in Toronto sent on by Marchant at the Goupil Gallery. Nothing at the Salon of mine this year. I sent to the International in London – also the Société Nouvelle in Paris. This is enough and I am not going to exhibit again this year. It is a bad habit to get into.

PLATE 34
Henri Matisse
c. 1912, Panel 4¾″ × 6″

A study of Matisse seated in a café or an outdoor table at the Hôtel de France in Tangiers in the late winter of 1912. In the purposely out of focus sketch, Morrice has painted his friend in a straw hat and white collar with a black ribbon tied in an artist's bow, his left hand is placed casually in a trouser pocket. Beyond are the vertical green bars of a picket fence. Even without the details of his features, the personality of Matisse, expressed by his attitudes and posture, clearly shines through.

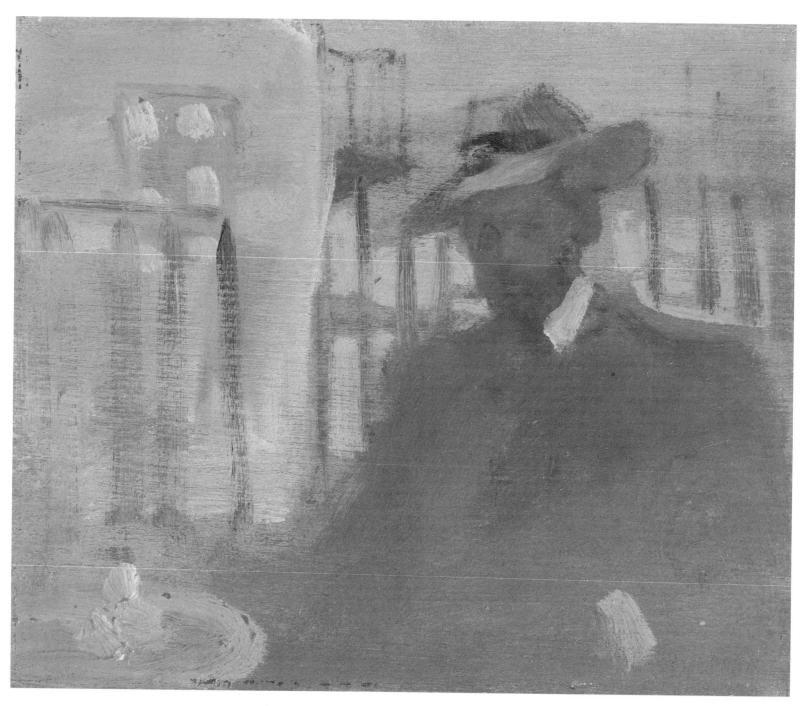

PLATE 34

He may not have liked the Cubists, but he was far ahead of his time in his appreciation of El Greco and the Spaniards. He did change his mind about exhibiting that year, and showed at the Salon d'Automne. Included in the exhibition were several of his Moroccan pictures.

In the same month he wrote in what seemed to be a dispirited mood:

What prevents me from going back to the Ontario bar is the love I have of paint – the privilege of gloating over things.

It is interesting to note that as late as 1913, Morrice seemed to be struggling against some pressure within himself about his chosen profession.

PLATE 35
Environs of Tangiers
c. 1912, Canvas 25″ × 32″

A classic composition by Morrice. Probably painted in Paris on his return from Morocco in the spring of 1912, it was shown that same year in Paris at the Salon d'Automne. The picture again features the artist's innate sense of pictorial balance. The group of three little Moorish figures sitting in the grassy foreground is echoed by the whites and reds of the nearby town, while the large green field arrests the eye before it reaches another settlement of white buildings.

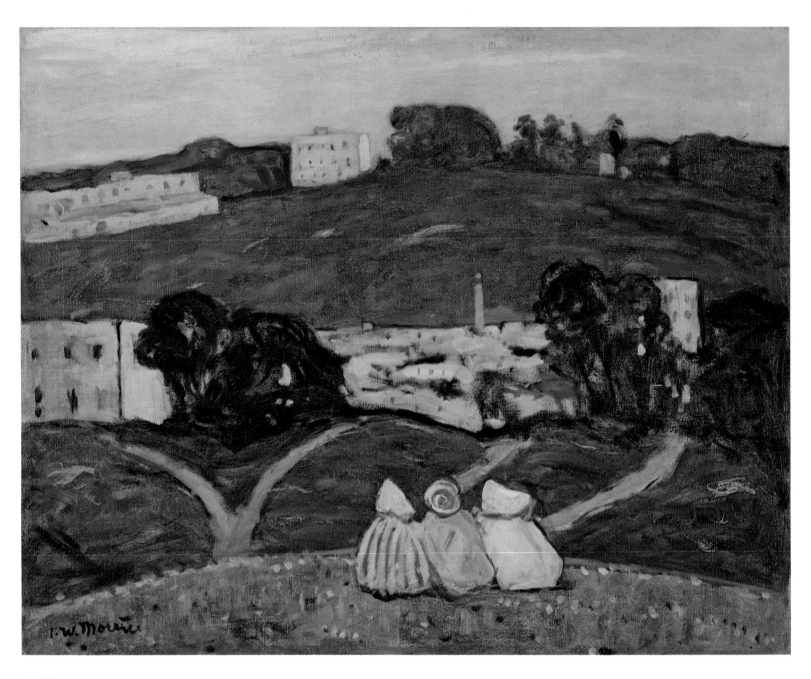

PLATE 35

5

MORRICE AND
HIS CIRCLE OF
PAINTER FRIENDS

PLATE 36

Figures in a Café, Dieppe
c. 1905, Panel 6″ × 4″

Four figures are sitting in an outdoor café, perhaps in Dieppe where the artist often went for a breath of sea air to escape from Paris. As well, Morrice always enjoyed seeing his Norwegian friend, the artist Fritz Thaulow, who had a studio there. This panel was once owned by Thaulow, and the Laing Galleries acquired it on the London market in 1975.

MORRICE SEEMED to have earned enormous regard and respect from his contemporaries, as much for his personal charm as for his painting skills and wry philosophical wisdom. He was well read in the classics of literature as well as being a connoisseur of music. He was a man who knew that the senses as much as the mind reveal important secrets in art as in life. It is perhaps not surprising that, unlike many artists, he had a wide circle of friends and acquaintances. Artists in particular sought his company, and spoke little ill of him.

One such artist was Gerald F. Kelly. When Kelly went to Paris in 1901 to study art, he arrived with letters of introduction to the painters Claude Monet, Pierre Auguste Renoir, and apparently to the Canadian James W. Morrice. (Kelly wrote friends in England that he had visited Monet and, unlike Morrice, was unimpressed with his garden. "Nice and large, it was covered with common rambling roses, which you know you get practically speaking in any suburban garden all over England. And there was a little piece of water where there were some common or garden water lilies.")

Kelly mentions that about this time he showed some of his field sketches to Morrice, which were in "a bit of a mess," and he describes how Morrice, with a few deft touches of his brush here and there, made Kelly's outdoor sketches come to life. Many years later, Kelly presented several of these early sketching efforts to Canada's National Gallery, and even a casual examination shows how Morrice's little colour accents improved them significantly. Kelly later became a successful society portrait painter in England, ultimately becoming President of the Royal Academy, which earned him an automatic knighthood.

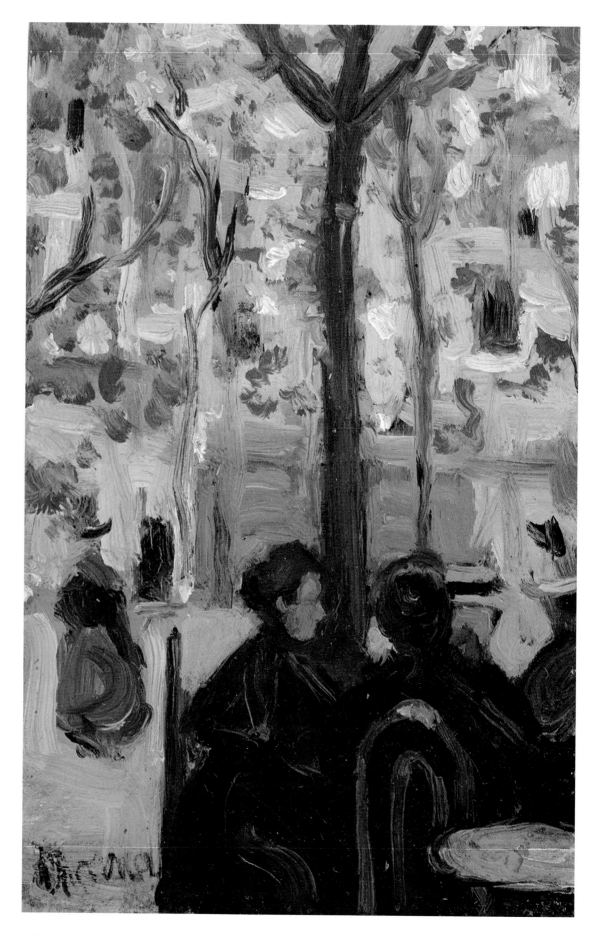

PLATE 36

Morrice knew other English artists like Walter Sickert (1860-1942), who had a studio at Dieppe. He was also acquainted with the English artist, W. Lee Hankey (1869-1958), who spent most of his life painting street and harbour scenes with fishing boats along the Normandy and Brittany coasts.

Another friend was Fritz Thaulow (1847-1906), the splendid Norwegian Post Impressionist painter. Thaulow was a founder member of the Champs de Mars Salon, where Morrice also exhibited. Thaulow was greatly influenced by Claude Monet, and specialized in canal and river scenes. He acquired from Morrice, on an artist's barter, one of his lovely turn-of-the-century Paris café panels, which only a year or so ago we discovered in London. Thaulow also had a studio in Dieppe, and had a thriving market for his pictures in Europe and the United States. Morrice records that he often went to Dieppe to get away from the city noises and breathe some fresh sea air.

The name and Paris address of another friend, Alexander (Sandy) Jamieson, the Scottish artist, appears from time to time in Morrice's sketch books. Two of his closest colleagues however, were Roderick O'Conor the expatriate Irish-born artist, and especially dear to him was Charles Conder, the Australian, who painted exquisite silk fans and was known as a great ladies' man. Conder died early at the age of forty, which Morrice notes with distress in a letter to Edmund Morris.

Roderick O'Conor had met Gauguin at Pont-Aven in 1894, and knew him well. He also bought and exchanged pictures and drawings with him. Gauguin urged O'Conor to accompany him on his second trip to Tahiti, but O'Conor declined because he lived a perfectly happy life in Paris. O'Conor probably introduced Morrice to Gauguin about this time, and later Morrice would have seen Ambrose Vollard's great exhibition of Gauguin's work in 1903, the year of Gauguin's death in the French Polynesian Islands. It would be at Vollard's that Morrice first saw what was probably the most daring nude painting produced in France since Manet's masterpiece *Olympia*. The painting was Gauguin's *Annah the Javanese*.

Although his name does not appear in his sketch books, Morrice certainly knew the work of Leon Bakst – the great Russian designer of exotic costumes for the Ballets Russes. Morrice might even have met Bakst, as they were fellow exhibitors in the Salon d'Automne.

Another individual of Russian ballet fame, who had moved to Paris in 1906, was the impresario Sergei Diaghilev, whose Ballets Russes was first seen in Paris in 1909, and who introduced modern ballet to the Western World. In 1899, and early in the next century, Diaghilev also arranged art

PLATE 37
St. Mark's and the Doges' Palace
c. 1899, Panel 10½″ × 12¾″

The architectural forms of St. Mark's and its great portals provide an impressive background for the many figures in the piazza. The Gothic doors and pink façade of the Doges' Palace blend with the gold of the basilica warmed by the light of the late autumn afternoon.

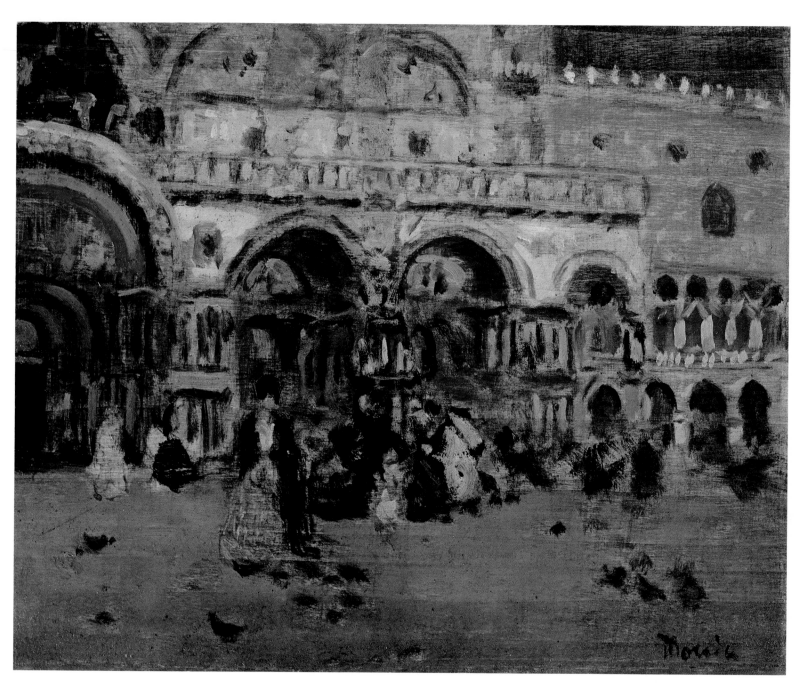

PLATE 37

exhibitions in Russia and Western Europe. He organized international shows which included contemporary Russian work and pictures by Whistler, Renoir, and Conder, all artists whom Morrice knew well. Diaghilev also arranged an exhibition of Russian art, including the work of Bakst, at the Salon d'Automne in 1906, which certainly would not have escaped Morrice's eager eye.

It is quite likely that Morrice knew the brilliant young caricaturist Aubrey Beardsley (1872-1898), who made highly erotic drawings in the Art Nouveau style. In 1894, Beardsley was appointed editor of a new English quarterly, *The Yellow Book*. People wonder sometimes if *The Yellow Book* had anything to do with yellow journalism. It did not. It was a quarterly literary publication. Arnold Bennett wrote short stories for it and Walter Sickert, Charles Conder, and Joseph Pennell, close friends of Morrice, all contributed illustrations. As late as 1915, Morrice was most anxious to get a copy of *The Yellow Book* himself. Apparently MacTavish had recently found someone in Toronto who owned an extra copy. Morrice wrote to MacTavish:

> *I shall be most pleased to make the exchange of one of my panels with your friend for The Yellow Book, there are a number of my panels at Scott's in Montreal. Your friend might be in Montreal and make a choice, or you could do it. Or if you like I will tell Scott to send one.*

But his artist friends and other closer acquaintances were scarcely all European. Joseph Pennell (1857-1926), the American illustrator and printmaker, lived in London from 1885 until 1917. He first met Morrice when he was on a committee to collect works in Paris and other continental towns for the International Society's exhibitions. James McNeill Whistler was the society's president.

Some years ago, amongst other material pertaining to Morrice, I acquired a letter written in 1935 by Mrs. Joseph Pennell. Elizabeth Pennell gives an extremely personal picture of Morrice:

> *You seldom saw Morrice during the day, rather it would be in the early evening at a café. . . . His friendship no less than his art was a source of great pleasure to my husband and myself. . . . My husband had seen Morrice's work and admired it immensely and he was one of the first artists in Paris he visited; this was the beginning of a very sincere friendship. But of those Paris days there is not very much to tell except much talk at dinner and over coffee in the usual artist's café. Then I remember a summer in Venice, when he was there and we were too. But both men were hard at work and my memories are chiefly, if not altogether, of the endless artist's talk over dinner and coffee. Then there was a visit he paid us in London after the outbreak of the war in 1914.*

PLATE 38
A Marabout, Morocco
c.1912, Panel 6½″ × 5¼″

This painting depicts the tomb of an Islamic holy man or saint, and is not, as previously named, The Monastery, Cuba. *A small figure in Moorish dress and a red fez stands in front of the wall which shelters a small monument set in a lush garden of tropical trees.*

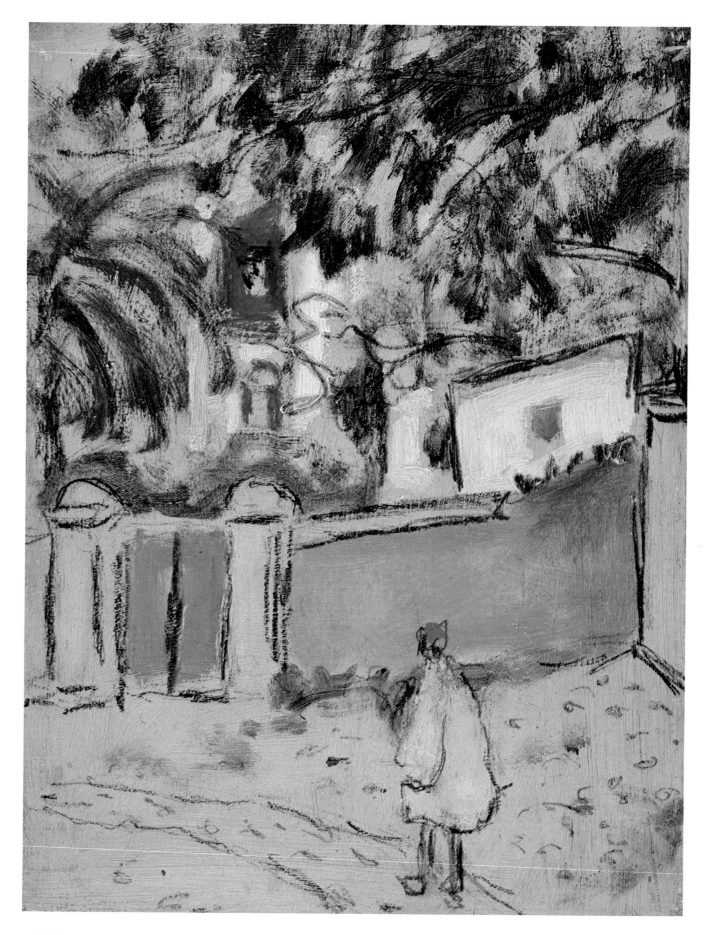

PLATE 38

James Morrice, we thought if he had had a wife would not have stirred from Paris. . . .

It is obvious Elizabeth Pennell knew nothing of the existence of Morrice's mistress, Léa Cadoret. She was certainly too warm-hearted a person to have ignored Léa, had she known her.

. . . but to be shut up in his studio alone after eight o'clock in the evening was too much for his nerves. He was almost as depressed as my husband over the whole tragedy and we did what we could to help him with our sympathy and company for we were both extremely fond of him.

Another artist with whom Morrice kept in close touch was Robert Henri (1867-1929), who returned to the United States from Paris in 1900 after several years of study and teaching. Henri later became the leader of a group of American painters named "The Eight." In June 1896, Morrice wrote him:

I left Paris precipately [sic] *a couple of days ago for St. Malo, where I am staying a couple of months. It is a delightful old town and the beach is lively in the summer. At present the bathers have not arrived and it is not so interesting as it will be in a couple of weeks . . . the living is cheap, I saw an apartment of two rooms, sitting room and bedroom with two beds for 40 francs a month. As for grub, I eat in places like the "Rougrin" for 1.5 or 2 francs. Write and let me know when you can come.*

Living was incredibly cheap in France during those days. From 1890 until 1914, the franc converted at five to the dollar, or twenty cents each. One can sense from this wistful letter how lonely the artist was and how he yearned for an agreeable painting companion. He delights in verbal expressions of humour from time to time – in this case the use of the non-word "precipately" and the word "grub" attesting to his North American background.

Much to Morrice's pleasure, Robert Henri did make the trip to St. Malo in June 1896, and much to my pleasure in the mid-1960s in New York, I stumbled upon a lovely Morrice, a Brittany street scene from the Robert Henri estate. Henri's name and the year 1896 are inscribed on the back, the painting obviously having been a gift from his friend. The colours are mellow and harmonious, and here Morrice seems to have finally found himself in a sympathetic rendition of a Brittany street scene with white-capped Breton women and a horse-drawn fiacre.

In 1908, Robert Henri organized the memorable exhibition of the work of "The Eight" in New York. Among others who participated were George Luks, John Sloan, the Newfoundland-born Maurice Prendergast (1859-1925),

PLATE 39

Pont Louis Philippe

c. 1902, Canvas 15″ × 21¾″

A grey early-winter afternoon in Paris. A few leaves still cling to a tree growing from the lower embankment of the Seine and a horse-drawn cart is about to cross the bridge. The great spire of the cathedral reaches up to the sky and its twin towers form an arresting silhouette. The whole picture is painted in low-key greys and ochres.

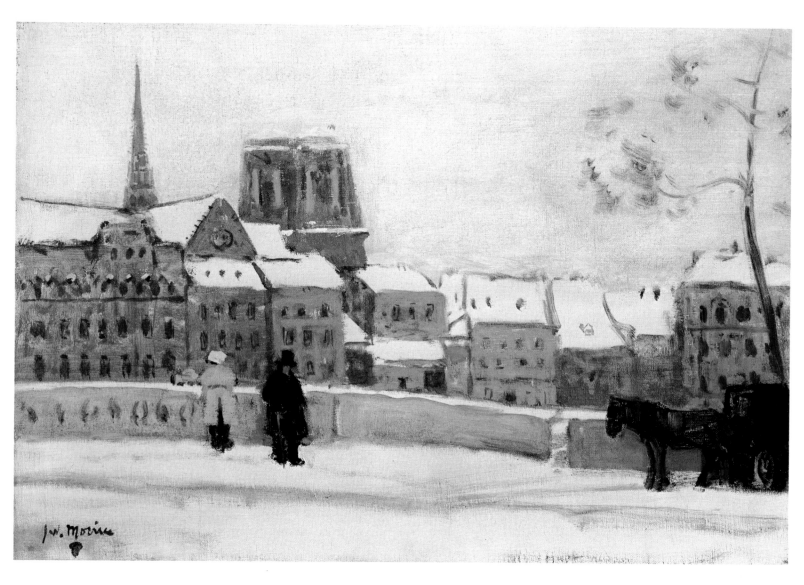

PLATE 39

Ernest Lawson (1873-1939), the Canadian from Nova Scotia, as well as Glackens. Morrice knew them all well and some, notably Prendergast, with whom he went on sketching trips, were influenced by Morrice's personal vision of painting.

Maurice Prendergast was one of America's renowned Modernists, who arrived on the scene in 1891, a year later than Morrice. Morrice and he studied at the Academy Julian, and later they sketched together in Venice and Paris – the cafés, along the river and in the Bois. In the summer, they painted on the Brittany coast. They formed a lasting friendship. Both men, during the mid-1890s, shared an interest in the work of Whistler and the problems of capturing atmosphere and weather effects on small surfaces. It was through Morrice that Prendergast became more aware of colour and form, and Morrice at one time possessed at least six Prendergast water-colours, exchanged no doubt for some of his own oil panels. Prendergast was indebted to Morrice for introducing him to the three painters, Charles Conder from Australia, Walter Sickert from England, and the Irishman Roderick O'Conor.

Other American artists, especially the younger ones, eagerly sought his company. Like Morrice himself, they were (at least for a time) expatriates. They had much to learn from him. In addition to developing a painting craft, many of them acquired other valuable lessons in style while part of the French milieu during their Paris student days. They returned to the United States from turn-of-the-century France secure in a knowledge of the Impressionist and Post Impressionist painting styles, along with a great love of the French heritage. This tradition of fine painting was soon applied with highly dramatic results to the American painting scene of the day. In all of this Morrice played his part.

George B. Luks (1866-1933), was an exuberant painter and artist-reporter for the *Philadelphia Evening Bulletin*. John Sloan (1871-1951) also came from Philadelphia, where he spent his early years working on a newspaper.

The Philadelphian William Glackens (1870-1938), also an artist-reporter, became a close friend of Morrice. Glackens went to Paris in 1895, and on his return to America settled in New York, where Morrice stayed with him from time to time. Years later, in 1912, he became art adviser to the brilliant and autocratic picture collector Dr. Albert C. Barnes of Merion, Pennsylvania. Barnes had amassed a fortune from his discovery of the antiseptic argyrol, and soon began to indulge freely in his great passion for art by collecting fine French and American paintings. It would be about then that Glackens recommended the Barnes Foundation purchase two paintings by his old

PLATE 40
Near Charenton
c. 1903, Panel 5¼″ × 6¼″

A view of one of the multi-arched bridges crossing the Seine on the outskirts of Paris. It was yet another panel that Jacques Dubourg acquired from the Charles Pacquement collection in the early 1930s. Exhibited in the National Gallery's Memorial Exhibition in 1937, it remained in Dubourg's possession for the next forty years.

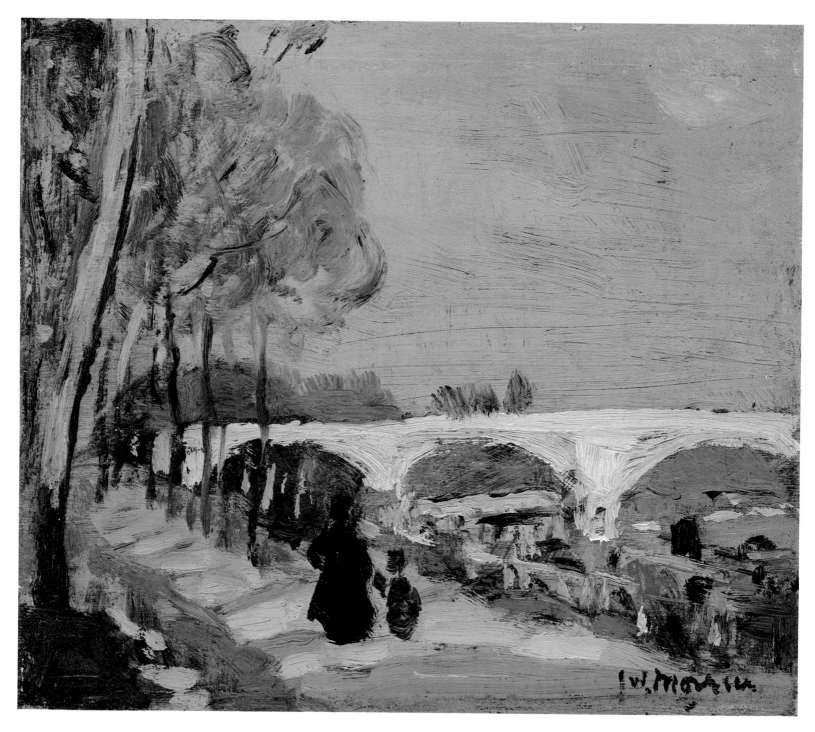

PLATE 40

friend James Morrice. One was a Quebec winter landscape of the late 1890s, and the second was a scene in France.

Everett Shinn (1876-1953) was yet another American artist-illustrator whom Morrice knew in France and who, back in New York, specialized in the world of theatre and circus. In a letter to Robert Henri around 1900, Morrice wrote:

> *Shinn made a quantity of pictures of Paris – in fact he did the place up. His career reminds me of the historic words of Caesar, Veni, Vidi, Vici.*

It would be interesting to know what Morrice thought of Shinn's later work, executed in New York, featuring the world of theatre and the circus.

Though Morrice's letters are often sparing of words, he had a forceful and colourful way of expressing himself. For years he kept in touch with Robert Henri, although apparently the surviving correspondence consists of only three letters. The final one is quoted above. Morrice looked forward to the opportunity of visiting his American artist friends in New York on his way back to France during stopovers, or coming home to Montreal via New York, after transatlantic voyages. These artists were aesthetically and intellectually a most compatible group.

Morrice never abandoned his Canadian artist acquaintances. He had a long and close association with Clarence Gagnon who lived in France for some years. He went on several sketching trips with Maurice Cullen in Quebec and Europe. He painted on the Ile d'Orléans, home of the eminent artist Horatio Walker. He knew Robert Harris, who had painted portraits of all his family, and he had great affection and respect for William Brymner who taught at the Art Association of Montreal from 1886 to 1921, and who received probably the last postcard Morrice ever wrote, in January 1924, from Sicily.

Although at times Morrice preferred a solitary and nomadic existence, he was on the other hand warm and generous in his associations with his artist friends.

PLATE 41
The Sugar Camp
c. 1897, Canvas 20″ × 16″

A Quebec maple sugar bush subject in early spring. The clearing is still full of snow but there is a slight tinge of colour in the maple trees showing a promise of budding and a flow of sap. Cordwood is piled high ready to fire the cauldrons and boil the sap. Painted in one of the late years of the nineteenth century, it is a forerunner of Morrice's other Quebec subjects.

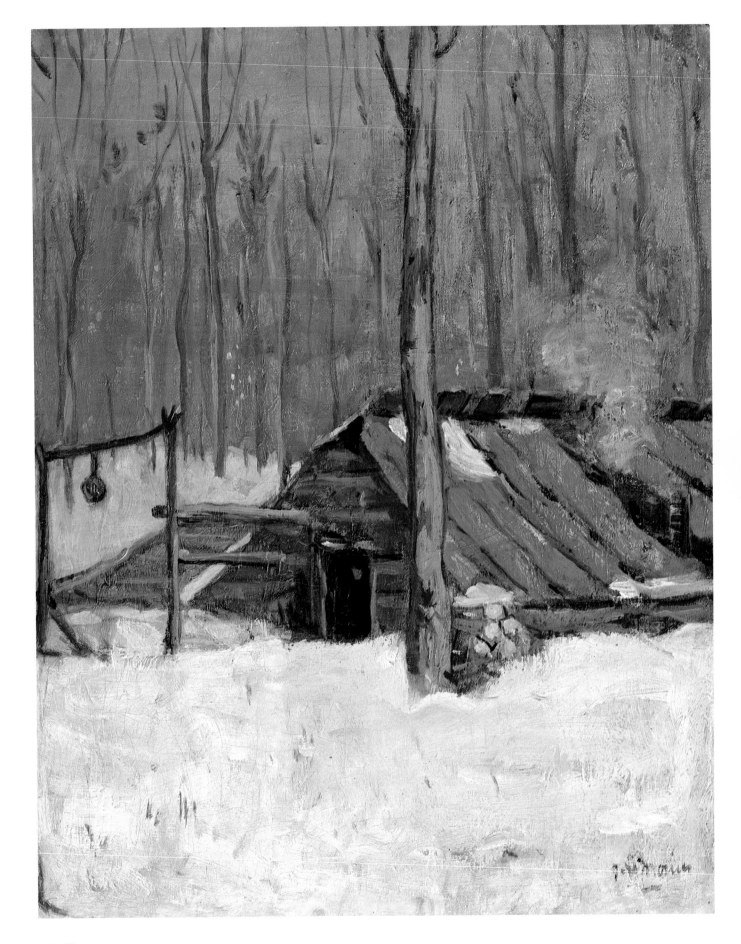

PLATE 41

6

WRITERS
HE KNEW IN
MONTPARNASSE

B Y THE TURN OF THE CENTURY Morrice had already spent ten years of his life in Paris. And, at the age of thirty-five, he was definitely making his presence felt on the contemporary art scene. Nineteen hundred was also the year of the great Paris Exposition that attracted some fifty million visitors. War was still almost fifteen years away and there were as yet no forbidding clouds on the horizon. And on the hilly streets of Montmartre and along the quais of the Seine, between 1900 and 1914, lived an inventive and immensely talented group of artists, musicians, poets, and writers, who introduced to the world a new way of looking at the arts.

During my fanciful and fruitful search into the life and times of James W. Morrice, which included a constant pursuit of his paintings, I came to perceive him as a man of diverse talents: a much more complex character than I had anticipated or than he had at first appeared to me to be. He was at once sociable, likeable, with many friends, yet he could also be retiring, even reclusive, and sometimes timid and petulant. He was well-read in the classics, liked poetry, and attended readings by Mallarmé and possibly Paul Verlaine. Despite his religious upbringing he was nonetheless most at home in the bizarre turn-of-the-century artists' world of Paris.

It should be recorded that, even after many years in Paris, the strong influence of his family background remained with him, and he maintained the closest of ties with his parents until they died in 1914. But he never showed even the slightest influence of his Montreal upbringing to his Paris friends and acquaintances. He had built up a façade and this was his secret. It was not known that he came from a strict Presbyterian family, that no

PLATE 42
Café, Venice
c. 1904, Panel 5″ × 6″

In Venice, as in Paris, Morrice liked to search out a quiet café where he could sit in the shade with an aperitif and paint one of his little panels. In this view from an awninged café on the Riva degli Schiavoni, Morrice shows his remarkable virtuosity. The rhythm of the empty elliptical café chairs is repeated and contrasted with the open space and sky outside, as a rest to the eye. A vertical streetlamp standard and a gondola help meld the scene into a satisfying composition. The colours are a blending of warm and cool and the mood of the picture is tranquil and restrained.

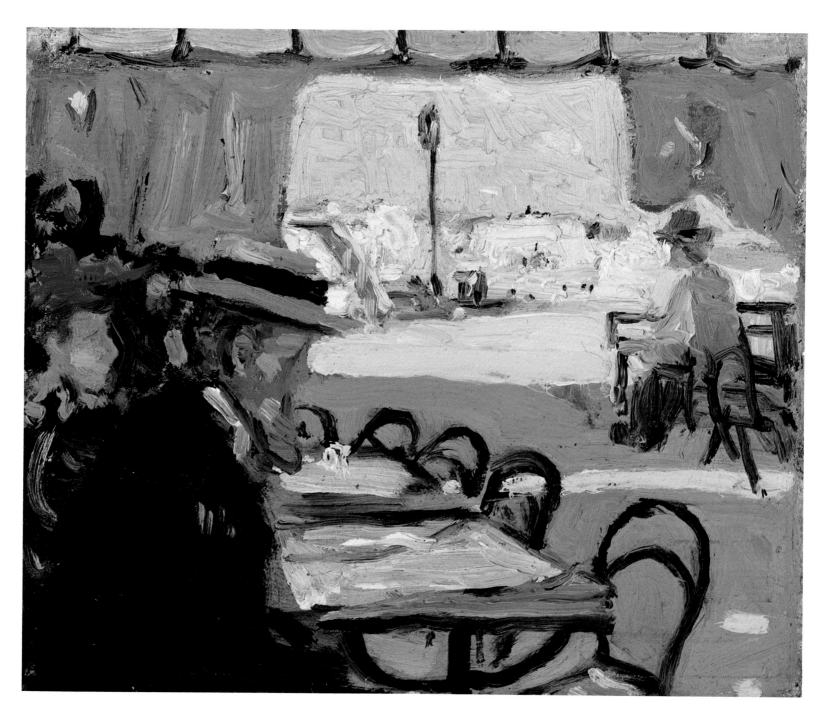

PLATE 42

liquor was allowed in the house, and Sunday was set aside as a day for church worship and complete abstinence from all other activities.

From later Paris letters, we know he developed a very un-Presbyterian taste for absinthe, and was devastated when, by 1909, his doctors forbade his use of any more of the potent stuff. Whether he gave it up completely is also unknown, but he certainly continued to drink rum and whisky. But even when drinking, he usually remained a gentle, timid, almost reclusive figure of a man.

We know that Morrice won the interest and approval of many of the finest painters of his day, and he did so both as an artist and a man. But he also attracted and piqued the attention and admiration of a number of writers. Among the most important of these literary figures were Somerset Maugham (1874-1965), who was born in France, Arnold Bennett (1867-1931) who went to Paris in 1903 and Clive Bell (1881-1964), who arrived there in 1904.

The letters of these men, who came to know James Morrice well, provide some interesting insights into the character of the man. I plunged into these accounts of Morrice and his life in Paris with fascination, wondering if they would corroborate or confute my own feelings about him. Indeed, they have enriched and enhanced my appreciation and understanding of the man.

Not the least of these accounts is by Somerset Maugham. In 1907, at the age of thirty-four, he apparently felt he had reached a writing impasse in London, and left for Paris to take a flat on the Left Bank in Montparnasse. Here he encountered many of Morrice's friends and fellow artists. And it was also in Paris that he acquired the material for his novel *The Magician*, which records with shrewd if cynical eye the world Morrice frequented.

In this novel, Maugham portrays Morrice at that time. Morrice would then have been forty-two years old and in his prime as a painter.

"Tell me who everyone is," said Arthur. "Well, look at the little bald man in the corner. That is Warren." He was a small person with a pate as shining as a billiard ball, and a pointed beard. He had protruding brilliant eyes. "Hasn't he had too much to drink?," Arthur asked frigidly. "Much," answered Susie promptly, "but he is always in that condition, and the further he goes from sobriety the more charming he is. He's the only man in this room of whom you'll never hear a word of evil. The strange thing is that he's very nearly a great painter. He has the most fascinating sense of colour in the world, and the more intoxicated he is the more delicate and beautiful is his painting. Sometimes, after more than the usual number of aperitifs, he will sit down in a café to do a sketch with his hand so shaky that he can hardly hold a brush; but has to

PLATE 43

The Circus, Montmartre
c. 1903, Canvas 19″ × 23½″

Morrice enjoyed the colour and excitement of the circus whether it was in Montmartre, Concarneau, or Cuba. In this version, there are three tiers of spectators with a circus girl riding a horse, and a clown in the foreground. Here the artist presents a tableau. All action is stopped, caught in a moment of time.

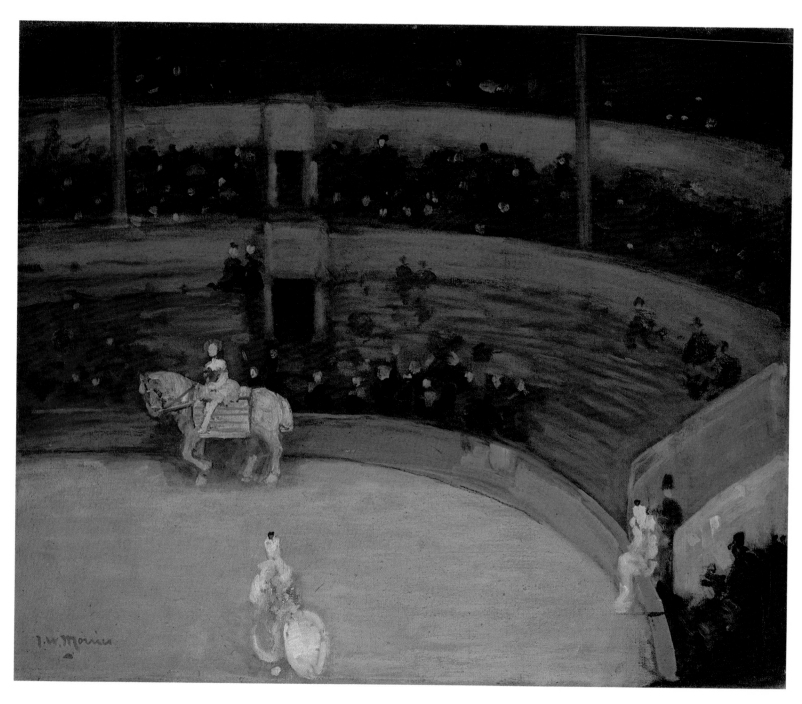

PLATE 43

wait for a favourable moment. And then he makes a jab at the panel. And the immoral thing is that each of these jabs is lovely. He is the most delightful interpreter of Paris I know, and when you have seen his sketches, and he's done hundreds, of unimaginable grace and feeling and distinction – you can never see Paris in the same way again."

As Maugham seems to be saying, everybody loved Morrice, whether he was drunk or sober and, as an interpreter of various aspects of the city, none was his equal. Indeed, when I myself first set foot in Paris in June 1950, nearly thirty years after Morrice's time, there were still many settings that were eloquent reminders of his pictures. The kiosks, flower vendors near the Madeleine, strollers in the parks, and especially the ubiquitous book stalls along the left bank of the Seine, remained for me vintage Morrice subjects.

Another artist whom Somerset Maugham met in Paris was Morrice's friend the Irishman, Roderick O'Conor, long a resident of the city. Maugham later bought three of O'Conor's still life studies for his private collection, which strangely included no Morrices. Perhaps, by the time Maugham had the means to buy pictures from royalties received from his books in the 1930s, there were no works by Morrice available for purchase on the London or European market.

If Maugham pins Morrice to the page in a few lucid lines, Arnold Bennett gives us a warmer, more human picture of Morrice's Paris. Bennett went to Paris in March 1903, staying for several weeks at the Hôtel du Quai Voltaire. He remained in Paris for five years and in France for over nine. He studied music and literature and took lessons from the excellent painter Pierre Laprade. He liked Impressionist painting and appreciated Diaghilev, who introduced the Ballets Russes and Stravinsky's music into Western culture.

During the years 1903-04, Arnold Bennett often met and dined with Morrice and his friends. It is in Bennett's autobiography, *Evening with Exiles*, published in 1910, that we find Bennett's portrait of Morrice. Although, like Maugham, Bennett disguised his characters, the etcher-cellist in *Exiles*, for example, was certainly Morrice, who in real life was an artist-flutist. Passages from Bennett's autobiography eloquently recall Morrice, his Paris home, his way of life, and some of his friends there.

Bennett talks about the sheer discomfort of Morrice's rooms. He was right, Morrice lived for art and cared little about his own personal surroundings. His bedroom was bare as a monk's cell with its iron bed and small night table. In his studio there were two easels, one on which to work on unfinished pictures and the other where finished or near-finished canvases were

PLATE 44
On the Shore, Brittany
c. 1902, Panel 8½" × 11½"

A young Breton woman in a white cap and bright red wooden shoes is sitting on the beach knitting. The abstract patterns of sea and rock provide an ideal background to focus on this subtle little figure study.

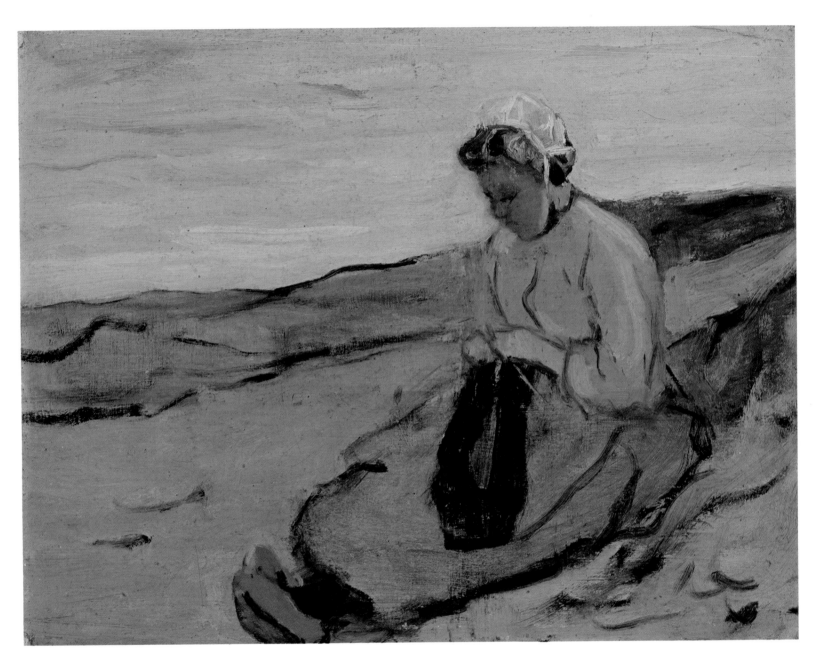

PLATE 44

fixed in their frames. Before completion, he often put thumbtacks at each corner of the canvas to hold it in place on the easel. As well, there were others of his works hanging on the studio walls. One was a study of *Léa in a Tall Hat*, and another, *Femme au Lit*, which shows the name Jane and his own initials, J.W.M. through the underpainting in the lower foreground. Despite the discrepancy in the name, I have always regarded this painting as a semi-nude study of his young mistress, Léa Cadoret. For years, Morrice also hung some colourful watercolours acquired by exchange from the American painter, Maurice Prendergast.

Bennett gives a description of spending an evening with his artist friend. The poignancy of the scene hints at an underlying sadness about the man.

> *With his greying hair and his fashionable grey suit, and his oldest friend, the brown 'cello, gleaming between his knees, he was the centre of a small region of light in the gloomy studio, and the sound of the 'cello filled the studio. He had no home, but if he had had a home this would have been his home, and this his home-life. As a private individual, as distinguished from a public artist, this was what he had arrived at. He had secured this refuge, and invented this relaxation, in the middle of Paris. By their aid he could defy Paris. There was something wistful about the scene, but it was also impressive, at any rate to me, who am otherwise constituted. He was an exile in the city of exiles; a characteristic item in it, though of a variety exceedingly rare. But he would have been equally an exile in any other city. He had no consciousness of being an exile, of being homeless. He was above patriotisms and homes. Why, when he wanted even a book he only borrowed.*

Actually, when Arnold Bennett knew Morrice, the painter's hair may have started to turn grey, but his dominant features were an almost totally bald head and a pair of piercing eyes. Bennett also mentions his fashionable grey suit, no doubt of Scottish tweed, made to measure by a good English tailor.

Bennett has caught something of the poignancy of Morrice's existence in Paris. He was an exile, but a willing one, and Paris was his home. He loved Paris, his friends, and his cheerful mistress, but still Bennett describes the scene as wistful, and a part of the melancholy side of Morrice's nature is revealed.

It is also clear from what Bennett says that Morrice remained aloof from politics, nor did he have any time for artists' "bawdy talk." "Excuse me," he would say, "I have to meet my sister who is arriving from Montreal to-night," and he would discreetly leave the table.

PLATE 45
On the Cliff, Normandy
c. 1902, Canvas 19″ × 23½″

Several small children with their nursemaid are standing or sitting on the grassy height of land overlooking a bay on the Normandy coast. Below the cliff to the right is a stretch of sandy beach with bathers enjoying the seaside, their beach-tents nearby. Morrice showed this picture at the Canadian Art Club's 1908 exhibition. It was priced at $500, and eventually sold for $400 to the Club's honorary President, the banker, D.R. Wilkie. On the Cliff was probably the first important Morrice canvas sold in Toronto and it remained in possession of the descendants of the Wilkie family for the next seventy years.

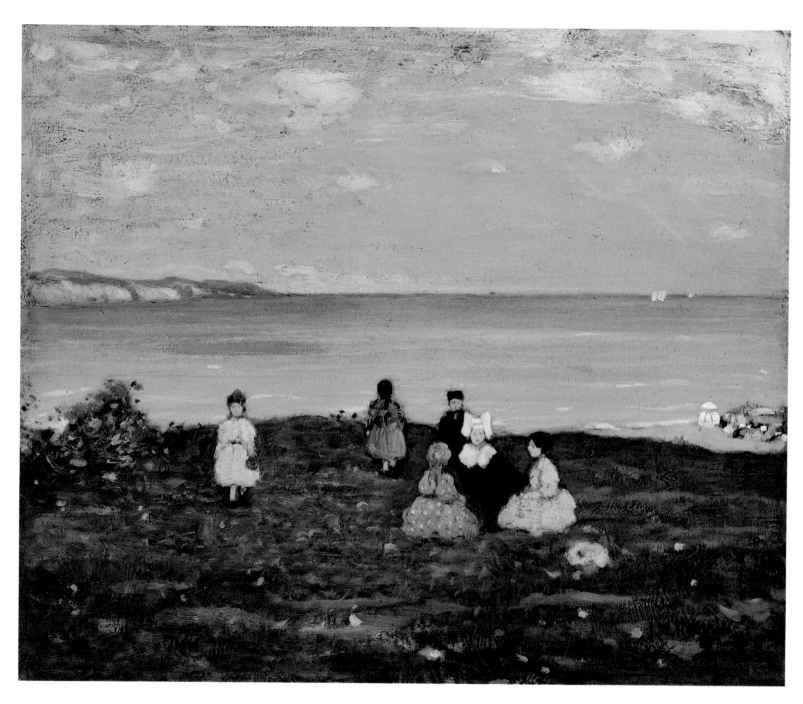

PLATE 45

Another visiting Englishman, who admired and respected Morrice, was the art critic and writer Clive Bell, who discusses James Morrice in an autobiographical book called *Old Friends*, published in 1956.

Bell recalls going to Paris in 1904, as a young Cambridge graduate, and meeting with Morrice and Roderick O'Conor. He makes the important observation that:

> *Although in daily company with them for a little while only, they played an influential part in my life. . . . Unluckily for some four months after I met him, Gerald Kelly disappeared from our quarter and hid himself in the wilds of Montmartre. It was left to Morrice and O'Conor to continue my education. Kelly came to Paris in 1901 to study art and was a man of wit, culture and ideas. Every now and then O'Conor, Morrice and I would meet by appointment in Arnold Bennett's flat and take him to a triperie. . . .*
>
> *The Canadian, J.W. Morrice, an excellent painter whose work is fairly well known, is still insufficiently admired, would be described as an Impressionist of the second generation. He was an accomplished flautist when he could keep his health and a passionate lover of music. He had been a friend of Charles Conder and an acquaintance of Toulouse-Lautrec. But essentially he was a solitary artist. Had he been more often sober he would have painted more and larger pictures but I doubt whether he would have painted better. . . . He liked knocking about Paris and sometimes he took me with him. From Morrice I learned to enjoy Paris. Also from Morrice I learnt more about pictures. The Paris to which Morrice introduced me, the Paris of 1904, was still the Paris of the Impressionists. It was a city of horse-omnibuses. . . .*
>
> *The Café de la Paix was a favourite cosmopolitan haven. This Paris was still full of little music halls and café chantants. Morrice delighted in such places. Morrice was one of those fortunate people who enjoy beauty as they enjoy wine; both to him necessities and he was not too difficult about the vintage. Beauty he found everywhere. He enjoyed his round, merry mistress, Léa, but he kept her in her place, that is on the fringe of his life.*

I wonder if Clive Bell is quite right in his description of Léa? In 1904, Léa would have been twenty-seven years of age and from drawings and sketches of her about this time she was attractive both in face and figure. But Bell's description of her as "merry" gives us an important clue as to why Morrice remained with Léa all his life. She balanced his rather dour, retiring Montreal Presbyterian nature with her vivacious and pleasing disposition.

Their considerable difference in ages didn't stop Clive Bell and Morrice from being good friends. Bell was a young Cambridge graduate at the time.

PLATE 46
Carting Sand, Brittany
c. 1904, Canvas 19¾" × 24⅛"

Not far from the coast a green jacketed figure is shovelling sand into a two-wheeled cart drawn by a team of horses. The bay and cliffs in the background remind one of the Normandy coast near Dieppe.

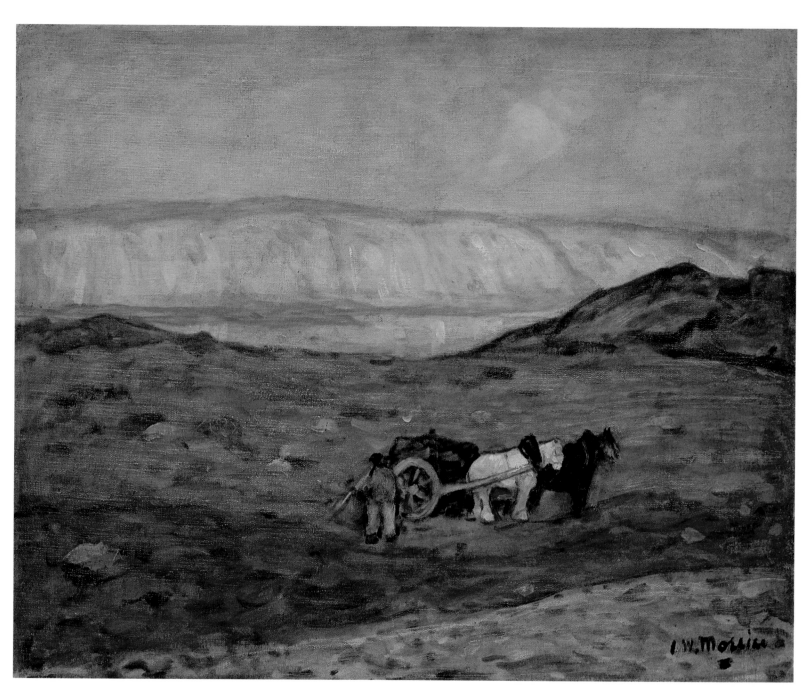

PLATE 46

They discussed art and aesthetics, and together visited the museums and art exhibitions in Paris. There can be little question that, through Clive Bell and his wife Vanessa, Morrice's sensibility would make itself felt later in the famous Bloomsbury Group.

These three writers and men of good taste saw Morrice at work and paused to record what they saw. What is manifestly apparent is that each of these able and perceptive writers held Morrice in the highest regard, both as a painter and as a man.

PLATE 47
Capri
c. 1910, Panel 9″ × 16¾″

Although Morrice visited other cities in Italy besides Venice, there is no specific mention in his notebooks of a trip to Capri. However, the location can be identified because of the square crenelated tower and flat white buildings. There are two black goats grazing in a large open meadow while two herders, one in a red cape, are conversing nearby. This is another example of Morrice's extraordinary range in subject matter and picture design.

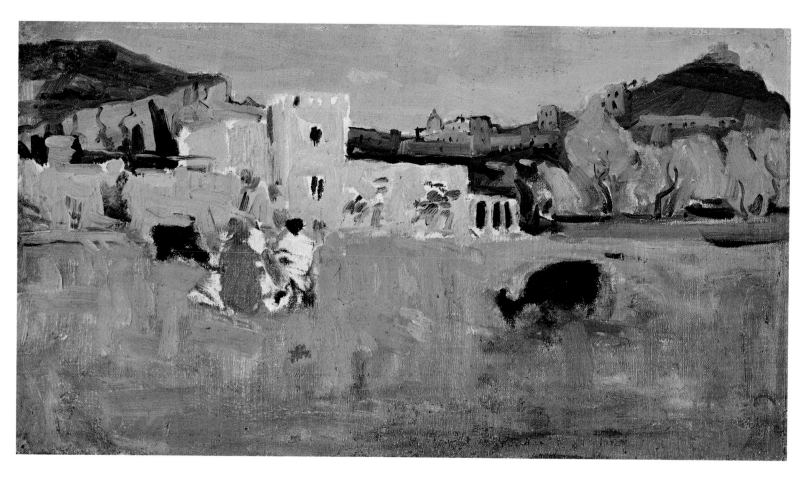

PLATE 47

7

THE ARTIST'S
FINAL YEARS

THE YEARS AFTER 1890 were truly a "Belle Epoque," lasting until August 1914, when the sullen sounds of guns shattered the peace. It was a war, frightful and far-reaching, which would cause the premature end of Paris as the great centre of the arts.

The Kaiser's guns were to affect or change the lives of millions, first in Europe and, a year or so later, in the United States. Canada was already committed to the war. As the Big Berthas lobbed shells into the Paris suburbs and a strict 8:00 p.m. curfew was enforced, Morrice's friends had all but disappeared from the city. The artist became increasingly despondent and restive. And by mid-September, he too left France to visit his brother Arthur who was living with his family in Montreux, Switzerland. It was one of the rare visits we know James made to see his brother, who was also afflicted with poor health. Shortly afterwards, James crossed the Channel to England where he stayed in London for about three weeks.

He was in no mood for painting. He made a few sketches, including a view of Trafalgar Square and one of the Parliament Buildings (later enlarged into canvases), and that was about all. However, the artist had many friends in London. His sketch books are filled with London addresses of fellow artists and literary acquaintances – the Joseph Pennells, Sandy Jamieson, Gerald F. Kelly, Augustus John and the art critics Roger Fry and Clive Bell. He called on his boot-makers, his hatter, and Harry Ash, his fashionable London tailor. Although James Morrice was considered an elegant dresser, his style was strictly Edwardian. He preferred British tweeds and wore high straight collars, usually encircled with a large polka-dotted cravat. He always carried an umbrella.

PLATE 48
Nude With Fan
c. 1914, Canvas 26″ × 20″

In this sumptuous painting Morrice pays a kind of homage to the artists who had influenced him up until this time. The colours remind one of Renoir's late Cagnes-sur-Mer figure studies. The flowered drapery acknowledges his debt to Matisse. The technique he uses to paint the body resembles Bonnard's and the flatness of the model's left arm reminds one of another Bonnard mannerism. The short-lived Whistlerian influence can be seen in the Japanese print on the wall at the upper right. Surely this is one of the most exotic nude studies painted by a Canadian artist.

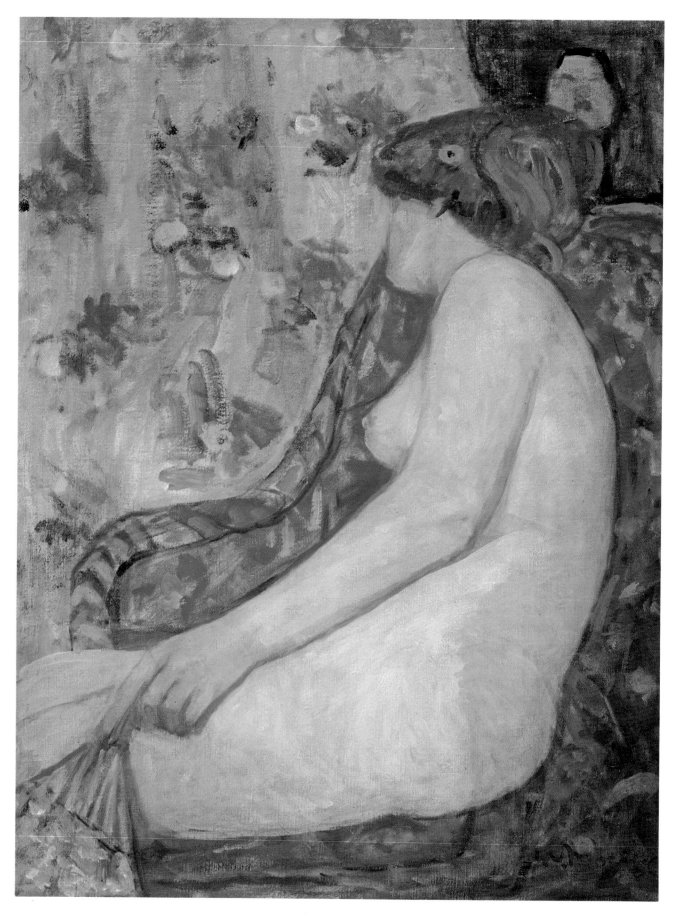

PLATE 48

After nearly twenty-five years, he was broken-hearted about leaving Paris, and it is clear that he had little interest in painting in England. "The weather gets so much on your nerves here that it's a great temptation to stay inside and drink whisky all day long," he remarked.

He sailed for New York, probably in early November, where he visited some of his old-time American artist friends. Then he went on to Montreal, and was home when his father died in late December 1914.

In Montreal after the funeral, there was the formal reading of the will and completion of other family business following the death of his father. Thanks to the family inheritance, James was now a wealthy man; but this bountiful patrimony would in no way change his parsimonious living habits. After the funeral, as if reluctant to leave Montreal because he feared he might never return, and still depressed, he tarried at home for another two months, apparently painting nothing. He was still there on February 5, 1915, writing a note to Newton MacTavish from the family house on Redpath Street.

Then an opportunity arose to go to Cuba. Sir William Van Horne's son, Bennie, an amateur artist like his father, asked James if he would like to accompany him there. It was just the right idea to pull Morrice out of his despondency, and in late February 1915, he passed through New York and Washington, en route to Havana. In a letter to Newton MacTavish from Washington, Morrice suggests that MacTavish delay the article in the English *Studio* magazine, "until I do something new in Cuba."

For some time James Morrice had heard about the beauties and wonderful climate in the tropical island of Cuba, and had wanted to visit it. His father's good friend, Sir William Van Horne, had built a railway in Cuba and owned a house there. This was the perfect opportunity.

It was Sir William Van Horne who had been among the first to encourage James W. Morrice's father to allow his son to go to Paris to study art. The artist thereafter maintained a long and amicable relationship with the great railway entrepreneur, who was also an early buyer of his pictures.

In 1898, Van Horne was invited by American business interests to supervise the electrification of the Havana Street Car system, at that time pulled by mule-power. Using his vast experience and engineering knowledge, Van Horne soon turned his mind to the more important challenge of modernizing the island's railroad system.

Van Horne built a palatial residence in the Spanish style among the green hills in the interior. He loved flowers and exotic shrubs, and landscaped his property with acres of magnificent gardens. Sir William's affection for Cuba increased through the years, as did his fondness for the island's aromatic

PLATE 49
Corner of a Village, Jamaica
c. 1915, Panel 5″ × 6¾″

Three figures are seated on a bench while another stands. Each is wearing a conical straw hat. The scene is one of indolent ease in the tropics. A graceful palm tree growing in the right-hand foreground adds vertical dimension to the picture.

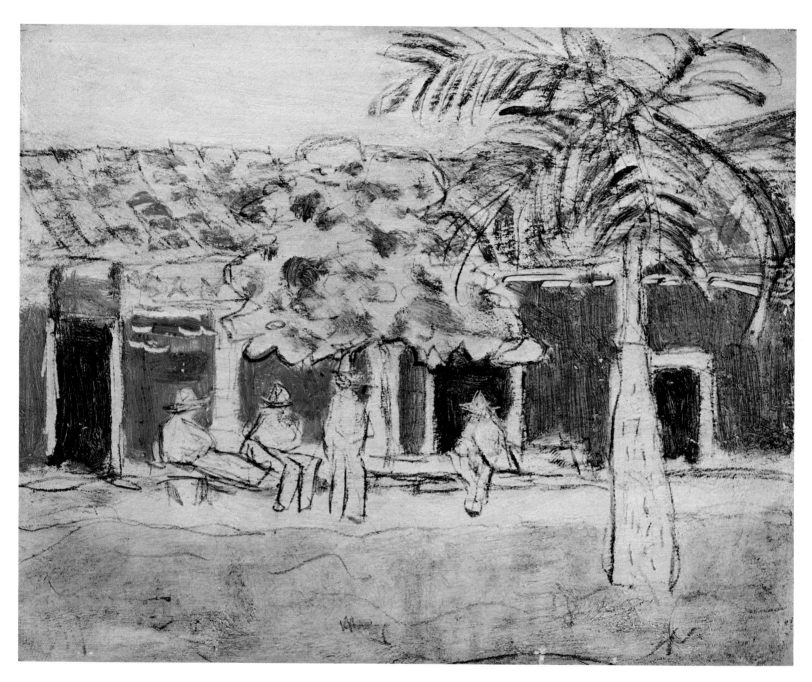

PLATE 49

hand-rolled Havana cigars. "It requires no effort to live there," was Van Horne's affable comment to James's father, David. However, there is no record of Morrice senior having taken advantage of any Van Horne invitation to visit the island. But understandably, in the aftermath of his father's death, James Morrice accepted Bennie Van Horne's invitation to Cuba with alacrity.

It was late in March or early April 1915 that Morrice reached Cuba, where he stayed for two or three weeks sketching café and street scenes in Havana, and in Santiago, horses and clowns performing at the circus. The artist then proceeded to nearby Jamaica, where his visit remained brief because he couldn't stand the tropical heat.

In the spring of 1915, Morrice returned to Paris where he painted up about a half-dozen Cuban canvases.

But it wasn't long before he was on the move again. To quote from one of Morrice's final letters to MacTavish written from Bayonne in September 1915:

> *I am just back from the South, Toulouse, Bayonne, Carcassonne. Those old provincial towns are delightful places with excellent hotels. Let me know about the photos and if you received them. A German submarine may have sunk them enroute.*

From England to Canada, Cuba and Jamaica, and then back to France, Morrice had been moving constantly for nearly a year. He was now enjoying a quiet time in the southwest country, far away from the guns and bloody trench fighting on the Western Front. Apparently this occasion was more in the nature of a holiday tour than a painting trip. There seems to be no record, however, of any pictures made during visits to these famous towns of southern France.

Life just seemed to go on much as usual in the southern provinces of France during the Great War of 1914-1918. But when Morrice returned to Paris, even though the curfew was eased, the former pre-war free-flowing café life of the artists had disappeared. His American and English artist and writer friends had long since departed. Paris would never be the same again.

He remained in Paris for most of 1917, and painted little. Then, in a December telegram from Lord Beaverbrook, Morrice was officially appointed a Canadian War Memorials artist. By February 1918, he was painting aftermath-of-war subjects near the Western Front in Flanders. He drew in pencil and sketched in oils the little First World War byplanes flying combat missions. He made numerous studies of horses and troops slogging along

PLATE 50
In Picardy
c. 1918, Panel 9½" × 13"

In 1918, Morrice spent several months near the Western Front as a war artist. He was especially successful in some of the sketches he made during the later stages of the war. The shelled-out Gothic church with a solitary soldier trudging down a broken road, is one of his most dramatic works.

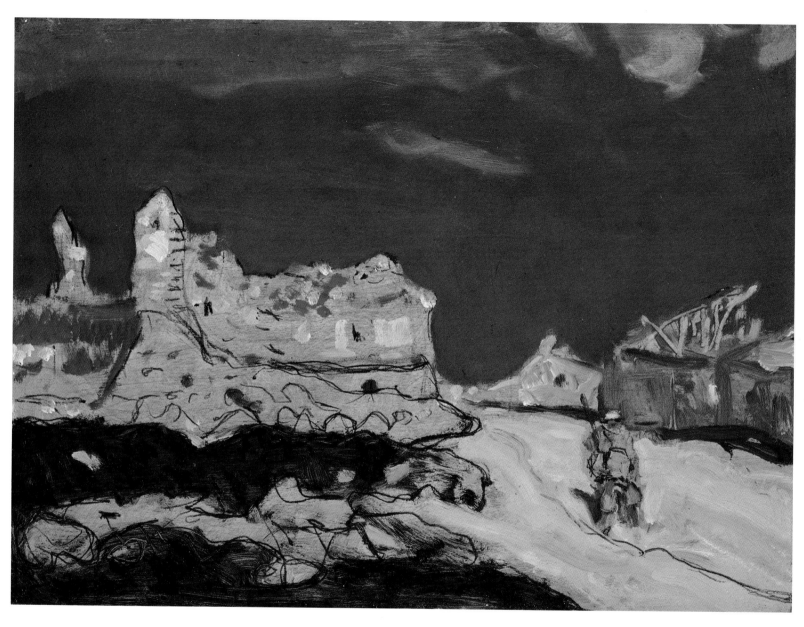

PLATE 50

muddy roads. He sketched the recent battlefields, where nothing remained on the horizon but blasted tree trunks.

Morrice was eager to complete his assignment as a war artist because he hated anything to do with the war. Fortunately, his term lasted only a few months. In spite of the circumstances, it is interesting to see how effective Morrice's painting style often was of these battlefield subjects.

Morrice's young sister Annie's husband, Alan Law, was a captain with the Royal Highlanders of Canada, and Morrice was able to catch up with him in the Picardy region through the war records office and get some of the family news. In February 1918, he was in Liévin, which had been virtually destroyed by heavy shelling. There he saw and painted what was once a fine Gothic church, its ruins silhouetted against a menacing, ink-blue sky. The painting has an eerie quality, further dramatized by the presence of a lone soldier carrying a full pack-sack trudging along a broken road. Months later, at his Concarneau studio, he finished an enormous mural-sized canvas, a composition of Canadian troops marching along a snowy roadway.

From studies in one of his sketch books, it seems clear that Morrice returned to North Africa after the war, though exact dates are unknown. What is certain is that, back in North Africa, he once again began using watercolours. And he painted the mosques and the harbour and ships in Algiers with brilliant results.

In September 1920, he became seriously ill in Paris and entered the St. Joseph Hospital suffering from a liver ailment.

Somewhat recovered, he made his final trip to Quebec City and Canada in 1921. He paused briefly in Montreal before continuing on through New York to Jamaica and Trinidad. This was his last visit to the West Indies, and was in fact the most productive trip of his final years. A striking feature was the sheer abandon with which he used pure colour. In Jamaica he painted mainly in watercolours. And from Trinidad he brought back some sketches of a sandy cove – a veritable tropical paradise. One can see in his painting *Fruit Boat, Trinidad* the artist's rendition of the shimmering blues of the sea, contrasted with a cool green background of palms and hillside vegetation.

Morrice returned to Paris and, in his Quai de la Tournelle studio over the next few months, painted up from sketches about half a dozen canvases of the West Indies, including the secluded bay in Trinidad. He also completed several canvases from his Jamaican watercolour sketches. These pictures were among the artist's final painting efforts. They demonstrated his ability to transform rich tropical subjects into a new painting idiom featuring bold patterns of pure colour.

PLATE 51

Fruit Boat, Trinidad
c. 1921, Canvas 15″ × 18″

On a sandy bay in Trinidad two white-clad natives are rowing a boat full of fresh fruit gathered at the tropical cove. Here Morrice has achieved a remarkable luminosity in his use of pure colours. The emerald greens of the hills in the background are in sharp contrast to the deep blue of the water in the bay, and the overall effect is spontaneous and brilliant. This canvas was painted back in his Paris studio from a watercolour sketch. It marked a new painting plateau in the artist's use of pure colour.

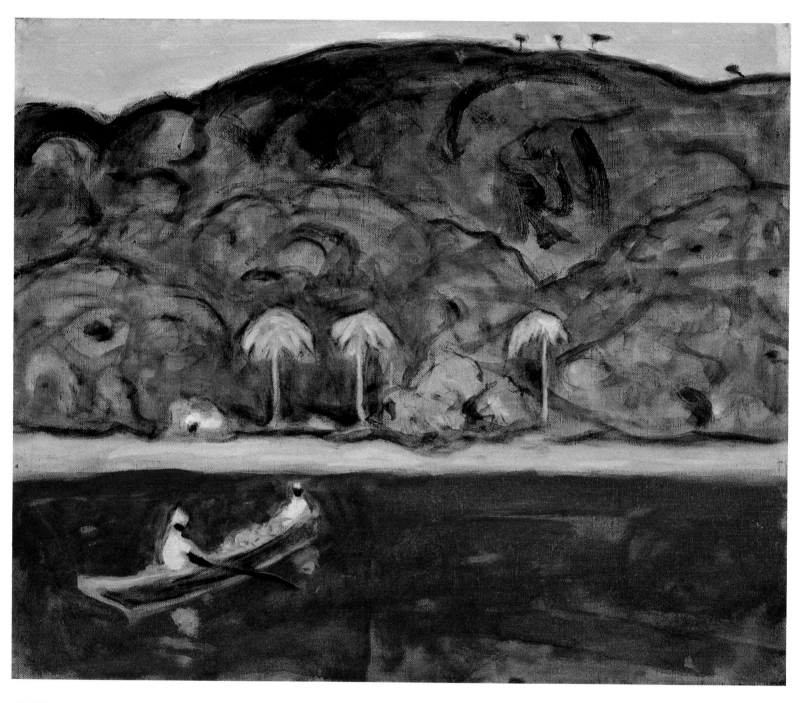

PLATE 51

The years after the war found Morrice more and more in complete seclusion, and after the spring of 1922 he apparently did no further painting. In fact, the last two years of Morrice's life were spent wandering through a dark valley of despondency, gloom, and ill-health from which he would never recover. His nerves were so bad he was unable to settle in one place for more than a short time. In February 1922, he was in Corsica, and March and April found him in Algiers. Here he painted a few watercolours and studies for what was probably his last large canvas, *The Port of Algiers*.

By the late summer of 1922, Morrice's worsening health weighed heavily on his mind, and he practically dropped out of sight. His English doctors in Paris had been warning him for years to stop drinking, which he had done for a while, but obviously it had been too late. In desperation he went to Evian-les-Bains, the famous health resort on the south shore of Lake Geneva, for a water cure. But there was no improvement in his condition. He then proceeded to Montreux, Switzerland, where his brother Arthur had been living, also for health reasons. There he became desperately ill. He eventually recovered enough to travel again, and he took the train to Cagnes to see Léa late in December 1923.

By then he had stopped painting, no longer having the power to concentrate. Interestingly, a surviving postcard written from Tunis on December 28, 1923, to Léa, and the final one from Palermo, dated January 14, 1924, to the artist William Brymner, did not reveal any suggestion of how ill he was. He died in Tunis on January 23, 1924, a lonely, sick, and broken man, not yet having reached his fifty-ninth birthday.

If James W. Morrice possessed a strong personal vision, he also had a strong practical side. Sometimes a shy recluse, he was a staunch friend of those he liked and respected. A too willing and congenial drinking companion, he was also an articulate conversationalist on art and literature. He knew there had to be music and art and colour, and the mirth and relief of absinthe and whisky.

He had known that he had to break from family and home city in order to pursue the kind of life he wanted, which, unbeknownst to him, would lead to a solitary end in Tunis. He must have suspected years before the end that the truth in the John Gay couplet, which he recorded in his sketch book, applied equally to himself.

Life is a jest and all things show it
I thought so once, but now I know it.

PLATE 52
Outside the Mosque
c. 1913, Canvas 23¾″ × 32″

There is order in the tangle of small green trees and red flowers in the foreground of the mosque. A low parapet runs along its length and a donkey covered with a blanket stands beside two closed archways. The artist deftly captures the texture of the ancient temple walls in tones of yellow ochre and creamy lime-greens.

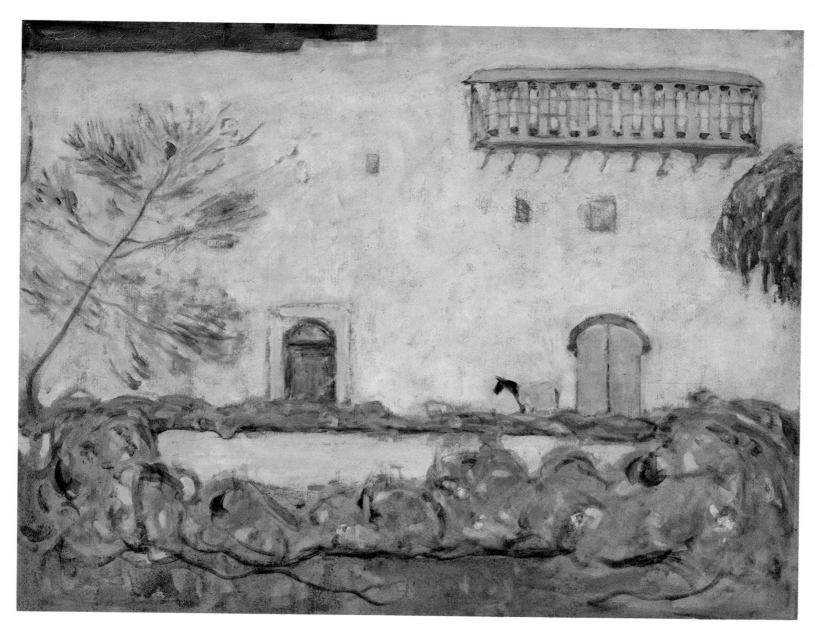

PLATE 52

8

LÉA CADORET
AND HER FRIEND

IN THE MID-1890s, Morrice had met a teenage girl who was to become his mistress in an affair which lasted until his death. Although she remained the only woman in the artist's life, he could be teasingly remote in a manner remindful of the elusive, mysterious qualities his paintings possess. But absent though he often was, for her he was forever endearing. Forty years after his death, in writing to a picture auctioneer in Montreal, she touchingly referred to Morrice as "her friend."

Marie-Louise Cadoret (Léa) was born on September 11, 1877, in Lamballe, Côtes-du-Nord, a market town in Brittany. Her father was a blacksmith and her mother worked as a *ménagère*, according to the town hall records. It is likely that Léa was an only child, her parents having died when she was quite young. Fortunately for her, she had an aunt who lived in Paris and was the owner of a small pastry shop near the Boulevard St. Germain. It wasn't long before Léa travelled to the great city of Paris to finish her schooling and work part-time in her aunt's pâtisserie. Not long after she was there, and young though she was, her aunt gave her permission to answer an advertisement for an artist's model.

Her fresh appearance and vivacious youthfulness delighted the artist, James W. Morrice. She possessed the complexion of a girl who had lived outdoors. About 5'2" in height, she had a roundish face, good-humoured brown eyes and full red lips. Morrice was enchanted and quickly decided that she would make a good model. They communicated freely, and her charms captivated him completely. Over dinner and wine one night, at the Périgourdine on the Place St. Michel, Léa agreed to become his unshared model.

PLATE 53

Marie Louise (Léa) Cadoret
c. 1896, Pencil drawing 6¼" × 5"

Léa holds an open umbrella over her left shoulder and wears a broad-brimmed hat with elaborate trimmings. This was probably Morrice's first outdoor drawing of Léa in the Fontainebleau Forest near Bois-le-Roi, and the pencil outline of bare tree trunks can be seen behind her and to the left. The fashion of Léa's dress, and the artist's style, suggest that the drawing might have been done about 1896 when Léa was nineteen. Her features – round lips, large eyes, and small perky nose – all reflect her attractive and pleasant personality.

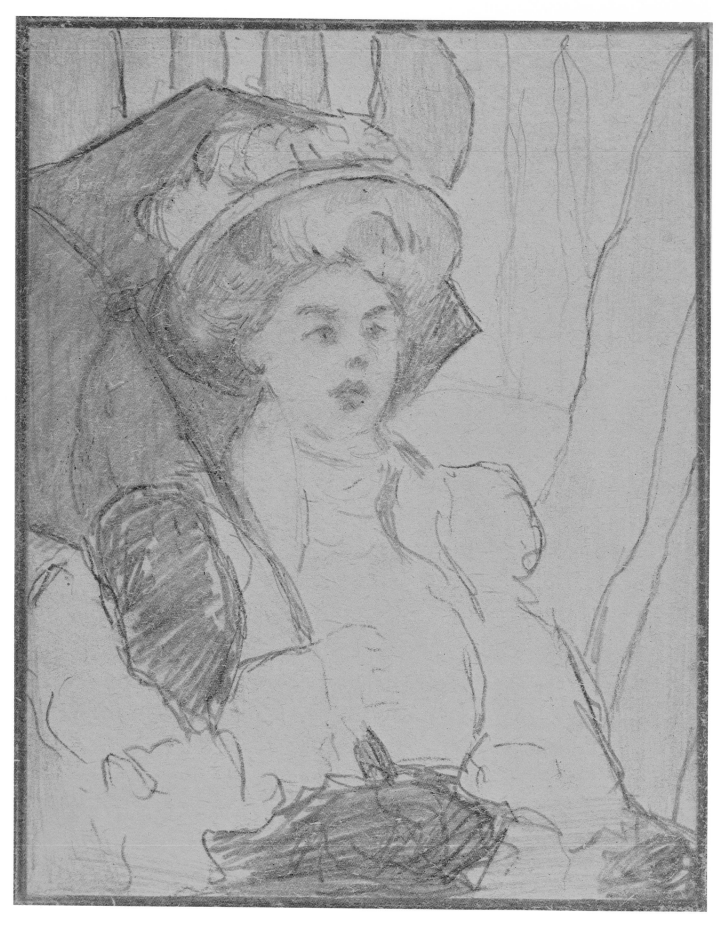

PLATE 53

Imagine Léa Cadoret beginning a life-long liaison with a strange Canadian artist character, then in his early thirties. Also think of the dapper Morrice, son of a Presbyterian Canadian merchant baron, forming a liaison with a Catholic peasant girl from Brittany, turned model. But they had been fortunate in meeting each other. She had such an amiable disposition, and in some ways filled Morrice's needs. His life so far had been his paintings and his flute. Now he had Léa. For her, Paris had been an escape route from Lamballe, first through her aunt and then through Morrice.

The artist agreed to provide Léa with a suitable apartment of her choice, and she maintained her own flat, supported by Morrice, where she observed her own way of life. At her urging, some time in 1916, Morrice moved from his Quai des Grands Augustins address to another studio about half a mile upstream on the Seine at 23 Quai de la Tournelle. Its windows provided a good view of the river and Notre Dame, but the quarter lacked the life and movement associated with his old stamping ground. Apparently Morrice never felt at home at his new address, besides he was constantly travelling and away from Paris for weeks on end. We are reminded of Matisse's description of Morrice as being in constant flight over hill and dale like a migrant bird.

Exactly how full a part Léa played in the life of this compulsive wanderer is unknown, though they remained loyal and devoted companions for thirty years. One remembers Clive Bell's comment: "He enjoyed his round merry mistress, Léa, but he kept her in her place, that is on the fringe of his life." Certainly, after a romantic beginning, it appears he half neglected her for years. Yet later in life, especially after the 1914 war broke out, he began to rely on her more and more, and she became and remained a stabilizing influence in his life.

Léa was small and attractive, and dressed well if modestly, except when Morrice bought her something fancy to wear to the Opéra-Comique or maybe an evening concert. She took her position as Morrice's companion and friend seriously, which at times must have been difficult, but she kept her self-respect. One of her greatest pleasures was dining with Morrice and his friends in fine restaurants like the Closerie des Lilas or Maxim's. Léa could reminisce years afterwards about these occasions. In a 1969 letter, near the end of her long life, she recalls posing for the artist in the Tuileries wearing a black boa and a tall hat. She adds: "My friend Morrice and the painters Thompson, Matisse and myself lunched at the Périgourdine."

In the early days of their romance they went everywhere together, to the best restaurants, on trips to the country, Bois-le-Roi, Dennemont, and to

PLATE 54
Femme au Lit
c. 1896, Canvas 16″ × 13″

Probably a study of Léa Cadoret when she was about nineteen years of age. This canvas reveals the artist's sympathetic painting of a young woman under the coverlets with her head and bare shoulders resting on large pillows. Why the artist signed with large initials and also printed the name "Jane," which can be seen under a light coat of paint, remains a mystery.

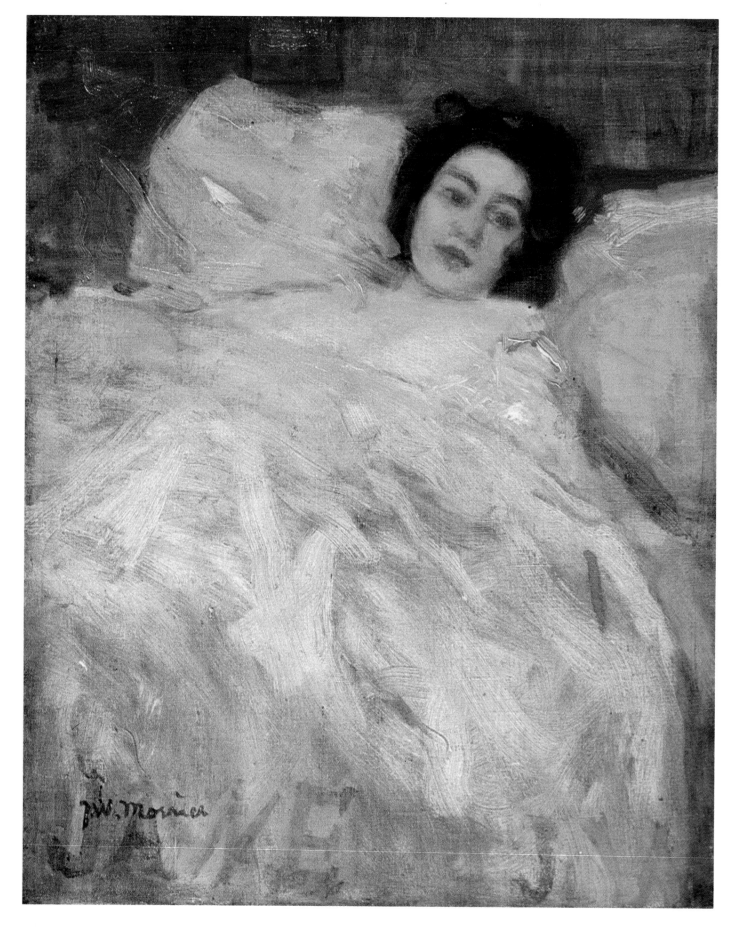

PLATE 54

many places in Normandy and Brittany. In 1922, Morrice chose a lovely spot in Cagnes-sur-Mer as a permanent home for Léa, and here he bought her a villa. When, two years later, he succumbed to the effects of *mal de foie* in Tunis, he left behind a still attractive and very vital forty-seven-year-old woman.

In his will, he bequeathed a legacy of $50,000 to "Mademoiselle Léa Cadoret." And, after directing his executors to make a selection of his pictures and drawings as a gift to the Art Association of Montreal, he left the remainder of his estate equally divided among his three brothers and sister.

Despite rumours, explicit knowledge of the existence of the engaging Léa Cadoret and her close relationship with James Morrice was not fully known, particularly to members of his family, until his last will and testament was read. That the affair would have caused embarrassment to the Morrice family is probably true, though, by 1924, James's parents had been dead for almost a decade. Now, with Léa's existence no longer a secret, the remaining brothers and a sister were sensitive to the possibility that Léa's role in Morrice's life might be sensationalized.

Léa never married, but lived in comfort almost to the end of her life. She divided her time between Paris and Juan les Pins, in the south of France.

But, by 1969, Léa Cadoret, then into her early nineties, encountered desperately hard times. She wrote in a letter to a Montreal auction house that she was weak and ill and had foolishly lent large sums of money to individuals from whom she received no interest or return of capital. Apparently now without any means, grasping at straws, she responded to a letter from the auction house with a plea to be allowed a ten per cent commission on a Morrice painting she at one time owned, *Léa in a Tall Hat*, which was being offered at a public sale in Montreal. Unfortunately this was a situation entirely out of the hands of the auctioneers, who did not own the picture but were selling it purely on commission for the real owners. Their letter to Léa Cadoret had merely been a request for her to identify the subject in the picture. This kind of pathetic response might not have been unusual for Léa at this point in her life, and illustrates the unfortunate situation she found herself in, during her latter years. On November 3, 1973, in Antibes, she died, at the age of ninety-six. By then, she had outlived her "friend" by close to a half a century.

During two successive years in June, the first being 1982, I flew to the south of France from Paris. I was seeking further clues about the later life of Morrice. Clues about those years when he became at once more private and

PLATE 55

Léa in the Garden, Dennemont
c. 1900, Panel 12¾″ × 9½″

Léa Cadoret at a table in the garden at the Old-Mill Hotel, Dennemont, on a quiet backwater of the Seine. It is summer and Léa's dark hair and light blue bodice catch the afternoon sun. As in the majority of Morrice's figure studies, the subject's facial characteristics are not portrayed in detail by the artist. But somehow Morrice's eloquent and imaginative use of colour allows the loving personality of his young mistress to shine through and touch the spectator.

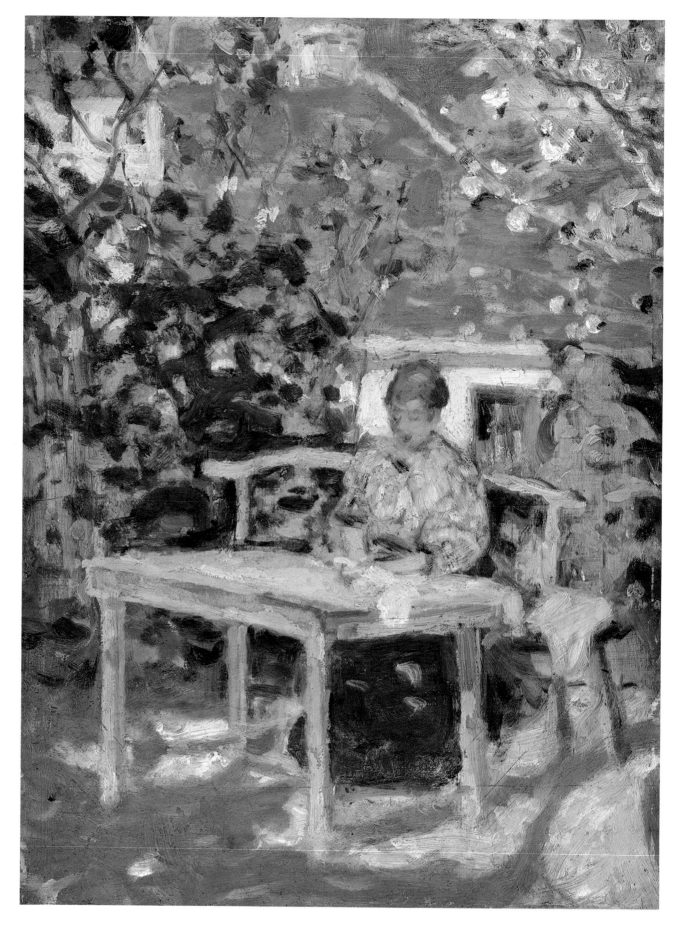

PLATE 55

also more of a nomad. Of course I was hopeful I might even find a painting in some place he had stayed, or possibly some local memories of him and his mistress. On the first occasion, I was met by Peter Eilers, my long-time Dutch partner and fine art connoisseur, at the Nice airport. We then drove on to nearby Cagnes-sur-Mer, where Morrice had bought a villa for Léa. Cagnes had become a mecca for artists, who went south in the winter to enjoy the mild weather and the incomparable Mediterranean light. Morrice acknowledged that Cagnes was full of character, though he found little time to paint there.

Slowly, up narrow streets solid with villas and artist's studios, we made our way to an ancient square where, at the summit, the mediaeval castle of the Grimaldi family stands. In late June, the climbing rose bushes clothed the grey stone fences and drab studio walls in a costume of brilliant scarlet. And so it was that I had my first glimpse of the hideaway town of Morrice and his Léa.

But it was getting late and we still had a considerable journey before we could expect to reach the Eilers' newly built house at Figanières in the Var. I therefore resolved to return another time, having garnered further clues to help explore the inner recesses of the town for traces of the artist and his companion in those earlier days.

The second time I visited Cagnes was in June 1983. Peter Eilers had by then become an interested observer of my Morrice explorations. He had seen an advertisement in the Nice newspaper placed by a writer seeking details about the lives of certain artists who had lived and painted in the Côte d'Azur region through the years. We set out to trace the author.

The person we met, Alain Dornic, was originally a Parisian. He and his wife had resided in Cagnes-sur-Mer for some years in a stone villa on the historic Grimaldi Square, at the highest level of the little town. Almost next door to his house, an oaken portal opened into a richly appointed mediaeval church entirely illuminated by candles. Through it, one could peer into ages past. Back in the square, we passed through an arch leading to a larger terrace where colourful banners fluttered high on the castle ramparts. And now I began to understand why Morrice had chosen Cagnes-sur-Mer as a private sanctuary. Léa apparently liked the climate, and the town was both attractive and peaceful.

M. Dornic greeted us with kindly interest and, in a matter of minutes, offered to guide us around town to search for some of the locations that James Morrice had marked in his sketch books those many years before. M. Dornic took us to the Hôtel Savournin where the front garden of tall palms

PLATE 56
Léa in a Tall Hat
c. 1896, Canvas 22½″ × 15¼″

This study portrays Léa Cadoret in a more conventional form than the majority of Morrice's other figure studies. The picture is painted thinly, the light brown background rubbed down for effect to show the texture and fine grain of the canvas. Her fashionably elegant high hat is magnificent but her thin black boa looks shabby and worn. She poses in a dress of shaded olive greens and her face is solemn and wistful. Léa looks much older in this painting than in the pencil drawing and small panel Morrice sketched of her around the same time at Bois-le-Roi in the Fontainebleau.

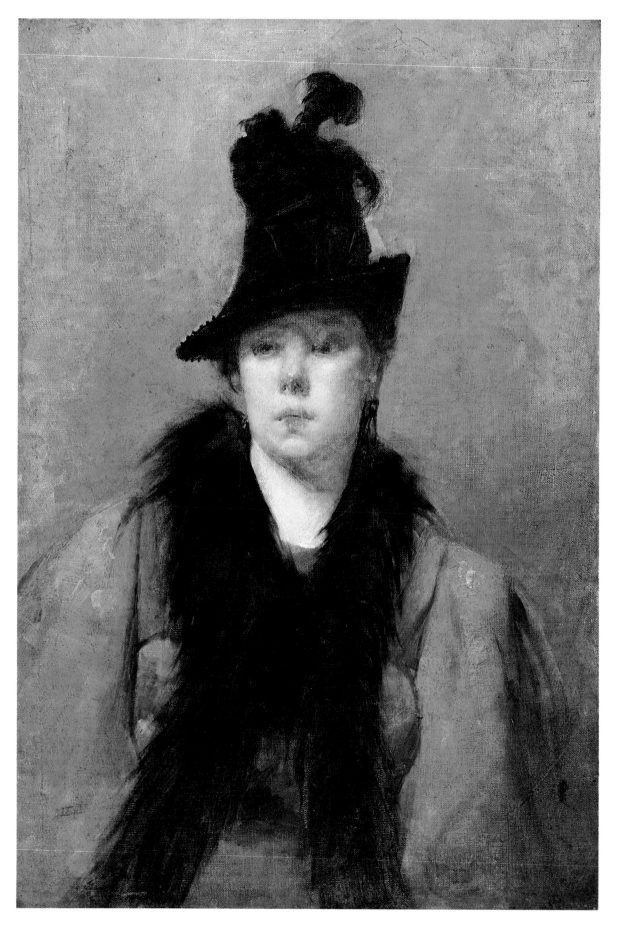

PLATE 56

overlooks the town square. Morrice had stayed here from time to time, but the proprietor no longer possessed guest records of the early 1920s. As it was a warm morning, we sat outside in the garden enjoying some cool mineral waters.

The villa that Morrice bought for Léa in 1922 was at 9 rue du Pérousin in Cagnes. There, looking east toward the rising sun in front of the next hill, were Renoir's olive orchards and white and pink stone house, "Les Colettes." Léa's villa has since been reconstructed and re-numbered 19. But the view is still an artist's vision. There presently lives, on this street, an old lady born in Cagnes who remembers a woman living there who was not a native. She was something of a mysterious figure whom the children called "La Dame." Indeed, the very phrase suggests something at once grand as well as a little *demi-mondaine*. The old woman told us that this lady sold the villa and moved away, probably to Juan les Pins or Paris. This rather illusive or shadowy "dame" was most likely Léa Cadoret.

Alain Dornic went to the local tax administration department to seek further information about Léa and Morrice. When questioned, one of the bureaucrats stated that they did have the old records of house sales in Cagnes, but were not permitted to furnish information without a written request from the heirs, or by court order. With a little coaxing, however, the clerk finally acknowledged that Morrice had indeed purchased a villa in 1922, in his own name. Also the name of Léa Cadoret was known to officials in Cagnes, as certain property transactions she had made were recorded.

Of course, as I strolled through the town, I kept thinking about Morrice and Léa. They had never married, never had children. I doubt that Morrice ever seriously contemplated marriage. It would not have fit his style or way of life. The fact is that Morrice wouldn't have wanted her, nor anyone, to actually live with him. As Clive Bell noted: "Morrice was the 'solitary artist type.'" And, as a further deterrent, his family would have wholeheartedly disapproved of a marriage to Léa.

No doubt Morrice still retained strong Presbyterian conventions, recognizing his family's belief that it was wrong or sinful for a man and a woman to live together unless they were married. He didn't want it known to his family in Montreal that he was in any way romantically involved with a French mistress, a peasant and Catholic one at that.

If one had any doubts about the importance of Léa's place in Morrice's life, the fact that he left his sketch books and a number of paintings with her surely dispels them. As an artist, his sketch books were certainly his most intimate possessions. They are doubly important to us. First, they record

PLATE 57
A Lake in the South of France
c. 1909, Panel 5″ × 6″

The setting of this view remains a mild mystery, but the wake from a small boat suggests a lake. The tree reminds one of the European birch and the flowers are overblown roses. It is probably a spot somewhere in the south of France, where Morrice perhaps visited with Léa.

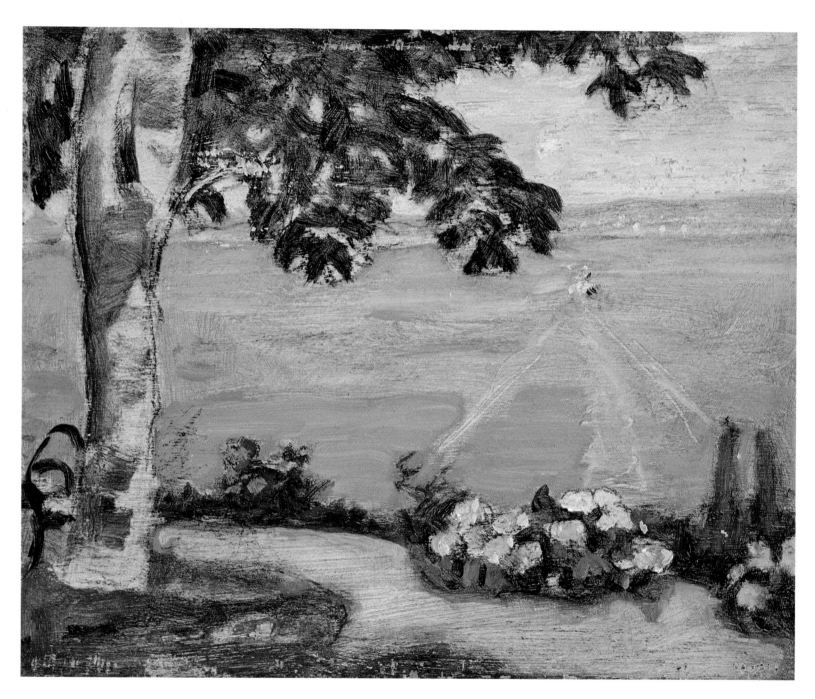

PLATE 57

and reveal such a variety of the artist's comments and attitudes. Second, they contain many hundreds of drawings in various stages of completion, but nearly all of interest.

There are thirty known Morrice sketch books, and over the past several years I have examined all of them. Twenty-four belong to the Montreal Museum. Two are in the National Gallery of Canada. One, a very early sketch book, is owned privately. Three others I acquired in 1962, in England, where they had been sent by Vincent Massey, Canada's former Governor General, to be sold at auction. When I examined the sketch books in the sale rooms at the time, I was delighted to find how finished so many of the drawings were. One of the books was dated 1906, and contained Brittany subjects. Another was full of Venetian drawings made possibly during the year 1899, while the third featured a variety of Paris views.

I had the sheets removed from the books by expert paper craftsmen in England. We then framed them and held an exhibition of the drawings at our galleries in 1962. Mr. Massey had chosen well. I believe he purchased them through D.W. Buchanan, the writer on Canadian art, in the mid-1930s, and I surmise that the remaining books were sold by Léa Cadoret to David Morrice when he visited her in Paris about 1952. They possessed little commercial value at the time and I am sure Léa was only too glad to find a good home for them. For some years, the artist's nephew, David Morrice, had known Léa, and on various visits had bought his uncle's pictures from her, including a small study of Léa herself holding an umbrella in the woods at Bois-le-Roi near Fontainebleau. Earlier, she had sold to the Kraushaar Galleries, New York, six small watercolour paintings by Morrice's American friend Maurice Prendergast.

There is an extensive amount of material – notes and observations – in these little notebooks. Some of it is straightforward, but many notations are enigmatic. Most of them are undated. Yet a study of these little sketchpads (they measure a mere 4½″ x 6¾″) affords further insight into the interests and personality of the artist. Morrice mentions the writers T.S. Eliot and James Joyce – *avant-garde* names in his day. We also know he was interested in the books of Sinclair Lewis and Theodore Dreiser. In particular, there is a reference to Louis Hémon's famed novel of French Canada – *Maria Chapdelaine*. This has a special interest for us because one edition of *Maria Chapdelaine* was superbly illustrated by the Canadian artist, Clarence Gagnon, a friend of Morrice. And among American artists, there is mention of the watercolourists John Marin and George Luks. There are, as well, the names of certain composers, such as Maurice Ravel. Morrice's interests appear to

have been wide-ranging, and not confined simply to the Paris art world of his day.

The reference to Gagnon in Morrice's sketch books is significant. We know Morrice admired Gagnon's work, particularly his etchings. In fact, Morrice went to the trouble of arranging a show of Gagnon's etchings at an exhibition of the Canadian Art Club in Toronto.

Morrice's notebook entries form no sustained chronological pattern. It is possible a sketch book begun in the late 1890s could also contain drawings executed years later. When he selected a sketch book for a trip, he would probably choose one at random, quickly checking to see how many vacant pages it held. Some critics state that Morrice was not an accomplished draftsman. Certainly a number of the pencil sketches were slight – simply lively reminders of places he had seen. But some are finely finished, and never stilted or over-worked. And some have all the formal elements necessary for the creation of a complete composition.

In one of his sketch books, Morrice records the purchase of the Cagnes-sur-Mer villa. This was during a period when he gave Léa substantial cash sums which he carefully recorded in his sketch books. What the actual total was is impossible to determine because one can't always tell from his figures whether the sums reported are in French francs or dollars. But suffice it to say the total was considerable and the buying power of the franc in those days was formidable.

In a January 1922 note he records:

Léa - 1,000 — House - Cagnes
100 — Monte Carlo
100 — Races, Nice

Could the latter two items represent some small gambling excursions to the Casino and race track? In February, James lists in his sketch book: 1,000 francs for a trip to Corsica. In March, he was in Algeria, but apparently back in Paris, April, May, June, and July of 1922. He records a total expenditure of 12,700 francs during those months – a lot of money for the parsimonious painter to spend.

Morrice's sketch books even tell us about his slight physique and delicate constitution. Around 1920, he records that his weight was 60 kilograms, or 133 pounds. His height was approximately 5'6". He was much concerned with his health in those days, and notes the names of various doctors in the books.

In one sketch book there is a list of young female models, scarcely a surprising fact. But what is interesting is that he basically classified some of them according to the colour of their hair. The list read:

Melina Edouard – *Stark's model* [Otto Stark, 1859-1926]
Maria Garner – *Red Hair*
Fanny Verguin – *Zorn's model* [Andres Zorn, 1860-1920]
Marguerite Patou – *Blond*
Maria Buesson – *Blond*

It would seem that Morrice didn't pay much personal attention to the faces or figures of the models he painted.

As he reached his mid-forties, and his health began to deteriorate, partly through drinking too much absinthe, Morrice became increasingly cynical about life and his place in it. It was in one of the later sketch books, that he jotted down the John Gay couplet.

And on a trip to Havana in 1915, he recorded a sardonic notice he saw on a hearse:

Look for me tomorrow, you will not find me.

And he would quote passages from the Bible (as applicable to himself, no doubt):

And I say unto you, I will not drink henceforth of this fruit of the vine, until that day when I drink it new with you in my Father's Kingdom.

Morrice's sketch books are indeed an interesting source of information. Perhaps some day art historian sleuths will follow these clues, and contribute even further to our knowledge of the man.

PLATE 58
Landscape, Trinidad
c. 1921, Canvas 29⅛″ × 36½″

This is one of the artist's final great paintings which he executed in Paris from watercolour sketches done on his last trip to the West Indies. It is another canvas originally owned by M. Cézar Guichardaz, Morrice's Paris colour supplier whom he acknowledged "does everything for me." It was acquired by Pierre Matisse, the New York picture dealer, a son of Henri Matisse, and sold to the Art Gallery of Toronto in 1936. In a clearing cut out of a green and lush tropical rain forest, a pink-walled native house fills the middle ground. A black figure in a white tunic stands nearby, lending perspective to the composition.

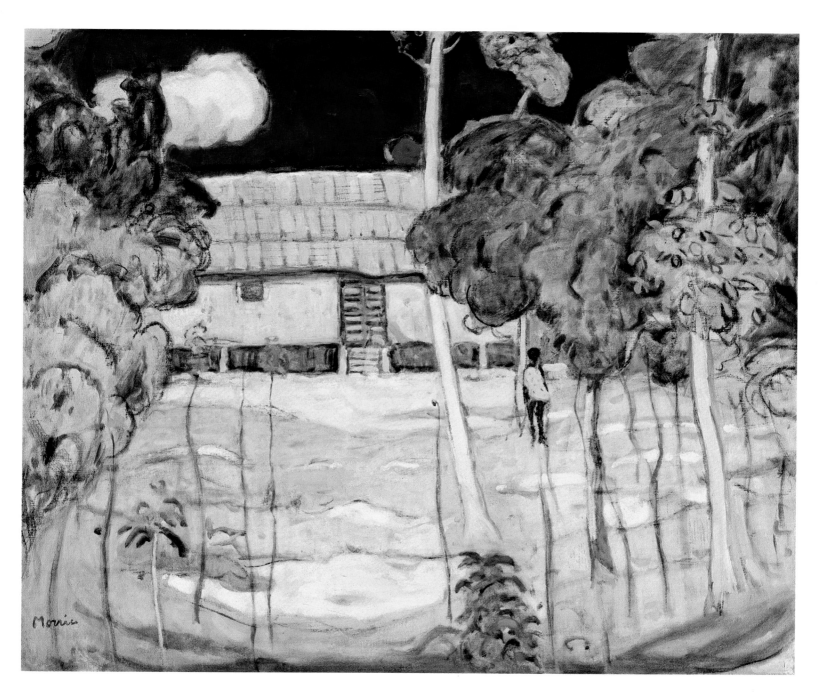

PLATE 58

9

MORRICE COMMENTS
ON PICTURE DEALERS

SOME OF THE NOTES in Morrice's sketch books refer to the commercial art dealers of his time. And these references are supported by comments in his letters to various friends. As a picture dealer myself, I found these very revealing, both of Morrice the man, and the artist.

His first reference to dealers is in a letter dated January 12, 1897, Ste. Anne de Beaupré, Quebec, to Edmund Morris who had enquired if Scott and Sons in Montreal might be interested in showing his work.

Morrice's reply was swift and to the point:

I don't think Scott is a likely man to sell your pictures. He doesn't bother himself about Canadian work. All the men in Montreal complain about it.

During his lifetime, Morrice was invited by various galleries to hold a one-man exhibition. And, on occasion, he would show as many as seven or eight works in group exhibitions. But Morrice never held a single one-man exhibition of his paintings. He remarked "he didn't particularly believe in one-man shows, they are apt to be tiresome." His modesty is striking.

On November 3, 1910, he wrote to Newton MacTavish:

I have received a letter from a picture dealer in Toronto – Francis Grattan, 5½-7 Bloor Street. He wants me to send him some of my pictures and says he has customers who have asked for them. Would it be advisable to send him some pictures? I wish you would let me know at once and oblige me very much.

MacTavish checked the personal and business credentials of Mr. Grattan and apparently arrived at some reservations. MacTavish's lukewarm refer-

PLATE 59
Venice
c. 1903, Canvas 21¾″ × 18¼″

The artist has here painted a group of nearly a dozen figures on the steps of an old building in the ancient Adriatic port of Venice. Gondolas in the nearby canal seem to be nodding their prows in anticipation of the arrival of fresh passengers. Across the dark waters of the canal are the pillars and the dome of St. Mark's. The colours are rich and hazy in the late-afternoon light.

150

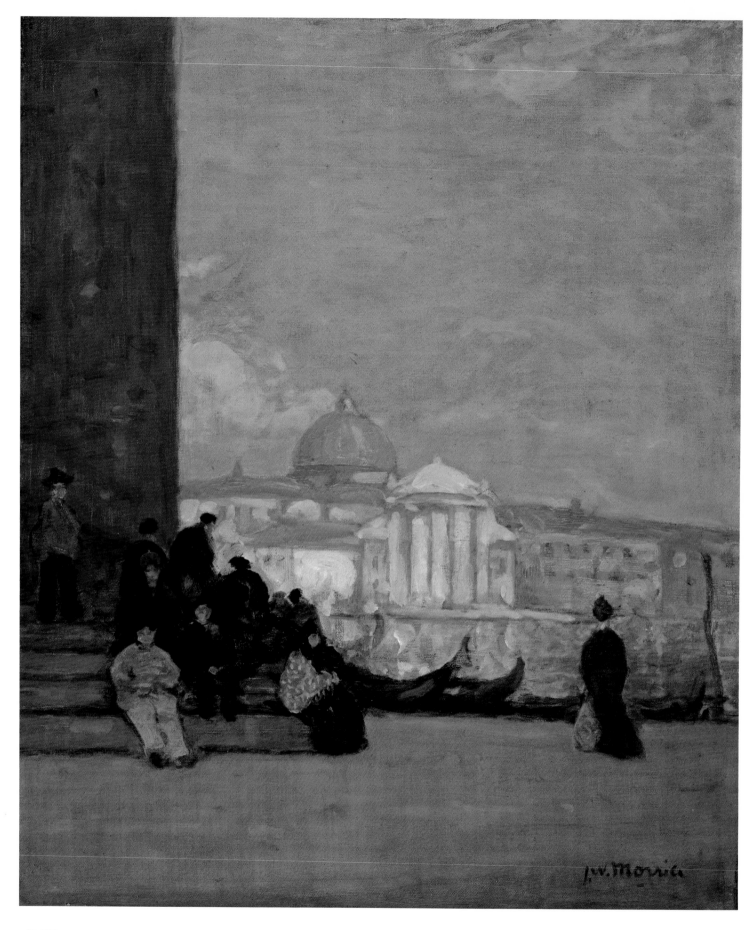

PLATE 59

ence was enough to convince Morrice not to send anything to the Toronto dealer for the time being.

Thanks for your letter with your guarded information about F. Grattan. I have no doubt that you are right about him but to me all picture dealers are alike. As long as he is an honest man that is enough. But I don't think I will send him anything at present.

It is clear from his letter that he wanted to sell some of his "stuff," as he called his pictures, in Toronto. The reasons were not merely financial, as money was not his chief concern. He was looking for recognition from the Canadian city where he had spent seven years of his life as a student, but he was always wary and cautious about who handled his work.

Francis H. Grattan was one of the early framers and picture dealers in Toronto; however, little is known about him. But he had shown foresight and taste in admiring the work of James Morrice and in suggesting he could sell it, and it took courage and imagination to write to the artist directly in Paris.

In a December 3, 1912 letter to Edmund Morris, Morrice refers to W. Lawson Peacock, who, from about 1900 until the First World War, made annual trips from London to Montreal. There he showed his collection of Dutch, English and French pictures with Wm. Scott and Sons. He also exhibited pictures in Toronto, from time to time, showing with the Goupil firm. Lawson Peacock was an enthusiastic and skilled picture salesman who helped fill wealthy Montrealers' homes with works of the Dutch-Hague and French academic schools – the kinds of pictures which made Morrice cringe. Strangely enough, during the 1960s and 1970s many of these same Dutch pictures were bought up by Dutch dealers and are now back in Holland.

In a late December 1912 letter to Edmund Morris, Morrice comments with amazement and consternation at the number of pictures Peacock sold in Montreal.

I hear that Peacock has been in Montreal and sold about 100 pictures. Damned Dutch water colours, no doubt – they do more to vitiate the taste for art in Canada than anything I know.

Five months later, in a more relaxed mood, if with a touch of scorn, Morrice wrote:

. . . but after all what difference does it make where our pictures go, and whether it is Van Horne or Peacock who buys them.

PLATE 60
In a Paris Park
c. 1905, Panel 5″ × 6″

Morrice exhibited this picture in 1905 at the Salon d'Automne. A critic covering the exhibition for the English publication Truth, *wrote: "A young Canadian painter, Mr. Morrice is among the exhibitors. Look at his small picture, the size of your hand, of a nurse in a park with three little dotties, blue, red and yellow, playing in front of her. I like his work extremely."*

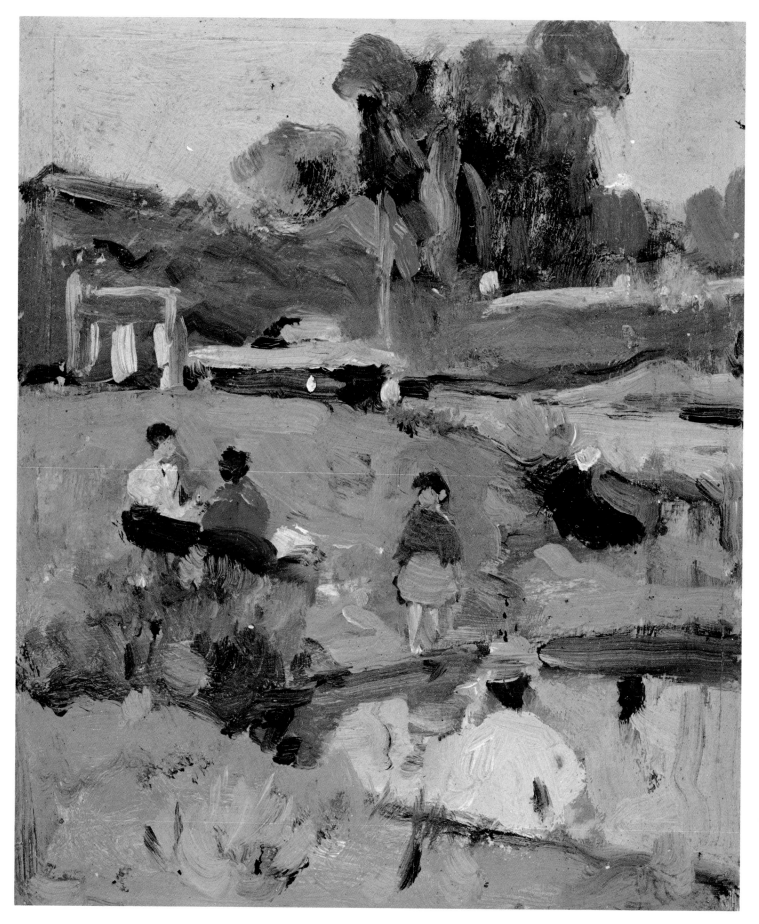

PLATE 60

The Fifth Avenue, New York address of a branch of the Gallery Durand-Ruel is recorded in a sketch book – as well as the address of the New York picture dealer Wonderlich & Co. It is doubtful if Morrice ever showed with either firm. He did know the Paris premises of Durand-Ruel and frequently attended their famous exhibitions.

In another letter, Morrice praised the London-based Goupil & Co. as a most enterprising art firm. Originally founded in Paris in the 1820s, they were now located on Regent Street and were among the oldest art dealers in Europe. In 1913, the *Studio* Magazine reported that the annual salon of the Goupil Gallery in Regent Street is nowadays one of the leading events of the autumn season in London. The director was a Mr. Marchant and he had an associate, his brother-in-law, W.P. Winchester. They were alert business people, and they understood the importance of knowing the prominent individuals in a community who might have the means to buy expensive pictures.

One excellent way to meet potential buyers in Toronto during those days was to become a member of the Canadian Art Club. Being resourceful and ambitious individuals, Messrs. Marchant and Winchester took advantage of the first opportunity to become members. William Marchant left no stone unturned in order to promote his picture sales.

Morrice wrote to Edmund Morris from Paris on November 1, 1912:

The Automne Salon closes this week – not a success from an artistic point of view, and financially no sales. Marchant of the Goupil Gallery came to see me and I have sent six pictures to their autumn exhibition (in London); he seems to be a decent sort of chap.

Morrice also mentions in a sketch book the name of the famous *avant-garde* Paris art dealer Paul Guillaume. It was from Guillaume that the avid and singular collector Dr. Albert C. Barnes, of Philadelphia, bought so many of his superb French pictures. Bernheim Jeune was another prominent Paris dealer who acquired Morrices for sale. This was the gallery that showed the work of Vuillard and Bonnard early in their careers.

But Morrice's earliest dealer was the Montreal firm of Wm. Scott and Sons, whose proprietor, by the late 1890s, was F.R. Heaton. Frank Robert Heaton was a son-in-law of William Scott, who founded Wm. Scott and Sons in 1859. Heaton carried on the art business during the prosperous days before the First War, when so many fine private collections were being formed in Montreal. In 1913, on graduation from McGill, Frank Heaton's son John joined the firm. It was John Heaton whom I knew and who

PLATE 61

The Bull Ring, Marseilles
c. 1904, Panel 9¼" × 13"

Here at the bright and sunny bull ring in Marseilles, Morrice painted another of his richly coloured works. The bull is standing still at the moment and the toreador with his red cape awaits his move while his assistant is nearby on the alert. Spectators are in the stands and others await their turn to enter the arena. The bull ring had an attraction for Morrice similar to his life-long love of the circus.

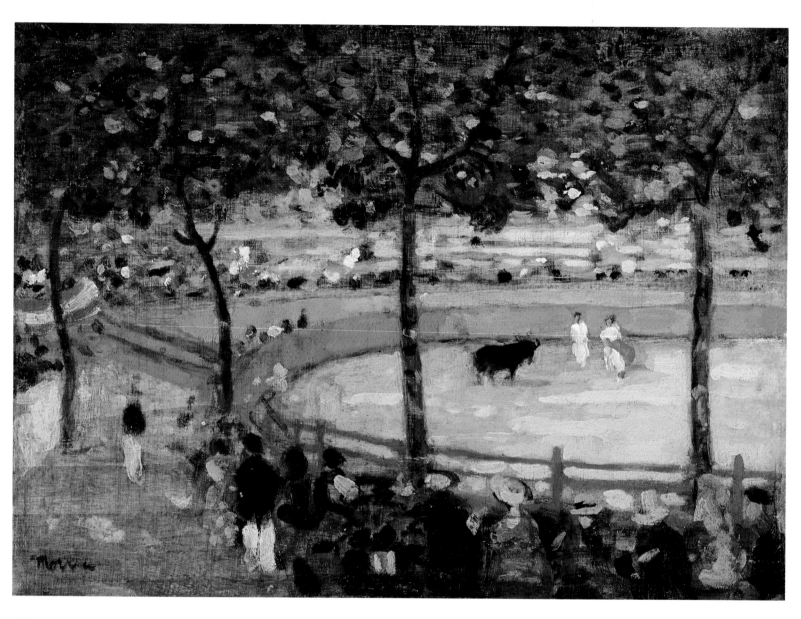

PLATE 61

arranged the 1934 J.W. Morrice exhibition with us. The Scott firm closed its doors for good in March 1939. The closing was preceded in March 1938 by an auction sale of all their stock. Included in it were twenty-six oils and watercolours by J.W. Morrice. Under the auctioneer's hammer the Morrices fetched prices ranging from a paltry $20 for a West Indian watercolour to $1,000 and a bit more, for some of his finest and most desirable canvases. This must have been an all-time low in Canada for an auction of fine pictures. Certainly it was a catastrophe for the owners.

A total of fourteen works from the collections of Morrice's former Paris friends and patrons, Jacques Rouché, Ch. Pacquement, André Schoeller and Franz Jourdain were shown at the Salon d'Automne retrospective in 1923. By then the artist was already presumed dead, no word of him having reached the salon officials. In 1926, the Galerie Simonson held a Morrice memorial exhibition in their Paris gallery. M. Simonson borrowed extensively from private owners and French museums for this exhibition. But also included were several pictures which he had personally acquired direct from the artist.

In the late 1940s and early 1950s, the Continental Galleries, Montreal, took over the handling of the remaining Morrice paintings from the Heaton family. Even then there were still nearly one hundred panels and canvases left in the estate. Those were a good supply source for us during the next few years.

The picture we get from Morrice's notebooks and letters is of a wry, tart, rather timid man who was clearly brought up as a gentleman, and of an artist who was admired by his painting peers and by a number of dealers with foresight. But alas, he was largely overlooked by the public in his own lifetime.

PLATE 62
On the Beach, Tangiers
c. 1913, Canvas 23¾" × 28¾"

A Moorish figure in a short white tunic, bare legs, and sandals, wears a red fez. Holding a stick, he is driving his donkey along the beach. White waves roll up to the shore and you can distinctly see, beyond the blue water of the Strait of Gibraltar, the hilly shores of southern Spain.

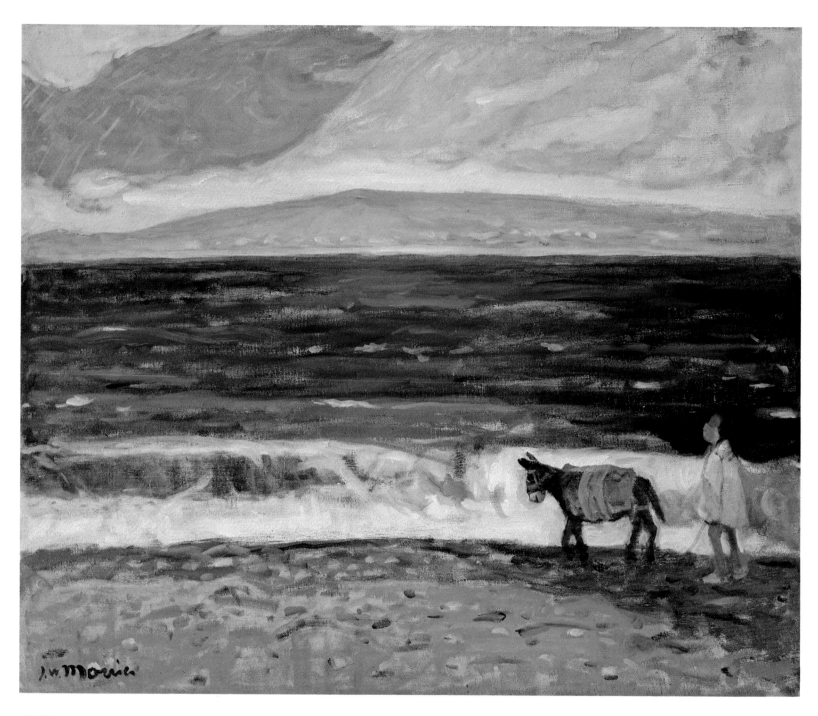

PLATE 62

10

LETTERS TO
EDMUND MORRIS
AND THE
"EXCELLENT"
MACTAVISH

ONE OF THE BEST WAYS we have of following Morrice's life, beyond the salons of Paris, is through his letters. There are just enough of these extant to give us quite a complete picture of the man.

The largest surviving group of Morrice's letters is his correspondence with Edmund Morris, the Toronto artist. Morris was one of the original members and became secretary of the Canadian Art Club. He was noted for his paintings of the Sioux and other Indian tribes. There are thirty-four letters in all. And those, along with the smaller Newton MacTavish collection of letters, help fill some gaps in the life of J.W. Morrice. Indeed, through them we can follow many of the larger movements and concerns of his life. A careful reading of these letters is illuminating and rewarding, as it gradually reveals certain aspects of the artist's complex personality. Together, they almost form a collage of his painting years.

Morrice had met Edmund Morris in 1895, in Paris, where the latter had arrived to study, one of the many eager young art students from North America who had high hopes for future fame. Two of the earliest letters on record were written to Edmund Morris from Ste. Anne de Beaupré, Quebec in January and February 1897. It was during this 1897 trip to Quebec, that he had first met Maurice Cullen, the Newfoundland-born artist. Morrice enjoyed the company of the talented Cullen on this extensive sketching trip along the St. Lawrence North Shore. A few months later, they painted together on visits to France and Venice. He called Edmund Morris's attention to Cullen's abilities in one of these letters, referring to him as an "Associate of the new Salon." Apparently being an Associate of the Société Nationale, Paris, was to Morrice an important artistic honour and recognition.

PLATE 63
Pink Clouds Above the Boulevard
c. 1908, Panel 5″ × 6″

Daring in colour, this composition was probably painted from a café on the Boulevard St. Germain. In the middle distance are some five- and six-storey buildings framed against a crimson sky. Figures in hats are grouped in the sidewalk café.

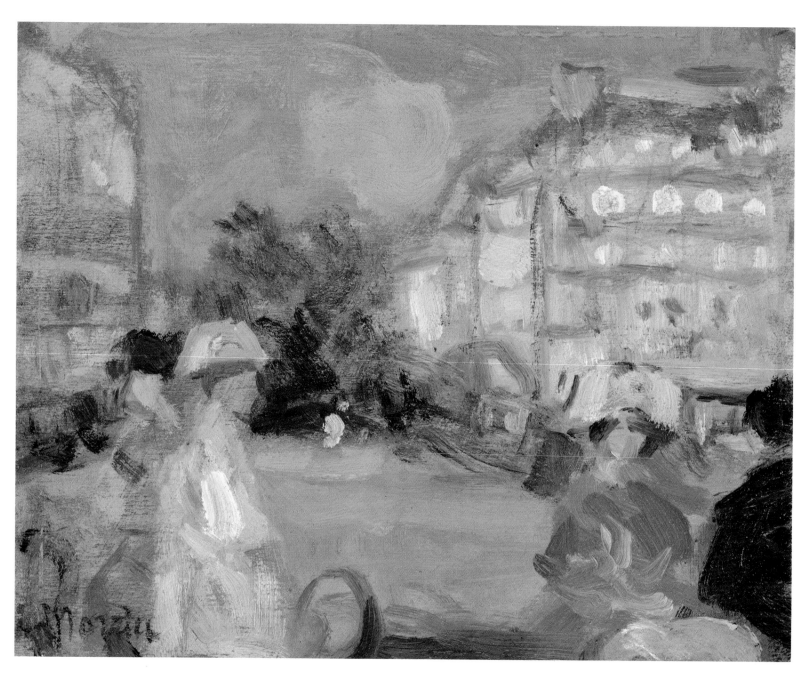

PLATE 63

Morrice adds this little bit of gossip in his February 1897 letter from Beaupré:

Your Torontonian artist Bell-Smith has been giving a lecture in Montreal. Cullen and I had a good laugh over his advertisement in the paper. It was just like a circus announcement.

There seems to be a long break in the Morrice-Morris correspondence, which was finally renewed when the former wrote Edmund Morris from Paris in January 1907.

I had intended writing you a letter before now to acknowledge receipt of your catalogue. I am sorry I couldn't see your exhibition, hope you made some good sales. You know I am back again in Paris, busy at present with my Salon pictures – must make a good show this year. Cullen is over here. He is now down at Pont Aven or Concarneau. I suppose you are sending to Buffalo. I have just received an invitation so will send something. I noted in your catalogue that one of the pictures belonged to E.F.B. Johnston. I knew him when he lived in Toronto, give him my kindest regards next time you see him. Edmund Osler is also a good judge of pictures. Let me know how you have done in sales. I have been thinking of sending some work to Toronto. Paris is the same. I am living the same monotonous virtuous existence.

Sir Edmund Osler was a politician, bank president, and distinguished citizen of Toronto, and E.F.B. Johnston was a noted criminal lawyer and collector of Barbizon and Dutch-Hague School pictures. He also wrote articles about them.

The last sentence shows that in his own low-keyed and witty way Morrice knew that his life had little in common with many of the artists around him – certainly little in common with the sexually flamboyant lives of some of his younger artist acquaintances. His own existence remained serene and uneventful, the quiet Canadian in Paris who shared a portion of his life with the undemanding Léa Cadoret.

On July 1, 1907, Morrice writes again, accepting an invitation by Morris to became a member of what became a significant new art organization – the Canadian Art Club.

I shall be glad to become a member of your society and will send as many masterpieces as possible. The idea appeals to me, but you must keep the number of members limited, I think, and no amateur work.

PLATE 64

The Place St. Michel

c. 1905, Panel 5″ × 6″

Several young ladies are sitting under the awning in the sidewalk section of the restaurant Lapérouse on the Place St. Michel looking towards Notre Dame. This was one of two pictures a former president of the Art Gallery of Toronto, William Finlayson, once owned. He presented the other to the Toronto Gallery in 1957.

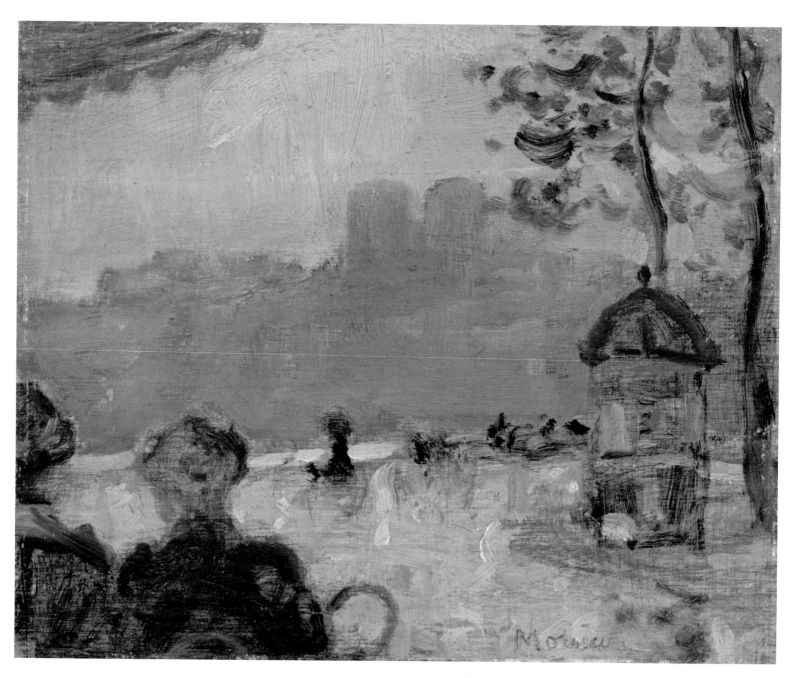

PLATE 64

Six months later on December 15, 1907, he informs Edmund Morris:

I am sorry I won't be able to be over for Christmas. The measles have left me rather weak and I am afraid of crossing the Atlantic at present, but will probably come next month. It is too late to send my pictures now from Paris and I have written Scott of Montreal and told him to send a picture he has to Toronto.

The Canadian Art Club was founded in Toronto in 1907, by a group of Canadian-born painters and sculptors, and a selected number of business, professional, and financial leaders. The inaugural exhibition was formally opened by the Lieutenant Governor, Sir Mortimer Clarke, in February 1908.

D.R. Wilkie, the Honorary Club President, was seriously considering the purchase of Morrice's *On the Cliff, Normandy*, and Morrice comments:

I don't think $500. is too much for it as it is one of my best things. I have three pictures in the International in London and am working on my Salon pictures. I suppose Williamson [Curtis] *will let me know. By the way you got the title of my picture wrong, it is "On the Cliff, Normandy" and not "Morning off the Coast of St. Augustin."*

Then he asks vaguely, "Where is St. Augustin?"

The Canadian Art Club exhibitions were regarded by the press and Toronto's small but active art community as important artistic events. However, the actual sale of paintings the club made over the years was pitifully small.

On the following day, February 22, Morrice again wrote to Morris:

I noted the subscription to the Club has been reduced to $25. which is not to be regretted. I wrote my brother [William] *in Montreal asking him to send $100. which I suppose he has done, so the secretary will send him back the $75. I think my picture* [On the Cliff, Normandy] *ought to sell for $500. but I will take $400.*

This is a rare example of him reducing a price, but he added with conviction:

We must keep up prices. It is better not to sell at all than very cheap unless absolute poverty is in your face. I have been made a member of the Société Nouvelle, the principal members are Blanche, Cottet, Simon, Dauchez and La Touche. We have an exhibition next month.

The men he mentioned were highly important figures in the Paris art scene of the day.

PLATE 65

A Roadway, Barbados

1921, Watercolour 8″ × 13″

One of a group of significant but small watercolours Morrice painted on his final trip to the Caribbean in the winter of 1921. Figures enveloped in white garments are walking toward the spectator along a sandy roadway while a hazy tropical sky and the dusty road attest to the heat. On the left a tall black figure stands in front of his small house with its sagging roof. The scene evokes a feeling of poor and indolent living in the tropics.

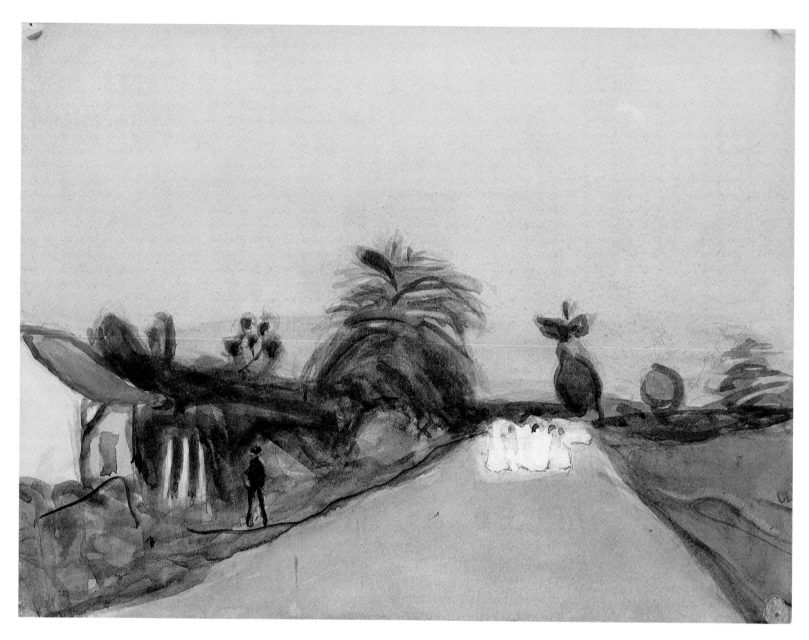

PLATE 65

At this particular period in Morrice's painting life, he was a member of many clubs and art societies in Europe and North America. As mentioned earlier, this may have been a reflection of his Canadian upbringing in general and his Westmount background in particular, for French artists rarely had the same inclination.

Morrice shows his curiosity, perhaps tinged with a touch of apprehension, regarding the success of the first of a series of eight annual Canadian Art Club shows beginning in 1908 and ending in 1915.

How was the exhibition? I got a catalogue all right – but what was the average appreciation of the pictures in Toronto?

In another letter from Paris, he wrote to Morris on April 5, 1908:

In your last letter you said that this summer you intended going west to paint the red-skins – the Sioux Indians, and that you had done the same last year. Now I should like very much to go with you if it is agreeable to you. The change will be good for me.

He was still not feeling himself after a serious bout of the measles during the previous winter. He had spent precious painting time convalescing in a Paris hospital ward in isolation. He continues:

The prospect of painting something so entirely new is extremely fascinating. Let me know at once when you intend going and how do you live? Do you camp out, or what? . . . Let me hear from you at once. My regards to [Curtis] William-son and tell him an Austrian Count was asking for him the other day.

Sometimes Morrice could be forgetful about the contents of letters he had recently written. For example, only three weeks later, on April 26, 1908, he wrote as if for the first time to Morris on the subject of a trip to western Canada. Perhaps his mind had been clouded with too much alcohol when he wrote the earlier letter.

Unfortunately, the trip never took place, either as a result of his illness or because he had lost interest in it. But it startles the imagination to think of what colourful figure studies of the Indians might have resulted had Morrice made the trip with Edmund Morris. It surely would have added something of a new dimension to Canadian art.

From his father's house on Redpath Street in Montreal, Morrice wrote to Edmund Morris in February 1909:

I write this hasty note which my brother Arthur will take up to Toronto to-night. I am expecting a number of pictures, fourteen, from Paris but they have not

PLATE 66

A Brittany Estuary

c. 1905, Panel 9¼″ × 13″

A smaller version on panel of the canvas bought by the voracious Russian collector Sergio Morosov, probably from Morrice himself in Paris about 1907. It represents a narrow stretch of an estuary with a figure at the oars of a small boat rowing towards the opposite shore. A white sailboat appears near the beach and one can see the hilly shore beyond. Other boats are anchored nearby. Again Morrice's pure and personal colour sense has created an astonishingly original work of art. When the Russian government confiscated the Morosov collection in 1918, the larger version of this painting went to the Hermitage in Leningrad where it remains today as one of two works by Morrice in that museum. The other canvas is Fête Montmartre.

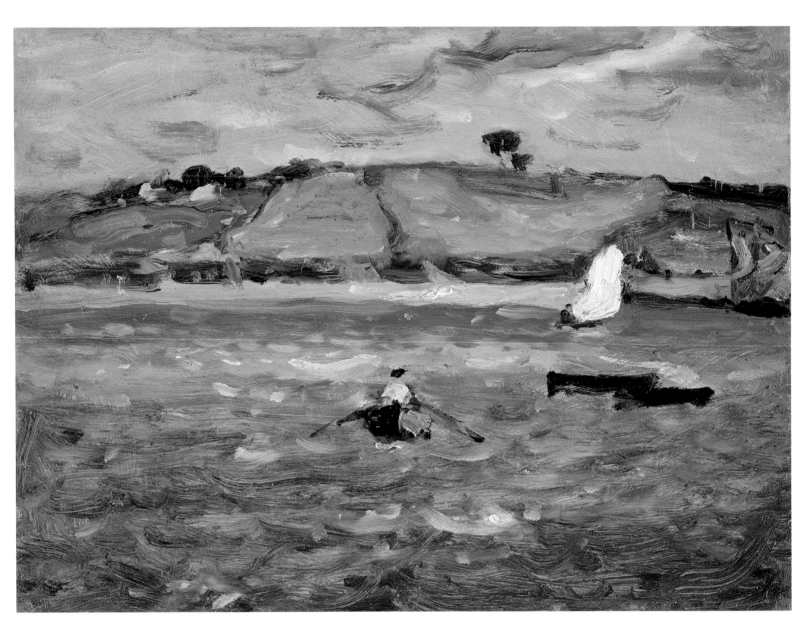

PLATE 66

arrived. Would like to have them exhibited at the Club in Toronto and will let you know.

Fourteen was an extraordinarily large number of paintings for Morrice to have on hand at one time for exhibition purposes. But at this period of his painting life, it is clear he still considered his Canadian Art Club showings important.

Later in the same month he again wrote to Morris from Redpath Street:

I went out to the Montmorenci Falls and stayed three days at the Kent House and got some good sketches. My pictures have arrived from Paris and to-morrow I intend showing them to the "art critics" here, Sir William Van Horne, R.B. Angus and others and then I shall bring them up to Toronto next week. . . .

In late February 1909, he was still in Montreal and wrote Morris:

You will see me turn up in Toronto Thursday in the afternoon. Could you come down to the Queen's Hotel about 5:30 if you have nothing else to do. I have had some success with my pictures here – four sold and one to the Government – which shows they are beginning to appreciate good things.

He doubtless wanted to celebrate his own good fortune by having a few drinks with his friends at the Queen's.

In the same letter, Morrice suggests to Morris that either he or Curtis Williamson invite Clarence Gagnon to send his etchings to the club show.

The invitation was duly sent to Gagnon, and the latter showed nine of his splendid etchings of French and Italian subjects at the Canadian Art Club exhibition of March 1909. This is yet another example of how Morrice helped Canadian artists.

In May 1909, Morrice again wrote to Morris from Paris, encouraging him to send some of his Indian pictures for exhibition at the Salon d'Automne in Paris. But in the interim, the Government of Ontario bought Morris's collection of Indian portraits, which are now housed in the Royal Ontario Museum.

Morrice wrote to Morris from Paris on January 30, 1910:

I came up to Paris from Concarneau a week ago only to get into this fearful flood. The Quai des Grands Augustins where my studio is, is now a lake. I have to sleep in a hotel and take a boat every morning to my studio. It looks exactly like Venice but although picturesque is anything but pleasant and I shall be glad when the water goes down. The city is in a fearful state and it is almost impossible to get about. . . it will be a bad year for selling anything here as

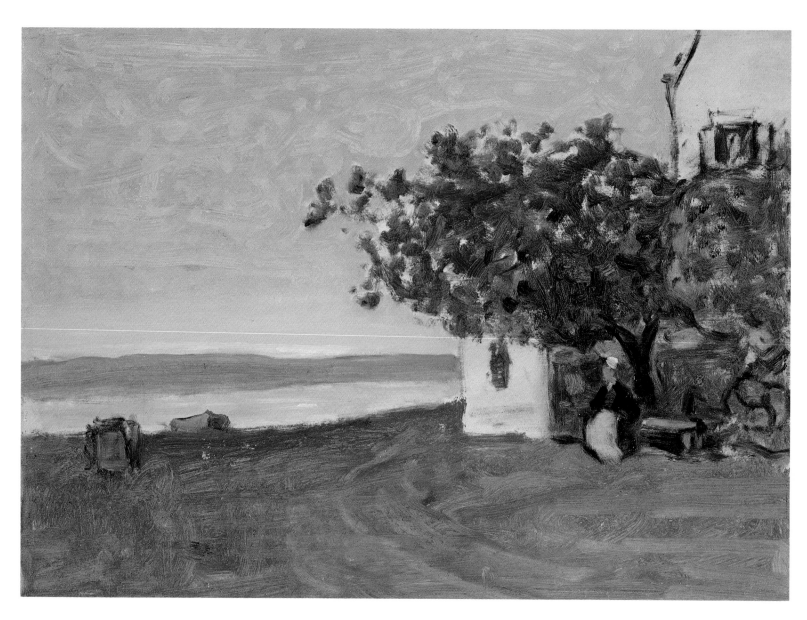

PLATE 67

there has been so much financial loss. . . . There is a fine show of Cézanne's pictures on now. Fine work almost criminally fine. I once disliked some of his pictures but now I like them all. His is the savage work that one would expect to come from America. But it is always France that produces anything emphatic in art.

There is a wonderful photograph of him at this time treading on some wooden planking because of the high waters. He gingerly balances himself, while stepping from a small rowboat in front of the restaurant Lapérouse to gain access to his nearby studio.

Although Morrice was a man of strong convictions, he usually said his piece calmly. For example, he wrote to Morris on January 9, 1911, about an historic exhibition in London:

There was some excitement in London last month over the exhibition called the "Post Impressionists." Everybody laughed and jeered but with a few exceptions it consisted of good things – Art that will last. I may send to the New English Art Club this year instead of the International but not decided yet.

These comments are all the more impressive when it is remembered how controversial and daring the show was. The title was "Manet and the Post Impressionists." It was the first group exhibition of its kind anywhere, and was organized by the artist-historian Roger Fry, who coined the phrase "Post Impressionist." The exhibition took place at the Grafton Galleries, London, from November 1910 to January 1911, and included great examples by Manet, Gauguin, Van Gogh, Cézanne, Seurat, Redon, Picasso, Matisse, and others. Morrice was clearly in the vanguard of those recognizing the excellence of such contemporary masters.

Three other letters are on file in the Edmund Morris collection at the Art Gallery of Ontario: two from Morrice's father and the third from his father's secretary. By now, David Morrice realized that his son had become relatively famous in the international art world. In his letter of March 22, 1911, David Morrice wrote to Edmund Morris:

I am sending him [James] a copy of your letter so that he may also see from outside sources that it would be distinctly in his interest to send out more of his important work to Canada, than he had been in the habit of doing. Of course he cannot altogether be blamed for this, as up to a comparatively recent date his work was not recognized to the extent it is to-day. This did not arise from quality, but his style of painting is peculiar – distinctly his own, and in a community like Montreal and Toronto both of whom are young insofar as art is

PLATE 68
Fishing Boats, Concarneau
c. 1910, Panel 5″ × 6″

Figures stand on the docks where several fishing boats are moored. Opposite is the vague shoreline and a setting sun casts horizontal reflections well into the centre of the harbour. Concarneau was a favourite painting place for Morrice and, around 1910, he had a studio there.

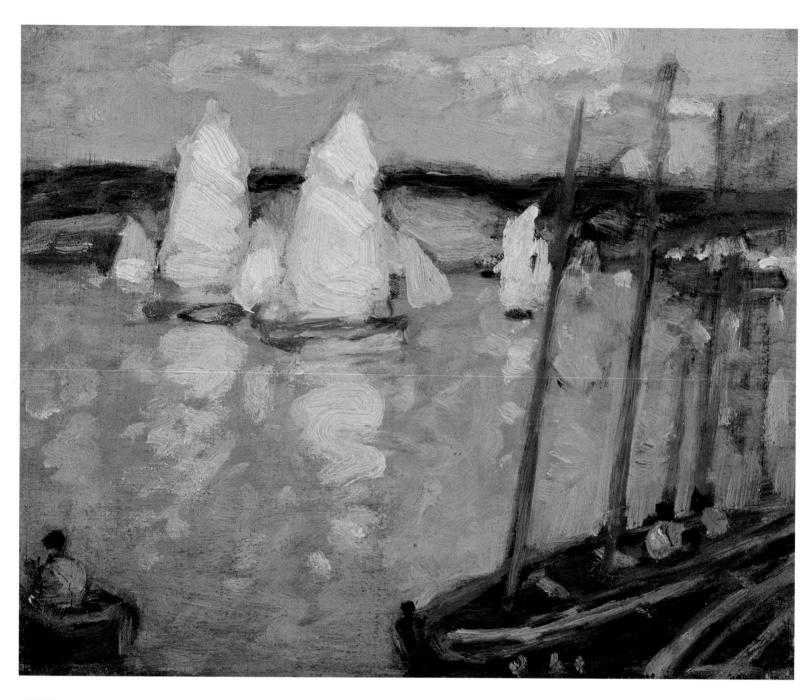

PLATE 68

concerned, they have not been accustomed to regard work simply on its merits: they looked, and still do to-day for something more pleasing to the general eye.

Despite the fact that David Morrice regarded his son's work as somewhat "peculiar," it was important, and admirable, that he gave him such strong support.

Even if James's life in Paris seemed strange and remote to his father, there is little doubt that David Morrice's decision to become a major contributor to the new Montreal museum was a result of the pride he felt in his son's international success as an artist.

By February 12, 1911, it seems Morrice was feeling rather despondent, and had become quite indifferent to the idea of sending paintings to the Canadian Art Club exhibitions. He wrote to Morris:

It will be impossible for me to send over six of my better pictures as you suggest. I have just sent two to Bordeaux and two to Nantes and have to send to the Société Nouvelle next month. (This is always my most important exhibition), also to the International in London and afterwards to the Salon. Besides I am becoming doubtful about the advisability of sending pictures to Toronto. Nothing is sold (except to our excellent friend MacTavish) nobody understands them and it involves a great expense. I have not the slightest desire to improve the taste of the Canadian public. . . . I am sending a picture to Pittsburgh to-morrow so you can easily understand I can't send my best pictures to Toronto.

The mood of the letter is petulant, which may give insight into a growing dissatisfaction with the results of the Canadian Art Club exhibitions. There is also much about Morrice that might suggest a man capable of petulance. Nonetheless, while he might say that he had no desire to improve Canadian taste, he continued to do so simply by showing his pictures.

Morrice writes to Edmund Morris from Paris in April 1911, recording his pleasure at seeing Ernest Lawson become a painting member of the club, and goes on to express his disgust with the offensive attitude of certain art critics.

I was glad you made Lawson a member, he is a good painter and an old friend of mine. We have had lively times together in New York. I was also glad to know one of my pictures was sold. You called it the Dutch Pier. It is not in Holland but at Le Havre in France. I saw Horatio Walker and found him in good spirits. I see he has sold a picture to the Canadian Government. I have two things at the International – one a figure is considered indecent by the art critics – they must have dirty minds. . . .

PLATE 69
The Portal, Marrakesh
c. 1910, Panel 5″ × 6″

Three Arab figures in white dominate the right foreground. A black-clad figure stands to the left while a crowd of people are converging on a pink-topped archway opening into a bazaar or casbah.

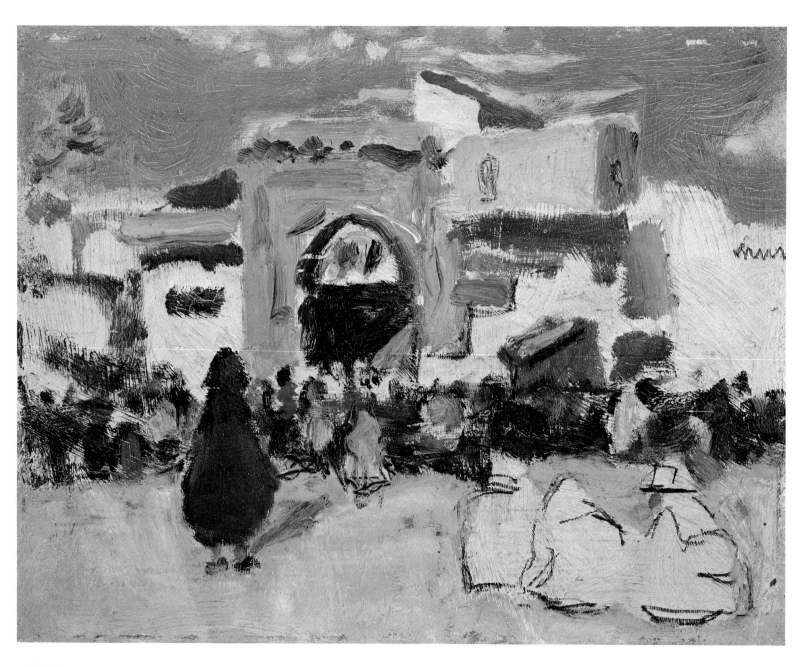

PLATE 69

And in a flight of whimsy Morrice writes to Morris on June 20, 1911:

Why not get a pretty typewriter girl – a blond – and have her ready for me when I come over?

The new gallery is being built in Montreal and I must paint something for it. The Salon this year was not interesting but there have been a number of good shows of modern men who are practically unknown – particularly Bonnard who is the best man here since Gauguin died.

But there was one contemporary art style Morrice had no use for. In November 1911, Morrice wrote to Morris:

Nothing new here except the pictures of the "Cubists" at the Salon d'Automne. This new art I am incapable of understanding.

Morrice's reaction was shared by pre-eminent contemporary critics like Louis Vauxcelles and Franz Jourdain. There was something about the Cubists that was the antithesis of his own floating forms and melodious palette.

He wrote to Morris from Quebec City on January 14, 1912:

I arrived here a couple of days ago – a wonderful old place this is. I am coming up to Toronto before the end of the month. . . . I sail for Gibralter on the 3rd of February. The Duke of Connaught is to be received by the Mount Royal Club on the 8th of February and there will be a room of Canadian pictures to honour him. To this room I will contribute so that I won't be able to send all my pictures to the Club but will send as many as I can.

In general he had little use for things English except well-tailored tweed suits. But he appears to have respected the Royal Family and the institution of the Monarchy. This was probably the influence of his strict upbringing in English-speaking Montreal.

Morrice's correspondence with Edmund Morris continued until April 1913. Then a few months later on August 21, 1913, Morris drowned in the St. Lawrence River, while visiting his artist colleague Horatio Walker at his extensive house and gardens on the Ile d'Orléans. His tragic death cut off yet another of Morrice's close links with Canada.

The other individual in Toronto with whom Morrice had an intimate association was Newton MacTavish.

Newton M. MacTavish (1877-1941) was editor of the *Canadian Magazine* for twenty years, from 1906 to 1926. His correspondence with James Morrice

PLATE 70

The Beach, St. Malo

c. 1900, Canvas 15³/₁₆″ × 21⅞″

One of the artist's most richly coloured works. Several beach tents are anchored in the sand beneath the ramparts of St. Malo. Many figures, some with red umbrellas, are sitting or standing, enjoying the warmth of a sunny summer day. A Breton woman has spread out a series of white sheets to dry on the sand. The sea is a deep indigo-blue and three white boats can be seen sailing near a distant shore.

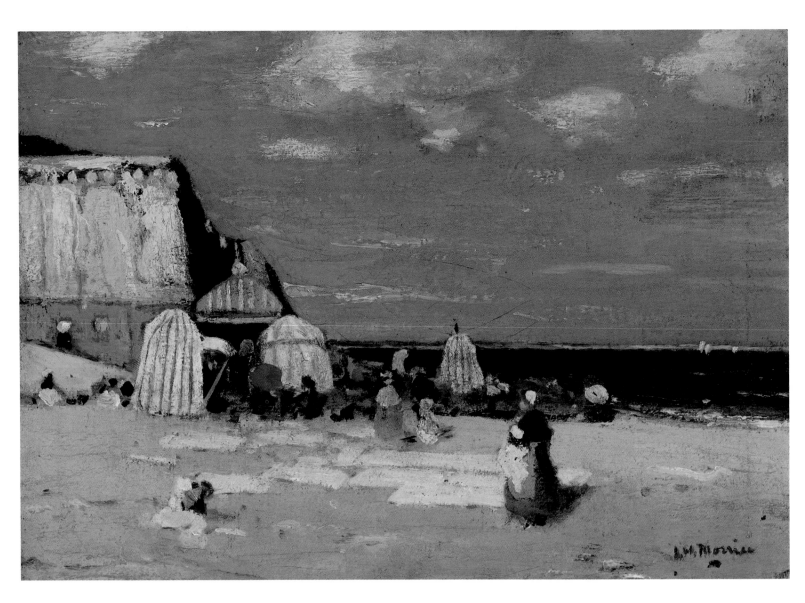

PLATE 70

is spread out thinly from March 1909 to December 1914. At least that is the period covered in Morrice's surviving fifteen letters to him. They are full of the artist's pithy comments and views on art and life.

MacTavish wrote the first literary and comprehensive book on Canadian art, *The Fine Arts in Canada*, published in 1925. He said of Morrice: "Considering his recognition both in Canada and abroad, he might be regarded as the most distinguished Canadian painter." MacTavish was among a limited number of cognoscenti in Toronto who fully appreciated Morrice's work and proved his deep interest by buying some panels for himself.

MacTavish was also an able interpreter of Morrice's painting qualities to other potential patrons, few as they were at the time. For example, it is almost certain that MacTavish convinced D.R. Wilkie to buy *On the Cliff, Normandy* in the Canadian Art Club exhibition of 1908. He encouraged Senator A.C. Hardy to acquire *The Jetty, Dieppe* in 1911. In addition, we know that Alfred B. Fisher, the Toronto fabric importer, consulted MacTavish before he bought *The Promenade, Dieppe* at the 1914 Royal Canadian Academy exhibition of art in aid of the Allied cause in the Great War.

Newton MacTavish was certainly my earliest mentor in Canadian Art. He was Canada's pioneer art historian and personally knew nearly all the Canadian artists and art patrons of his time. I first met him in 1934, at the opening of our historic James W. Morrice exhibition.

Unfortunately, from the mid-1930s on, MacTavish's health deteriorated badly. He suffered from a serious nerve disorder that caused his walk to become a mere shuffle. Moreover, he needed money, and sold us two of his lovely Morrice panels that he had bought in Canadian Art Club exhibitions more than twenty-five years earlier. One was *The Beach, St. Malo*. Then a month or so later, we also bought *Venice, the Grand Canal* from him. Morrice describes the occasion of painting this picture in a letter to MacTavish in February 1910. After referring to the lack of sales in the current exhibition at the Canadian Art Club, he wrote:

> *The glory of this thing is evidently not of a financial character. But you, I am told, have set a noble example by buying one of my panels - a very good one it is. I remember well the evening I painted it at the Café Oriental and Joseph Pennell was sitting next to me drinking his second absinthe.*

But he doesn't mention how many absinthes he had himself! There is throughout these lines a touch of Morrice's elegant, sometimes prim humour. A wit that is often at his own expense.

The first Morrice-MacTavish letter we have on record is dated March 24, 1909. Its main thrust concerns payment for the Paris art critic Louis Vauxcelles,

PLATE 71

Yachting Near St. Malo
c. 1902, Canvas 15″ × 18″

Here a yacht race is in progress off the coast of St. Malo. The artist is a spectator looking from midship towards the stern where several other spectators, one of whom holds a crimson parasol, are enjoying the regatta. Beyond the many sailboats the Brittany coast can be plainly seen.

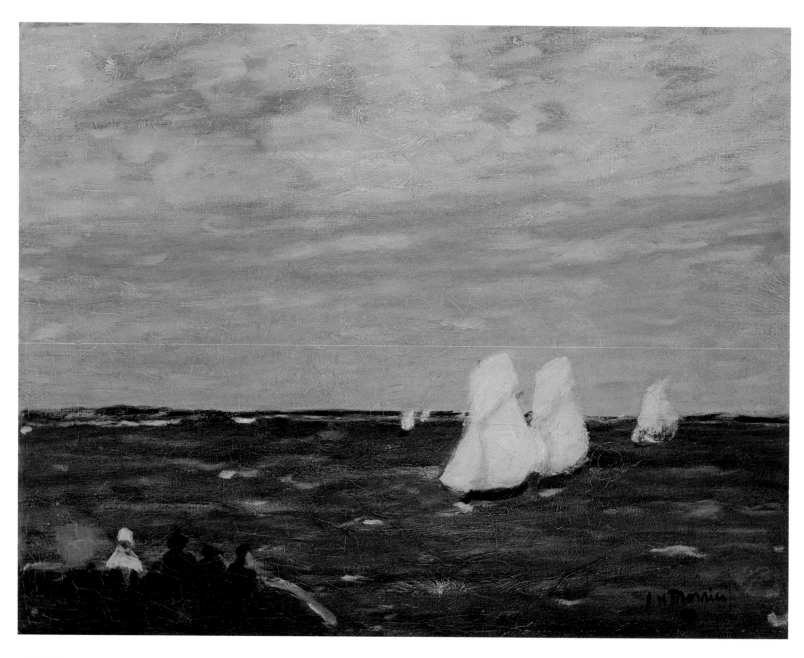

PLATE 71

who wrote a glowing account of Morrice's work for MacTavish's *Canadian Magazine*, a publication dealing with arts and letters of the time.

I got your letter. You are quite right. Keeping the brains open is easy but the head is difficult to keep cool. I am writing this in the Café de la Paix near the Opéra. Bitches all around me and men drinking absinthe which maddens me because I'm not allowed to drink it anymore. . . . I think you had better send M. Vauxcelles what you are in the habit of giving for similar articles. Otherwise you understand, our relationship will be considerably strained – at least for some time.

This remark understandably upset MacTavish. But Morrice probably didn't mean to hurt his feelings, it was just part of his Scottish Westmount nature to take the direct approach.

On November 7, 1909, he commends MacTavish on a piece he wrote for the magazine:

Your article about Canadian artists is excellent – too flattering in regard to my work, but an excellent protest to absurd criticism. I was glad to read it because in Montreal particularly, Canadian art is considered of no importance.

The reproductions of my pictures you have sent me are excellent. I am sending out six pictures to the show. . . . I have not seen Vauxcelles but no doubt he has received his cheque. By the way, Morris in his last letter seemed to think I had offended you. If so, I assure you it was not intentional in any way.

Vauxcelles asked me several times about the payment for his article and so I decided to mention it to you. . . . I am leaving Paris in a few days for Brittany where I shall spend most of the winter away from the maddening [sic] *crowd.*

On December 3, 1909, Morrice writes to MacTavish from the Grand Hôtel des Voyageurs, Concarneau:

I expect to see the Xmas number of your magazine soon. I have a capital studio with nothing in front of me but the sea, a change from Paris and its autos. I have sent 6 pictures to the Club not so important as last year but they represent my work well.

On December 23, 1910, in another letter to MacTavish we find Morrice back in his Paris studio at the height of the great flooding of the Seine.

[Edmund] Morris writes me in his own intelligible way there will be an exhibition at the Club in January or February. I will send over a picture or two although the prospects of selling in Canada are not promising. As you say these

PLATE 72
The Beach, St. Malo
c. 1901, Panel 5″ × 6″

It is high summer and the beach is covered with sunbathers and beach tents. A corner of the great rampart looms up on the right, and the white-accented buildings in the town strongly reflect the light from the beach and water.

178

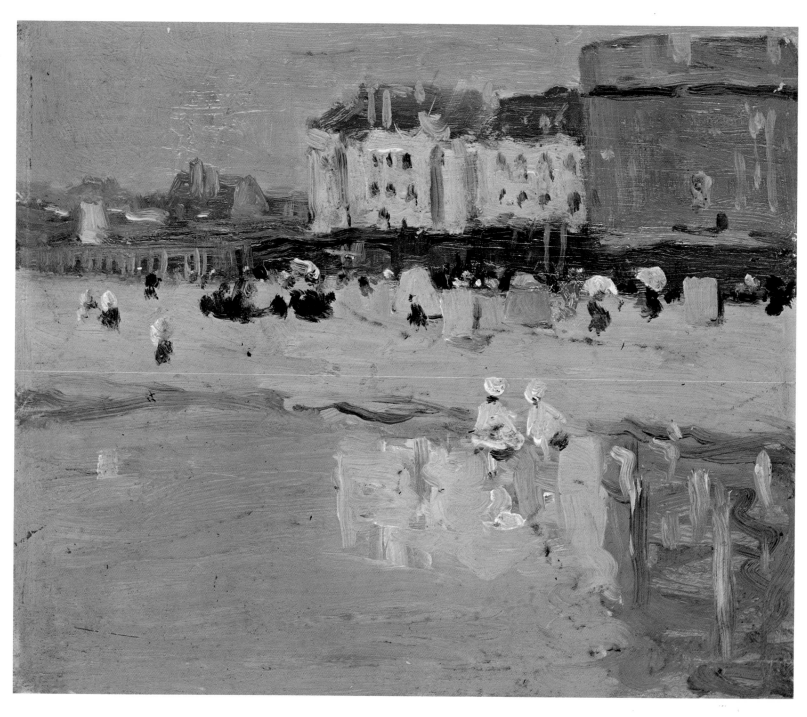

PLATE 72

English dealers, with their ghastly monochromes have poisoned everything. Healthy, lusty colour which you see in Canada is no doubt considered vulgar. Cullen, I see from the Montreal papers, has painted a good picture of St. John's, Newfoundland. He is the one man in Canada who gets at the guts of things. Our excellent friend Vauxcelles has become very important and is now lecturing on art in one of the academies of painting.

His enthusiastic comment on Vauxcelles points up the high regard in which he held this critic's taste in art.

Louis Vauxcelles, whose real name was Louis Mayer, was born in Paris in 1870. By 1900, he was active as a critic in many of the French art review journals, including *Gil Blas*. Morrice considered him among the best of the art critics.

As has been noted, it was Vauxcelles who coined the word "fauve," referring to a group of French painters in 1904 and 1905, who were associated with Matisse and worked in bright clashing colours.

Vauxcelles was also a connoisseur of music, and encouraged great musicians like Debussy and Ravel to perform during musical evenings in his Paris flat. Clearly, this would appeal particularly to James Morrice and was another reason for their friendship.

After a long break in the correspondence, seven short Morrice-MacTavish letters were written, all dated during 1915. The first came from the Morrice family home in Montreal, where two of his brothers still lived. He mentions the dealer-connoisseur John Ogilvie, whom he affectionately refers to as "Uncle John." Morrice had recently painted a sketch portrait of John Ogilvie, which he then had photographed by Notman's.

On September 13, 1915, Morrice wrote MacTavish to say he was sending over a number of photographs, including some "figure work," which he wanted to have reproduced. He mentioned an article which appeared in a Chicago journal by an art critic, a certain Mr. C.L. Borgmeyer.

In a September 22, 1914 letter he bitterly complains about the poor quality reproduction of the John Ogilvie portrait in the MacTavish publication.

And in the final letter on record, dated December 23, 1915, Morrice writes an apology to MacTavish:

. . . to make amends honourably in the photograph of Mr. John Ogilvie. I showed it to my friend and he says that the reproduction is good and better than what one generally sees. So I was hasty in my judgement . . . and forgive the unjust irritability of the painter.

PLATE 73
Le Pouldu
c. 1910, Panel 4¾″ × 5⅞″

This panel was bought from Mrs. Clarence Gagnon, whose husband was a friend of Morrice's. To the right is the seashore and in front a red striped beach hut. In the left foreground two women in Brittany headdress are standing. Beyond are the cliffs with a white house on the crest of the peninsula. This was a little painting that Clarence Gagnon probably got from Morrice in Paris about 1908 in exchange for one of his own panels.

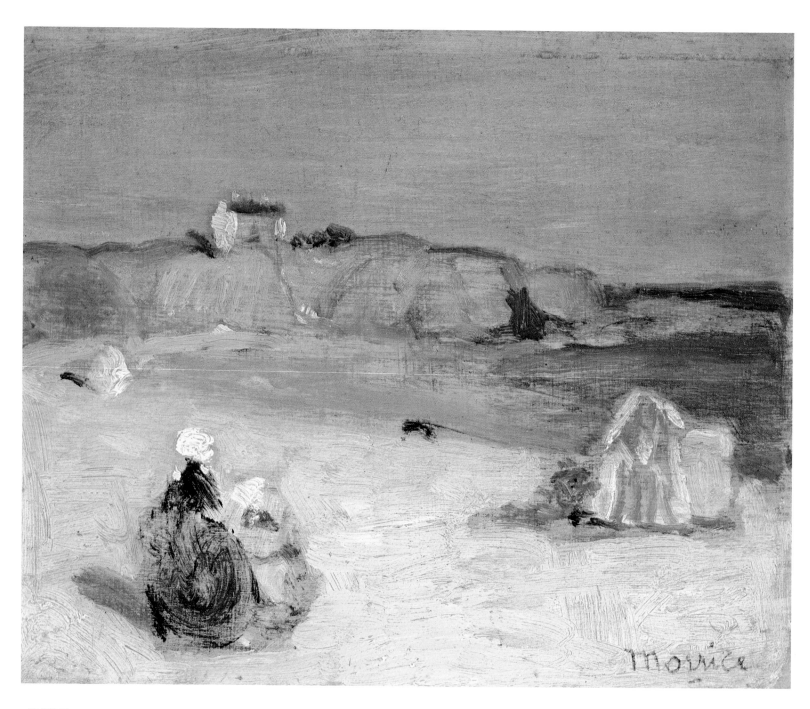

PLATE 73

Both Edmund Morris and Newton MacTavish realized they were corresponding with a talented and highly creative individual, as each of them preserved his letters. Morrice's legal training helped teach him a clarity and conciseness in his writing. His letters were usually incisive, sometimes terse and laconic. They could be aggressive and demanding: regarding an error in the price of a picture at a Canadian Art Club exhibition, he demanded of Edmund Morris, "Will you see this is rectified at once." Occasionally he was petulant: "I am not about to try to improve the taste in art of the Canadian public." His letters could be succinct and forthright, but were usually tempered by his wit. A wary, complicated man, he was parsimonious and congenitally thrifty. And, as we have seen, he could also be forgetful about the contents of a letter he might have sent a few days previously. An absinthe or two, and some wine at a restaurant, where he sometimes wrote letters on the house's fancy stationery, undoubtedly aided this forgetfulness.

The Morrice-Newton MacTavish letters are understandably, both in tone and philosophic content, quite different from those he wrote to his artist friend Edmund Morris. They also show how in tune he was with the views of certain art critics. They reveal the innate pride he had in his own work, and that he knew instinctively that he was a painter of exceptional talent. He cared deeply how his paintings were presented, and was always anxious that his work be well hung in the salons. He was also meticulous in providing the best photographs available for use as reproductions in various publications.

MacTavish's friendship for Morrice, and his patronage of the artist, are among the former's contributions to the Canadian art world of his time.

PLATE 74

The Prows of Three Gondolas
c. 1903, Panel 5″ × 6″

The artist has again painted a unique and wonderfully satisfying composition. Opposite the gondolas and the shimmering waters of the canal are the Gothic doors of Venetian palaces, reflected on the lagoon waters in golden cadences.

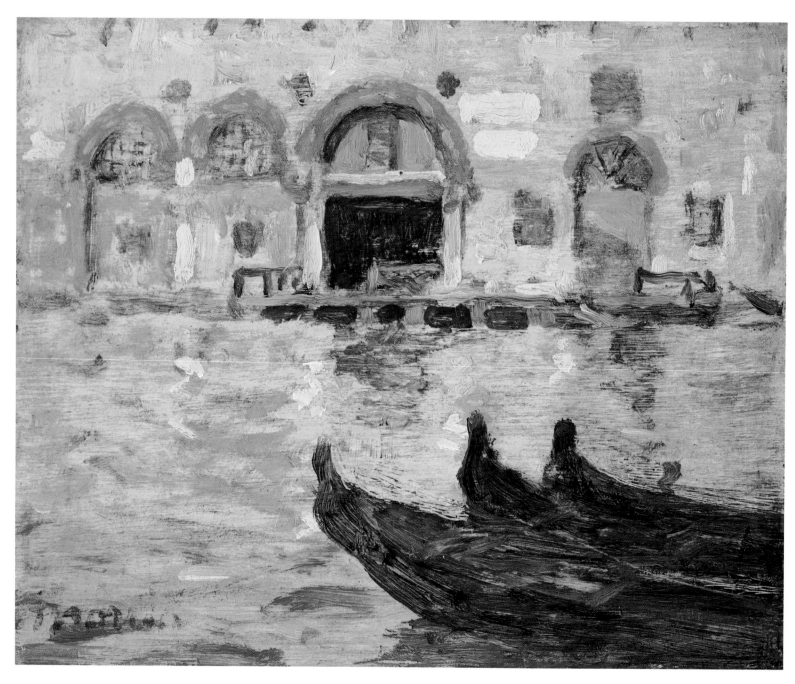

PLATE 74

THE DRAMA
OF DISCOVERY

PLATE 75

A KNOWLEDGE AND APPRECIATION of art is built up by innumerable encounters with works of art – and by spending many reflective moments with them. This is a continuing process of education. It is aided by travel, studying the history of art, and general observation. Alas, opportunities for viewing exhibitions of world-famous masters are becoming increasingly rare. The costs for such exhibitions have become staggering. Moreover, there is a growing reluctance on the part of museums and private owners to lend. Thus it was a privilege to visit the monumental Edouard Manet exhibition at the Grand Palais, Paris, in June 1983. Manet was one of James Morrice's cherished masters, and the spirit of Morrice was my unseen companion as I looked at such masterpieces as *The Boy with Fife*, *Olympia*, and *Bar at the Follies Bergères*, which I knew Morrice had so greatly admired.

The exhibition that marked my life and remains fixed in my mind as clearly today as when I first saw it, was the showing in our own gallery in April 1934 of the works of James Wilson Morrice. And as I write now, 1984 marks the fiftieth anniversary of that occasion. It was the memory of this event that motivated me during the many years following when I searched for Morrice paintings. I resolved that some time or another, if and when I had acquired sufficient means, I would begin to collect Morrices for myself, although it would be a good many years before I was in a position to do so.

I remember when the Morrice collection arrived from his long-time Montreal dealers, William Scott and Sons, and that I was fascinated to glimpse the pictures as they were unpacked. I can recall how the pictures

The Ferry, Quebec
c. 1909, Panel 7″ × 10″

This is Morrice's original sketch for his large and famous canvas of the same title. This panel together with the canvas painted up from it were both in our gallery's 1934 Morrice exhibition. Painted on a trip to Quebec City about 1909, Morrice catches the ferry boat steaming from Lévis to Quebec. It is one of its final passages across the St. Lawrence through the ice floes before Arctic winds completely freeze the mighty river. Here the artist illustrates his keen sense of composition.

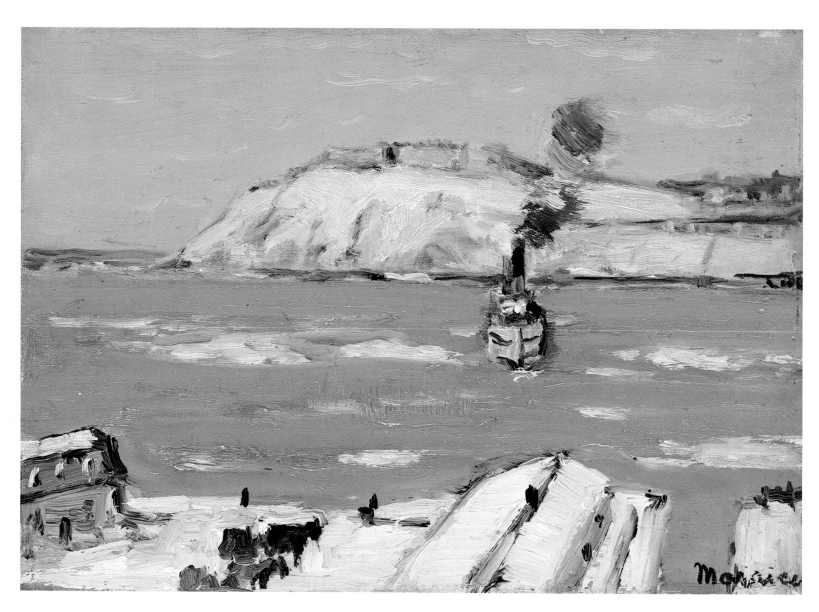

PLATE 75

appeared on the walls glowing under the gallery lights. Although this was my first viewing of the artist's work, I realized I was looking at paintings that were produced by an unusually talented and perceptive artist. In addition to *The Ferry Boat, Quebec* canvas, destined to become one of Canada's most famous pictures, we also had its original sketch-panel version. There was his colourful 1915 canvas *Café el Pasaje, Havana*, and two views of the quais and the Seine as seen from his studio windows, one in spring and the other in autumn. The exhibition consisted of thirty canvases and panels, and twenty-one of his late watercolours. The emotional impact on me was such that in the half-century since, I have increasingly pursued works by James Morrice, and have been haunted by visions of the man himself – a statement I hope that this book bears out.

Our 1934 exhibition was a complete financial failure. Our sales were as poor as they were for Morrice himself during earlier days in Toronto. Despite extensive advertising, few visitors turned up, and no critical reviews appeared.

The sad truth was that during the ten years following the artist's death, his work was all but forgotten. Most people at the time were not even acquainted with the artist's name. They found his style and colour sense difficult to accept. Indeed, from the 1930s until the 1950s, there was literally no market in Canada or Europe for the work of Morrice. However, there were a few individuals who recognized the quality of his paintings. It is an incredible situation in retrospect, but we could have bought out the entire collection of fifty-one works for a total of less than $30,000. Our sole sale was three watercolours to Vincent Massey at a price of $300 – for all three.

Ours was one of the early retrospective exhibitions of Morrice's work held in Canada – a full three years before the National Gallery honoured him with a similar show of its own. But it was scarcely the first of its kind. As early as October 1923, fourteen of his canvases were shown at the Salon d'Automne, arranged by Dunoyer de Segonzac. The pictures were lent by four of the artist's early Paris patrons: Messrs. Rouché, Jourdain, Pacquement, and Schoeller. It was catalogued as a memorial exhibition, carrying the printed statement that the artist had died towards the end of the previous summer. The bizarre situation was that Morrice was still alive during 1923, yet his friends and officials at the Salon were convinced that he was dead. It appears that he had not been seen in Paris for some months, having abandoned his studio on the Quai de la Tournelle without informing anyone but Léa Cadoret.

In January-February 1925, the Art Association of Montreal, appropriately since it was his hometown, held a memorial exhibition of more than a

PLATE 76
Horse and Sleigh, Quebec
c. 1900, Canvas 16″ × 20″

A horse covered with a blanket is hitched to a farmer's sleigh loaded with cordwood. To the left is a log house surrounded by a low wooden fence. In the mid-distance are other village houses. The atmosphere is cold and grey and above is an ominous cloudy sky. The artist has succeeded in capturing the mood of a small habitant village on the St. Lawrence's north shore in the depths of winter.

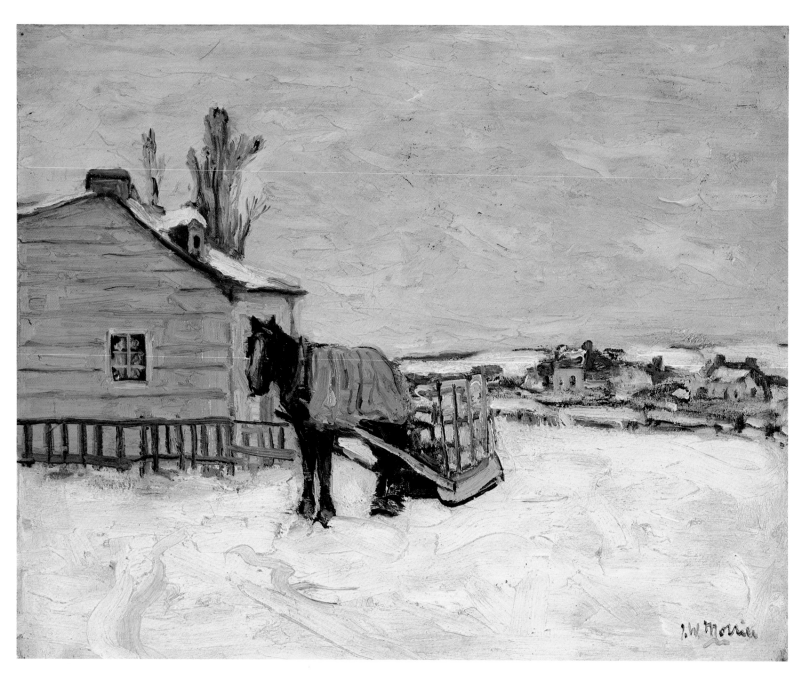

PLATE 76

hundred of his canvases and sketch panels. Many were borrowed from the artist's family and his estate. The names of the other lenders read like a veritable *Who's Who* of English-speaking Montrealers.

There was another Morrice memorial show in 1926 at the Galerie Simonson in Paris. M. Simonson was an admirer of Morrice's work, particularly his later Caribbean subjects. The following year, in 1927, there was a retrospective of fifty Morrice paintings at the Musée du Jeu de Paume, Paris. This included a general exhibition of Canadian art sponsored by the National Gallery of Canada and the French government.

Years later, in 1968, an exhibition of paintings by James Wilson Morrice was held in Paris and Bordeaux. The distinguished painter, Dunoyer de Segonzac, had this to say about him in the catalogue preface:

Although I have not seen his works for nearly fifty years, the memory and rare talent of the painter James Morrice remains strong in my spirit and memory. I discovered him when I was very young while at the Salon de la Société Nationale des Beaux Arts at the Grand Palais, Paris. I was struck by his remarkable sensibility as a colourist and the subtle character of his pictures, joined with a freedom of expression which contrasted so often with the conventional works surrounding him. His talent, very free and personal, approached that of his contemporary Pierre Bonnard. Along with those qualities he brings a poetic feeling of the landscape like that of Sisley, notably in his winter landscapes. The exhibition at the Galerie Durand-Ruel, whose name is intimately associated with the Impressionist School, places in its true place the painter from beyond the Atlantic, the spiritual brother of Claude Monet and Alfred Sisley.

High praise indeed for one artist to extend to another!

Morrice introduced the Post Impressionist style of painting to Canadian art. He was the first Canadian artist to paint the villages of rural Quebec in the Modernist manner. In the late 1890s, he dearly loved the challenge of sketching in winter, even when the temperature fell below zero while he painted the horses and sleighs of old Quebec in his characteristic style. Maurice Cullen, whom he first met in 1897 while sketching at Sainte Anne de Beaupré and Quebec City, followed in his footsteps. Morrice also exerted significant influence on a number of younger Canadian artists of the time, including A.Y. Jackson, John Lymon, Clarence Gagnon, and Albert Robinson. Strange to relate, Jackson, who had spent several years studying in Paris before 1910, never met or knew Morrice personally. At least he never mentioned the fact in his letters or book. He apparently first saw

PLATE 77
The Sea Jetty
c. 1908, Panel 4⅞″ × 6″

The artist enjoyed watching people, particularly ladies in large hats, promenade along sea jetties. White sailboats and the sea lend a coolness and vibrancy to the picture.

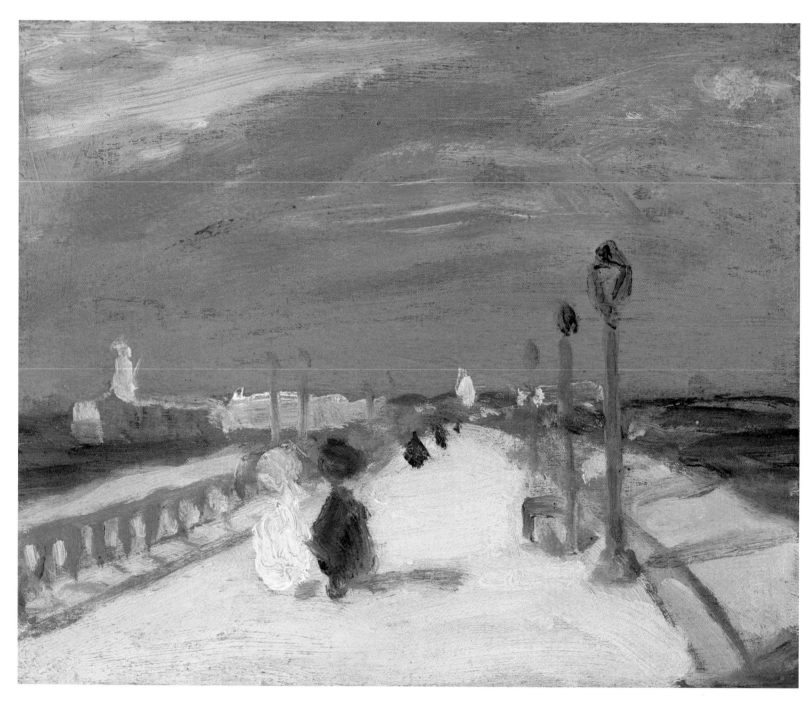

PLATE 77

Morrice's pictures in exhibitions at the old Montreal Art Association before the First World War.

At no time in his career was Morrice a highly productive artist. When at home in his studio, he sat working patiently and slowly. For the nine years from 1915 until his death in January 1924, his production was woefully small. Perhaps the tragedy of James Morrice's life was that he grew old too young. Yet even after the age of fifty, weakened by the effects of alcohol, he still found the inspiration and energy to paint a few more memorable works. At the most, he completed twenty-five canvases over those last years. During his entire painting lifetime, he probably produced no more than 230 canvases, including some unfinished work and several others that remain untraced. There exist about thirty canvases of Canadian subjects, many of which are snow scenes, reflecting his winter stays in Canada. Of panels both small and medium, there would be scarcely more than five to six hundred.

In the early 1890s, he used a type of hardboard and also canvas-covered boards, especially manufactured for the artist's use. He painted on various size rectangular wooden and cardboard panels, but seldom did his panels exceed 10″ x 15″ in size. By about 1898, the artist's favourite size became much smaller, which suited his style perfectly. He preferred his 5″ x 6″, or even the 3″ x 6″ blond wood panels that slipped neatly into a flat carrying case. These, along with some fine sable brushes, and a "made-out" palette, fit easily into his tweed jacket pocket. Clarence Gagnon got the idea of using small-size panels from Morrice in Paris about 1906. These panels were considerably smaller than the 8½″ x 10½″ outdoors sketch panels that Tom Thomson, A.Y. Jackson, and J.E.H. MacDonald favoured a decade or so later.

During his painting career he left nearly all of his sketches unsigned. If he sold one and the buyer requested a signature, he would sign it. He considered his style so personal (and it was) that a signature was unnecessary. When he did sign, it was either "Morrice" or "J.W. Morrice" and usually with a flourish below his name.

My search for works by Morrice gradually grew over the years and it would be impossible to recount all the stories in one book. But one of my interesting searches centres around the distinguished family of J.M. Rouché. It was about 1902 that M. Rouché, the erudite aristocrat, became a patron and friend of Morrice. He was one of the most prominent figures in the art and musical world of Paris during more than the first third of this century. Rouché was appointed director of the Paris Opéra in 1914, thereby realizing

PLATE 78
A Brittany Town
c. 1906, Panel 5″ x 6″

Several groups of black-robed Brittany women wearing their distinctive white headdresses are chatting in the town square. A little white dog enlivens the foreground. Like the majority of Morrice's figure groups on streets, squares, the beach, or elsewhere, faces are hidden or submerged. The true to life quality of the people in these groups is expressed entirely by their posture and attitudes.

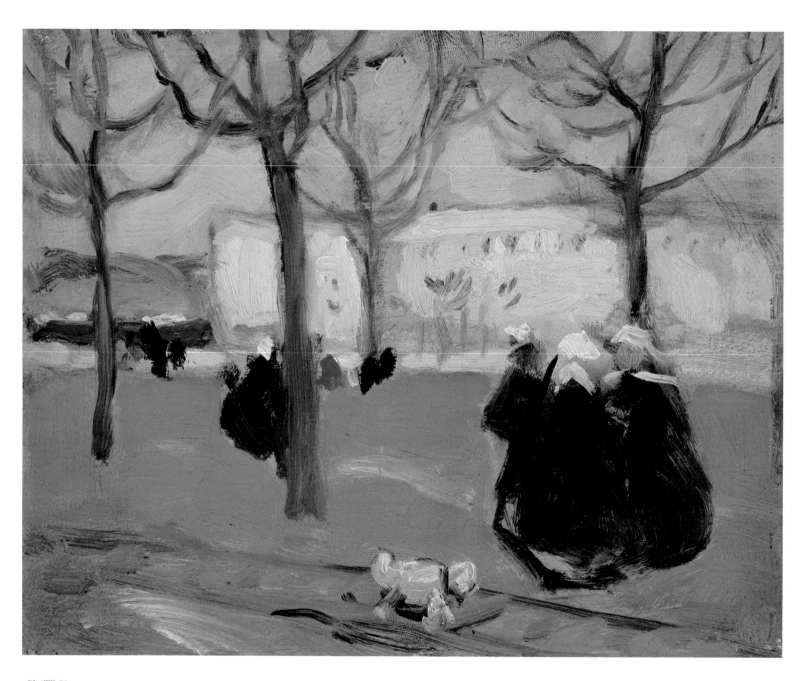

PLATE 78

a long personal ambition. Rouché, who retained that position for more than twenty years, until 1936, was an artistic innovator.

On trips to France during the 1950s, I found Paris the best place to buy good French art. Prices were low and relatively stable. French dealers and private owners were then willing to sell some of their fine pictures. At the same time, in the United States, works of the Impressionist and Post Impressionist schools were becoming more sought after and the prices rose. The American dealers found a ready market and bought quantities of good French art to sell in America. The Canadian market lagged far behind.

One day in 1957, while visiting my Paris friend Paul Brame in his second-floor gallery on the Boulevard Malesherbes, I asked if he thought it was possible to make arrangements for me to see the Rouché collection of Morrice paintings. By the mid-1950s we were buying a considerable number of French works of art from the Brame family firm and found both Paul and his son Philippe most agreeable and reliable to work with. We acquired jewel-like studies of circus girls and clowns by Georges Rouault; fauve works of Paris bridges by Albert Marquet (some reminiscent of Morrice's paintings); intimate interiors by Edouard Vuillard; drawings of circus horses by Toulouse-Lautrec; and other works by French masters.

Paul Brame agreed to seek permission from one of the Rouché daughters to visit the old mansion on the exclusive rue de Prony. When we arrived at the gates I was shocked by the neglected condition of the entrance: weeds and overgrown shrubs had completely taken over the front garden. We were greeted tentatively at the door by one of the old retainer-servants. I soon, however, had an opportunity to look around the house. Its interior was also in shambles. The Oriental rugs and fine drapes were tattered and worn out, and it was apparent that the house had not been lived in for some time.

But if the house was in shambles, it still remained an artistic wonderland. Downstairs hung three canvases by Albert Marquet, Morrice's and Rouché's mutual good friend. They hung askew on the walls, as if nobody cared about them anymore. There were six paintings by Morrice hanging in the downstairs drawing and dining rooms. One, a haunting study of a Paris quai under a snowfall, peered out at us from the semi-gloom of a murky corner.

We ascended the gracious circular stairway and, to the right at the top in the hallway, was a walk-in cupboard containing broken pieces of furniture, old frames, and other bits of discarded debris. On top of the pile, I instantly recognized Morrice's lovely painting *Concarneau cirque*. There it lay with a large three-cornered tear in the canvas, carelessly thrown aside as if it were an object no longer of value. All the furnishings in the house had been

PLATE 79
The Circus, Concarneau
c. 1908, Panel 5¼″ × 6⅝″

Morrice loved the atmosphere of the circus and the practised skills of the acrobats, clowns, and bareback riders. Also the shapes of tents attracted his pencil and brush. Here, in the mediaeval walled town of Concarneau, the circus tents are pitched close to the inner harbour where in the background numerous fishing boats with their high masts are riding at anchor. A canvas of the circus at Concarneau, entitled Concarneau cirque, *is part of the Beaverbrook Art Gallery's permanent collection.*

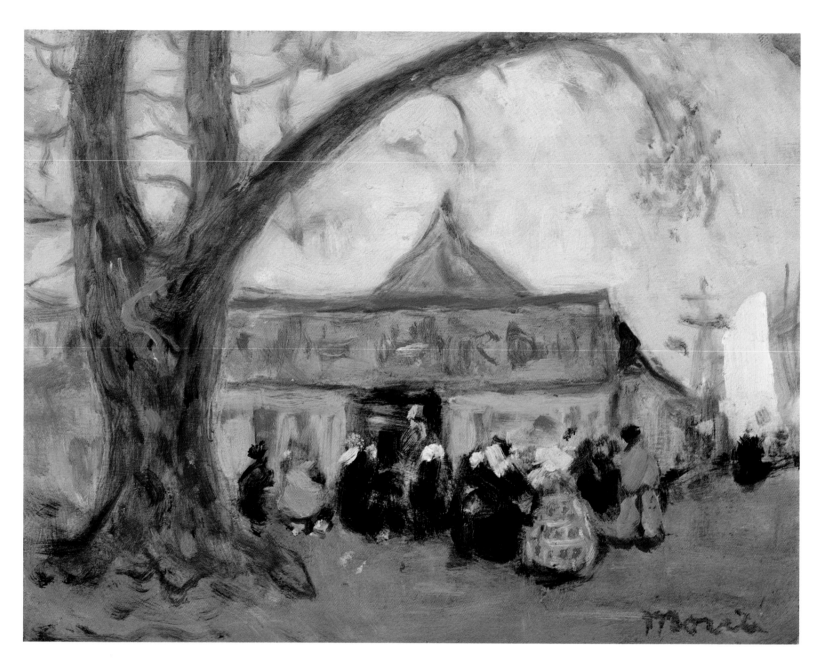

PLATE 79

allowed to disintegrate. Shortly after the visit, we learned that M. Rouché had recently died at the age of ninety-five, but none of the pictures was for sale as his estate was in process of succession.

About two years after this strange occasion, I received a typewritten note from a Madame Albert André, who, in her letter, introduced herself as the daughter of the late J.M. Rouché. In this terse letter she listed the titles of five Morrice canvases formerly in her father's collection. She quoted prices that were completely unrealistic, at least two or three times more than current market values. However, they were all fine pictures and one of them, a Venice scene, *Campo San Giovanni Nuova*, I thought I just might be able to buy. I wondered at the time why she had priced it considerably lower than some of the others. One of the conditions of sale was that she be paid in United States funds in New York. "I have a son presently staying at the Hotel Carlyle, just pay him," she wrote. However, I let the matter drop for a time because I knew of no one else who would have been willing to pay the very high sums she had in mind for her Morrices.

About six months passed by and I decided to contact Madame André again. I mentioned I was still interested in buying the Venice picture at her quoted price of $5,000. I was in London on my way to Amsterdam, and arranged to pick up the cash from Dutch colleagues and take it with me to Paris. Having arrived at my Paris hotel, I arranged an appointment with the lady, and confidently set out to meet her at her home the following morning.

Although not as opulent as her father's mansion had once been, it was much more modern, and situated on one of the broad streets that almost touched the long shadows cast by the Eiffel Tower.

A maid in a black uniform with a starched white cap and pinafore arrived at the door and invited me to sit down in a small waiting room. In a few moments Madame André herself appeared and, after a pleasant greeting, she ushered me into her well-furnished drawing room where at least four of her late father's Morrices were hanging. Madame André was a woman past middle age and handsome in face and figure. She was well dressed in an expensive Rodier suit. Almost immediately she assumed the air of a *grande dame*, as if arming herself for a confrontation regarding the prices of her pictures.

She then boldly announced that neither she nor her sister needed money and would sell only if they got the prices they knew the pictures were worth. She added in a knowing way that she was aware of the prices Morrice's work was now fetching in Canada. Madame then quoted me twice the sum already mentioned in her letter for the *Campo San Giovanni Nuova* picture. I

PLATE 80
Campo San Giovanni Nuova, Venice
c. 1901, Canvas 19¾" × 21¼"

Two Venetian women, long-robed with attractive hats, are conversing before an open portal. One of Morrice's great gifts was his ability to capture in paint the textures of walls, roofs and buildings. An early photograph of the picture reveals a figure of a priest in a black habit placed in the right foreground. Some time later Morrice removed the priestly figure, restoring the mid-foreground back to the wall and roadway.

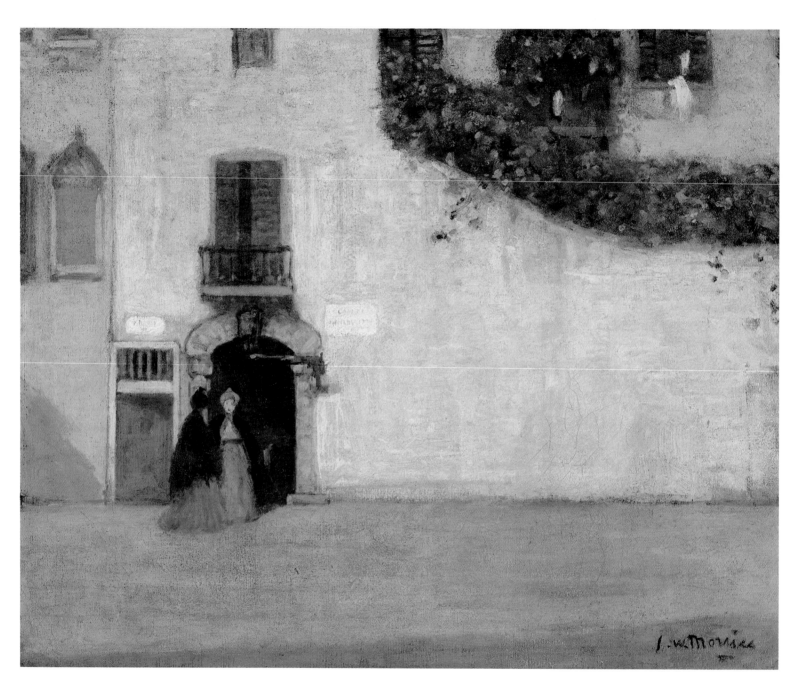

PLATE 80

was stunned at the woman's change of heart, but in a sense I rather grudgingly admired her sheer aplomb. She was obviously a favourite daughter of her father's, spoiled by the family wealth, brought up by governesses and servants, and used to getting her own way. However, after serving a glass of champagne, which preceded a serious little talk on the stature of Morrice as a painter, and his value in the art market, she became much easier to deal with. She then reduced her price to a more reasonable level and I agreed to buy. On being paid, she behaved most charmingly and summoned her beautiful daughter to drive me back to my hotel. She tilted her aristocratic head and said to her daughter: "Denise, take Monsieur Laing to the Flea Market on his way home. Sometimes one finds bargains there," she added in a serious tone.

I am glad to say that the badly rent canvas *Concarneau cirque* was relined and restored by French experts, and the picture made to look presentable. By some circuitous route it was brought to the attention of Lord Beaverbrook, who bought it in 1959 from the Continental Galleries for his newly opened gallery in Fredericton.

From Jacques Dubourg we later acquired another Rouché picture, *Early Snow on the Quai des Grands Augustins*, a view from his studio windows. The remaining Rouché Morrices seem to have disappeared.

Probably the finest small panels by J.W. Morrice I ever saw came from the English-born picture dealer John Nicholson. After the war, Nicholson opened up a gallery in a rather nondescript office building on East 57th Street in New York. His business was done almost entirely by appointment. He was a flamboyant buccaneer kind of man, but a truly good judge of pictures. He made numerous discoveries of works by Constable, Turner, Old Crome, and other English masters. Oddly enough, rather than selling these pictures in England, he marketed most of them in New York. He found the market there more buoyant and he also received higher prices. Indeed, John Nicholson had a flair for the "art trade," as the picture business is commonly called in England, and spent at least half his time in London searching for suitable pictures to sell in the United States.

One March afternoon in 1952, I met John Nicholson on the premises of Hahn & Son, the London picture restorers. This was an old family business run by two brothers, Charles and Sidney, grandsons of the founder. They were highly experienced restorers who also bought and sold pictures as a side business. So successful were they, and their connections so good, that they discovered at least thirty canvases by Cornelius Krieghoff in Britain and Ireland during the twenty years or more after 1950 that they worked for us as restorers.

PLATE 81
Umbrellas on the Beach, St. Malo
c. 1902, Panel 5″ × 6″

This picture suggests a holiday mood with brightly coloured umbrellas and figures on a beach. A small rowboat is anchored in the shallow water. The entire foreground, at least a third of the composition, is represented by the unpainted wood of the panel, and captures to perfection the texture of the sandy beach.

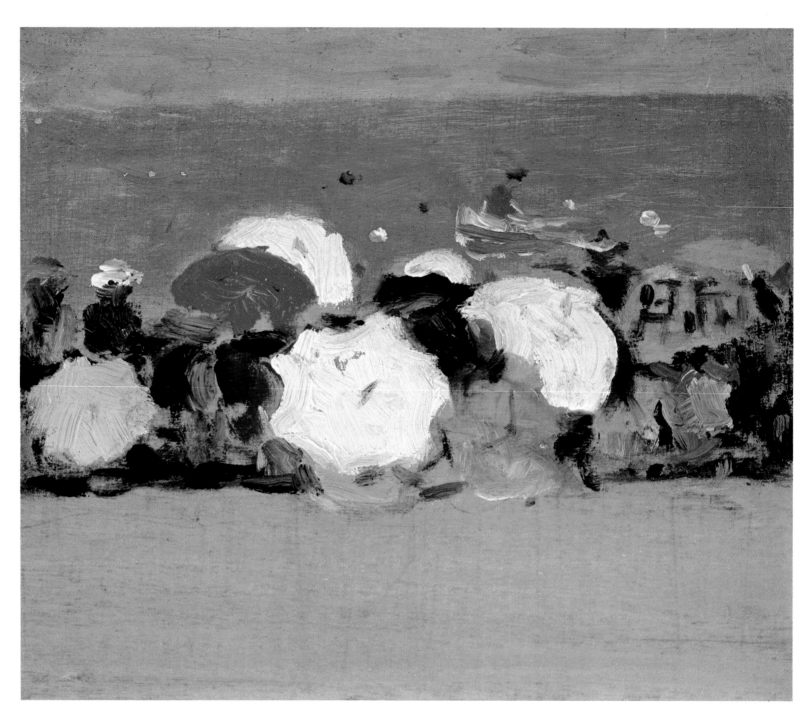

PLATE 81

On this particular day, John Nicholson was in a jaunty mood, exhilarated over an unexpected purchase. He had just bought another painting by the great English landscape painter John Constable. In a cheery voice, he also informed me that he had found six marvellous little paintings by the Canadian artist James Morrice. "Would you like to take a look at them?" he asked. My answer was a simple "Yes," but he cautioned me: "I will sell you only four because my wife is also fond of them."

We picked up a cab at the Ritz Hotel on Piccadilly and within ten minutes had arrived at John's flat, tastefully furnished in good English antiques. "How much do you want for the Morrice's?" I asked, thunderstruck by their superb quality. Then he said: "You can have your choice of four of them at a hundred pounds each, but the other two I shall give to my wife." Before leaving his flat, I extracted his promise that if he ever decided to sell the remaining two I would be the first to know about it.

Possibly two years passed by when, one day in New York, I looked up John Nicholson at his gallery. He had recently obtained yet another divorce from one of his charming English wives and, once again, was on his own. He recalled his promise to me about the two remaining Morrice panels and, to his credit, then and there said I could have them for $500 each.

Two of these diminutive works of art are café scenes: one is a Venice square featuring a male figure in a straw hat; another is a Paris restaurant with young ladies in wide-brimmed hats. There is also a panel with bright parasols shading figures at a Brittany seaside resort. These floating discs of colour are in contrast with the textured wood representing the sand of the beach. A fourth is the beach of St. Malo with children playing in the water near the grey ramparts. A fifth is a view of grey-blue fishing boats in the late afternoon light at Concarneau, and the sixth is a park scene with figures, exhibited at the Salon d'Automne in 1905.

Why did these little pictures affect me so profoundly, as they still do? I expect because they express Morrice's original way of looking at life. But I should fail in any attempt to try to put Morrice's vision into words. These were the six compositions represented in John Nicholson's Morrice panels. Although John Nicholson never revealed the source of the circumstances of his discovery, I surmised, since he seldom went to Paris, that they were probably among a handful that were sold privately by the artist in London some forty-five years earlier.

It was much closer to home that I made one of my most fortunate buys, the acquisition of Morrice's great canvas, *Promenade, Dieppe*, which came my way quite by chance. It was originally purchased by Alfred B. Fisher in

PLATE 82
Fishing Boats, Concarneau
c. 1908, Panel 6″ × 5″

Figures are standing on the docks where several fishing boats are moored. Opposite is the vague shoreline and a setting sun casts horizontal reflections well into the centre of the harbour.

200

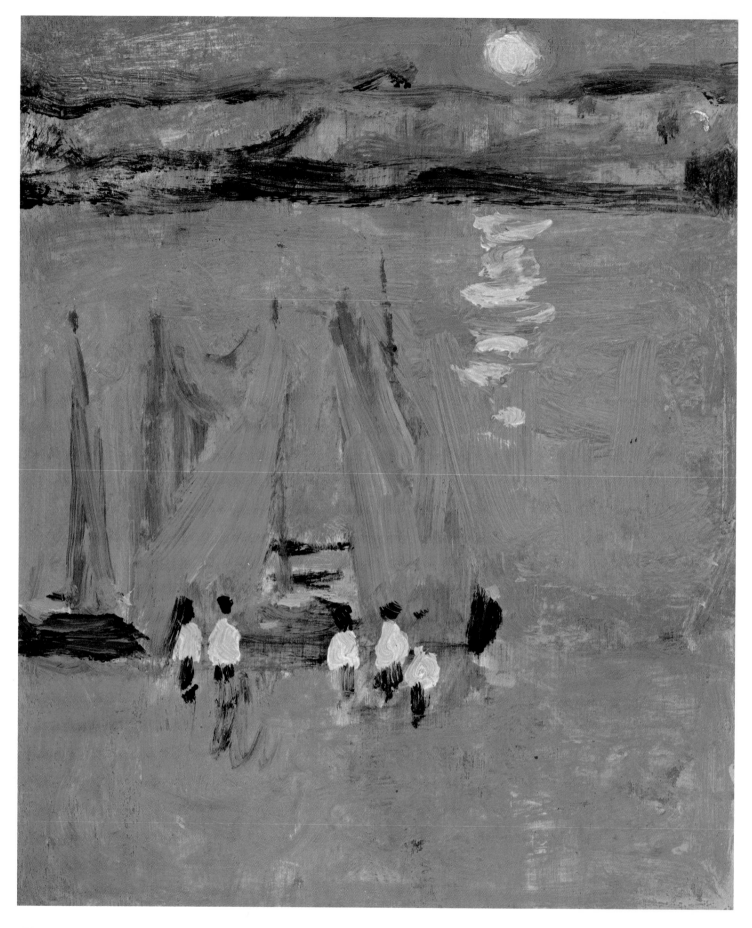

PLATE 82

1915, from a touring exhibition of pictures by members of the Royal Canadian Academy in aid of Canada's war effort.

One day in the spring of 1958, J.J. Vaughan, a retired executive of the T. Eaton Co., alerted me to the fact that a well-known New York dealer was on his way to Toronto to buy Fisher's Morrice. Since Mr. Fisher was extremely ill, I immediately got in touch with his wife to tell her I too was interested in acquiring this picture. She invited me to come to their home in south Rosedale and look at the picture again. Ill though Alfred Fisher was, his mind was clear and decisive, and he was quite eager and happy to sell the picture at once. His price was $5,000.

The next day, the New York dealer came into our galleries bewailing his bad luck in losing the chance to purchase the Morrice. I didn't tell him that I had bought the picture myself, but instead sold him something else that he could easily resell in New York to pay for his trip to Toronto.

In the final years of the nineteenth century and up to World War I, two wealthy Russian businessmen made regular buying trips to Paris to acquire examples of the Impressionist, Post Impressionist and School of Paris artists. Their names were Sergio Chtchoukine and Ivan Morozov, each of whom had inherited family fortunes. The French paintings from their collections are now in the Hermitage Museum in Leningrad and in the Pushkin in Moscow.

In France, Morozov and Chtchoukine bought from the renowned Paris commercial galleries of the time, Durand-Ruel, Druet, Bernheim Jeune, Vollard, and Kanweiller. Morozov, beginning in 1900, spent each year from 200,000 to 300,000 francs on pictures. He liked the works of Monet, Pissarro, Renoir, and Sisley, and later became interested in pictures by Van Gogh, Cézanne, Signac, Bonnard, and Matisse. From Vollard, he bought the famous Cubist portrait of the dealer himself, by Picasso. During his visits to Paris, he regularly attended the Salon d'Automne exhibitions and was himself made an honorary member of the institution.

It was on one of his visits to the Salon d'Automne that Morozov first saw and admired the paintings of James W. Morrice. Then with uncanny foresight, about 1906, he bought two of his canvases, *Fête Montmartre* and *A Brittany Estuary*. These are now in the Hermitage Museum, Leningrad. By 1913, the Morozov collection comprised 140 canvases of the French School, without counting drawings or sculptures. His paintings were housed in his magnificent Pretchistenka palace in Moscow. It is said (there is as yet no concrete evidence) that on Morozov's invitation, Morrice once visited Moscow.

James W. Morrice was the favourite Canadian painter of the Winnipeg collector, John A. MacAulay. Born on a farm in Morden, Manitoba, he had a

PLATE 83

Olympia

c. 1914, Canvas 32″ × 24″

One of the artist's most brilliant figure studies. The model is Blanche Baume, a striking-looking woman and all the more so when dressed as an exotic Balinese dancer. She has red painted toenails and lemon-coloured fingernails, inches long. Around her waist is an embroidered girdle and on her feet are gold sandals. She wears many bracelets set with jewels, and a large high-winged collar with an elaborate headdress resembling a spiked helmet. A red drape dotted with yellow flowers serves as a background for her turquoise silk pantaloons.

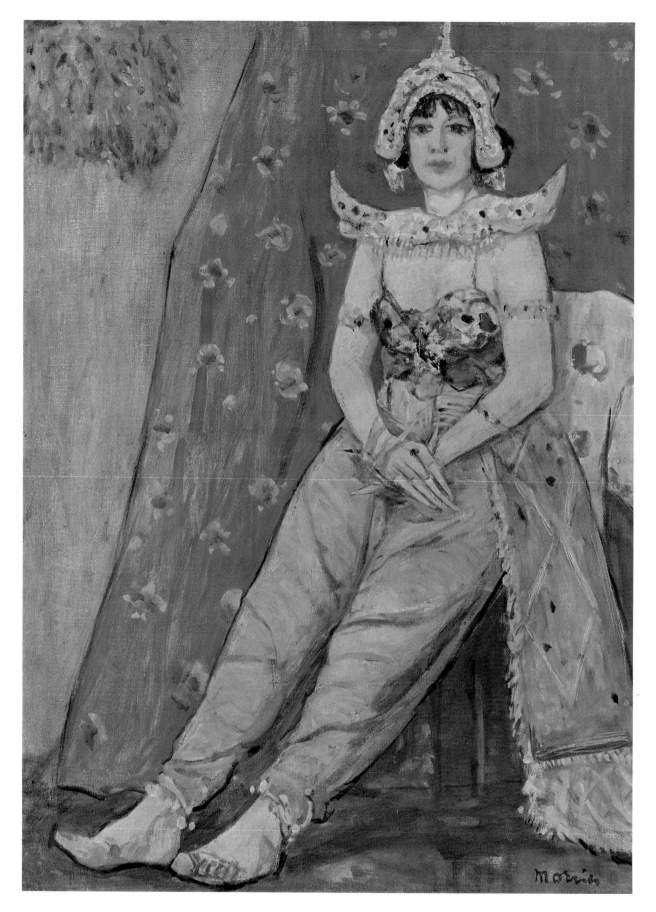

PLATE 83

brilliant career practising law in Winnipeg. He developed a great enthusiasm for pictures and sculpture. In his gracious Wellington Crescent house, he added a large room to accommodate his growing collection of Canadian art. It was after the war, about 1946, that John MacAulay began to buy Canadian and French art on a grand scale.

At one time John MacAulay possessed seven canvases and eight sketch panels by Morrice. One was the dramatic study of Blanche Baume, dressed in the eye-catching costume of a Balinese dancer, entitled *Olympia*. She sits with grand aplomb, with bare toes, long false fingernails, and large round eyes heightened with mascara. Magnificent in colour, she exudes a striking and bizarre presence.

I was dismayed when one day in 1957, on a visit to Winnipeg, I noted that *Olympia* had disappeared from the walls of the Canadian room. I discovered later that John MacAulay had recently sold the painting together with a landscape of Capri, for whatever personal reasons, to the Montreal Continental Galleries in 1956. The latter quickly resold the two pieces to the National Gallery of Canada. The stunning *Olympia* having departed, the Canadian room never quite seemed the same. Years later, I acquired from the MacAulay heirs the Morrice canvases *Café el Pasaje, Havana* and *Fishing Boats, Off the Finistère*.

As late as the early 1950s, Paris was still a good place to look for paintings by Morrice. One of the more likely spots to find one was at Jacques Dubourg's little picture gallery, and I bought a good many from him through the years. Dubourg had known the artist's work as a young salesman at the Galerie Georges Petit, just before the First World War. I originally met Dubourg back in 1938, when he brought to Toronto an exhibition of French Impressionists, Post Impressionists and School of Paris pictures. They were works of the finest quality, but we sold only one, a J.B. Jongkind *Honfleur* for $2,700. Soon after, the war intervened and I did not see or hear from Jacques Dubourg until I arrived in Paris for the first time in my life in June 1950.

Although Dubourg had not known Morrice personally, he first came into contact with the artist's work when he joined the respected Georges Petit art firm as a junior employee in 1914. As I have said, the director was André Schoeller who was with Georges Petit from 1905 to 1930. But Schoeller knew Morrice and, beginning as early as 1905, bought a number of his important canvases. It was at Georges Petit's elaborate gallery that the Société Nouvelle held its annual exhibitions. Its president was the renowned sculptor Auguste Rodin, and Morrice became a full member.

PLATE 84
Café el Pasaje, Havana
1915, Canvas 25″ × 26″

One of Morrice's most dramatic pictures is this Havana café canvas. The work was completed from sketches shortly after he returned to his final studio address in Paris on the Quai de la Tournelle. The colour scheme is different from his Moroccan works of 1912 and 1913. In fact the picture is accented with a distinctive Cuban rhythm. The circular discs of the café tables are contrasted with the open windows and vertical columns. These are balanced by rounded trees outside on the roadway.

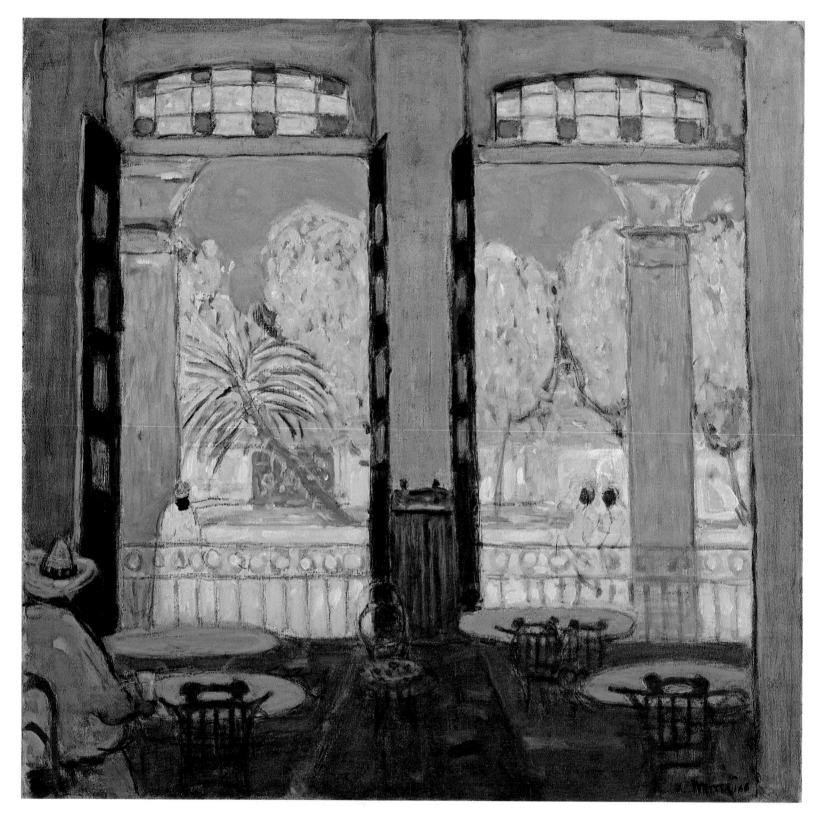

PLATE 84

Charles Pacquement (1871-1950), a noted French collector, also bought Morrices. Pacquement was an industrialist in textiles who began to buy pictures about 1900. In 1932, he sold his huge collection by auction at the Galerie Georges Petit. Dubourg acquired some of his Morrice panels at that time, including a Paris street view with a pink sky, as well as a study of a bull ring in Marseilles. Jacques Dubourg was one of the few Paris dealers who recognized the quality of Morrice's work and, over the years, even in the 1930s, he put aside in his private collection some fine panels and canvases that came his way in Paris.

Dubourg knew Léa Cadoret and, during the 1960s, bought up her remaining Morrices. As early as 1936, he had acquired from her a captivating portrait of a woman posing in a wicker chair. Other Morrice paintings I bought from Dubourg, previously owned by Léa Cadoret, were *Léa in a Tall Hat* and a colourful study of a nude with red hair reclining in a chair against a rich tapestry background. In 1960, I nearly lost Léa's portrait in a train mix-up in Switzerland. I had moved with my suitcase into the dining car for lunch, and got off at the next station for a short walk. When I returned to the train, the dining car had mysteriously disappeared. I frantically sought out the stationmaster to whom I told my problem. He calmly said he would telephone Brig immediately and have the case removed from the dining car, because, he informed me, "if the train goes on through the Simplon Tunnel into Italy, you will never see it again." I was certainly greatly relieved when my bag with Léa's precious portrait arrived back in Zurich a few hours later.

For the 1937-38 memorial exhibition of the works of Morrice, organized by the National Gallery of Canada, there were 131 catalogue numbers, including canvases, watercolours, and panel sketches; Jacques Dubourg owned three of these sketches, two of which I bought from him in the 1960s. About fifteen years ago, I happened to see in his apartment a rare Morrice panel of a Quebec City winter street with horse and sleigh, which he told me he was unwilling to sell. I believe it was a sentimental favourite since it was a scene of Quebec City, his wife's birthplace.

When Jacques Dubourg died in 1981, I did not see Madame Dubourg until June 1983, when I was unable to focus her attention on the little Morrice winter scene that I wanted – but as usual we had a warm and friendly talk. The Dubourg flat, still looking the same as when Jacques was alive, was filled with superb pictures, but there was not a Morrice panel in sight!

Three months passed after my return from Paris in early July. Then one day I had a telephone call from a Quebec City businessman, who inquired if

PLATE 85
Fishing Boats off the Finistère
c. 1902, Panel 5″ × 6″

The fishing fleet is off the Finistère coast and is returning to Concarneau with its catch of tunny. Painted at sunset the scene is colourful and eye catching. The fishing boats with their orange coloured sails and sculptural forms are sailing on an ocean of jade.

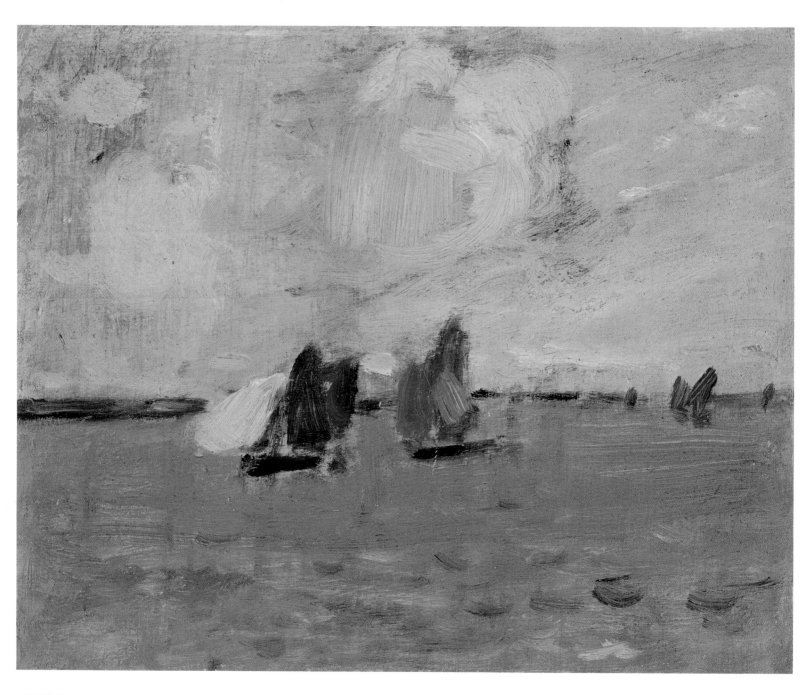

PLATE 85

I was interested in buying a small Quebec winter scene by Morrice. He then hastened to add that he had recently bought it himself in Paris from Madame Dubourg.

This was of course the same panel I had been trying unsuccessfully to get for many years. However, Madame Dubourg apparently extracted an agreement from the gentleman that if he ever decided to sell it, he would get in touch with me first – and he did.

I missed out on one of Morrice's figure pieces that Léa Cadoret once owned, the superlative *Woman in a Wicker Chair*. Dubourg had bought it from Léa around 1936, and, in 1937, lent it to the National Gallery for their Morrice memorial exhibition. Years later, Montreal's Continental Galleries had the painting, and, in 1956, during a trip to Montreal, I saw it and coveted it. But it was too late. It had been sold the day before to Lord Beaverbrook for his new gallery in Fredericton, his gift to the people of New Brunswick.

Henri Marcel (1854-1926) was a distinguished French scholar who appreciated good pictures. In 1904, during his term as Director of Fine Arts for the State, he bought Morrice's *Quai des Grands Augustins*. Marcel later became Director of the National Library and, in 1913, was appointed head of the National Museums. In 1902, Marcel, who owned several Morrices, wrote eloquently in a Paris art publication about a Morrice painting, *Port of St. Servan*, on view at the Société Nationale:

> *The picture is enveloped in an indefinable tonality of grey, mauve, and pale greens, before which one becomes lost in meditation for a long time.*

The *Port of St. Servan* remained in the Marcel family until 1975, when I was exceedingly fortunate to track it down and bring it to Canada.

In 1955, six small J.W. Morrice panels mysteriously appeared for sale in Canada. They were offered to the Art Gallery of Toronto by a Madame Andjelka Ivanie of Yugoslavia. These six Morrice panels were of the finest quality, and probably had been bought directly from the artist because they are all signed. Normally, Morrice signed his panels only at the request of the purchaser. How they ever got to Yugoslavia is a mystery, but it does reflect the impact Morrice's art had on individuals and connoisseurs from different countries who came into contact with his work in Paris.

It is a pity that officials of the Art Gallery of Toronto at the time weren't persuaded to inquire more fully into the background and provenance of these little works of art. What they might have discovered could have provided some clue as to how these pictures came into Madame Ivanie's

PLATE 86
Woman in a Wicker Chair
c. 1895, Oil on canvas 32¼″ × 18⅛″

It has been conjectured that the sitter is Blanche Baume, one of Morrice's favourite models, whom he painted in different costumes. This is now one of several important Morrice canvases in the Beaverbrook Art Gallery in Fredericton, New Brunswick. In greens, greys and yellows, this picture is a superlative example of Morrice's figure work.

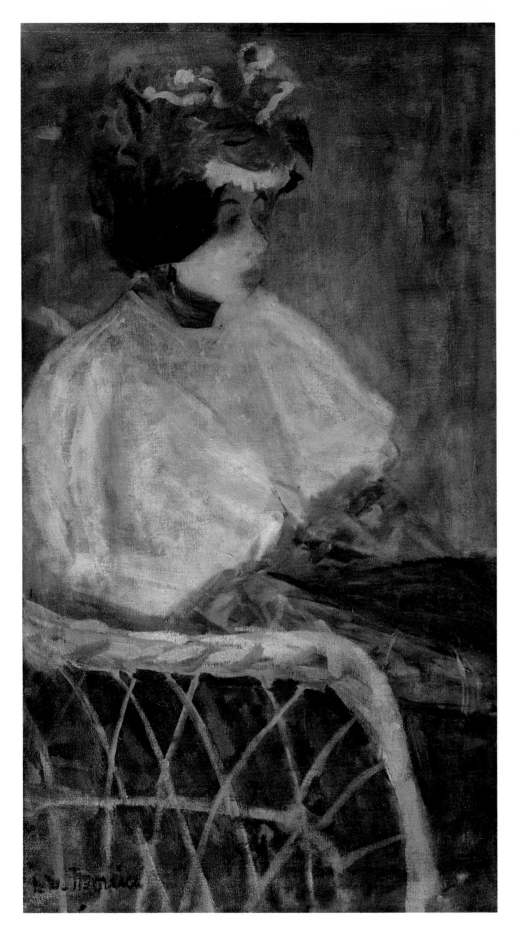

PLATE 86

possession in the first place, and perhaps told us more about the artist's contemporary European buyers.

Art dealers since the later part of the nineteenth century, the Reid family of Glasgow was an important name in the international picture world. The Reid family dealt in Impressionist and Post Impressionist French paintings as well as those of the most prominent Scottish artists. Alexander Reid Sr. had his portrait twice painted by Vincent van Gogh during the latter's Pairs period (1886-1888), when Reid worked as a salesman at Goupil's. Alexander Reid opened an art business in Glasgow which was patronized by wealthy Scottish ship builders. Among other clients was the wonderfully canny Burma oil recluse William Cargill, whose superb pictures were sold in a London auction in 1963.

A son, James A. McNeill Reid, carried on the family business, moved to London after the First World War, and opened a gallery there. After surviving the hard times in the thirties and the Second World War, Alex Reid and Lefevre, as the firm was then renamed, began a steady climb to international prominence.

Reid and Lefevre always seemed to have some good French pictures on hand, and one Saturday morning in the autumn of 1953 was no exception. James Reid was there in his Bruton Street Gallery and I promptly borrowed, for an upcoming exhibition in western Canada, a River Loing landscape by Alfred Sisley and a still life study by Raoul Dufy.

Also, I mentioned to Mr. Reid my interest in paintings by the Canadian, James W. Morrice. He immediately said that he knew of a fine one depicting the Seine on the outskirts of Paris which his firm had sold back in 1910. It belonged to a private individual in Scotland and the owner was prepared to sell. "If you would like to see it, I can have it sent down to London on the overnight train," he said. I became very attentive because I knew the Reid firm sold nothing but the finest pictures.

James McNeill Reid was a man of action as well as his word, and by Monday morning the picture had arrived. To my great delight, he produced a striking Morrice – a 1910 canvas of the Seine at St. Cloud with figures walking on the banks in their Sunday-best attire. I immediately bought the painting.

Another unusual individual, and a great admirer of the work of Morrice, was Col. A. Hamilton Gault of Montreal. Born in England in 1882, he came to Canada when very young and was educated at the elite Bishop's College and McGill University. At the age of nineteen, he served as an officer of the 2nd Canadian Mounted Rifles in the South African War. He was a great

PLATE 87

The Market Place, Concarneau
c. 1910, Canvas 23¾″ × 28¾″

A famous Brittany canvas. The dozen or more Breton women are gathered around an open market. The bare branches of a tree occupy the right-hand portion of the foreground. In the middle distance you catch a glimpse of Concarneau's inner harbour, and beyond is the famous clock tower and ramparts of the mediaeval town.

PLATE 87

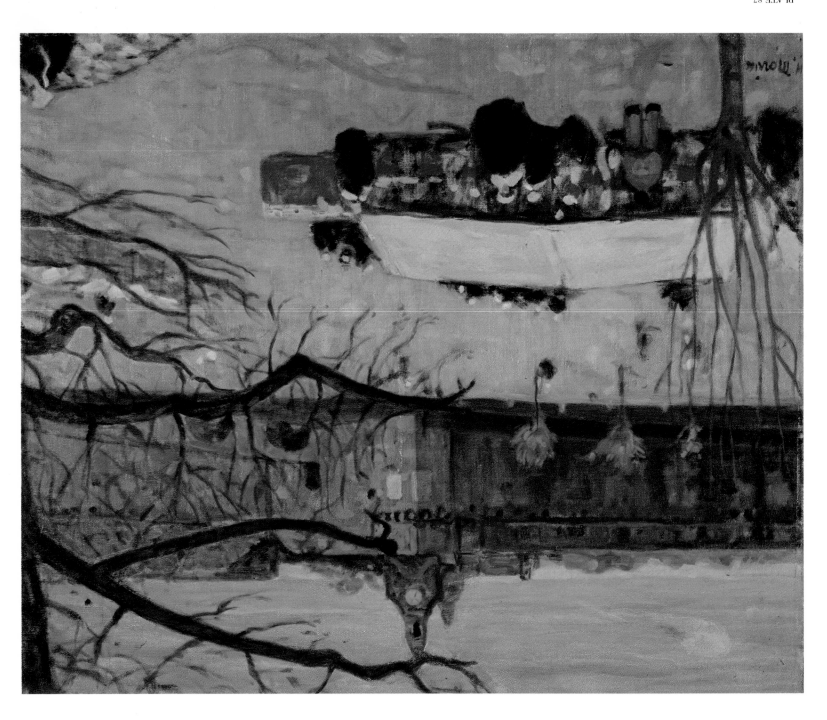

outdoorsman and bought Mount St. Hilaire, where he built a chalet on a lake noted for its trout fishing. He bequeathed the entire mountain to McGill University to be maintained as a conservation area.

When the Great War broke out in 1914, he travelled to Ottawa, offering to raise and equip a military unit at his own expense. This resulted in the formation of the Princess Patricia's Canadian Light Infantry Battalion. He returned to Montreal after the war and continued his lucrative business career in the cotton and wool industry.

It was probably just before the war that he bought J.W. Morrice's canvas, *The Surf, Dieppe*, as well as small panels of a Seine bridge and a scene on a Venice lagoon.

On his return to Montreal after the war, he acquired a pair of the artist's Flanders war subjects and a 1921 watercolour of a Jamaican coastal theme. He was proud of his little Morrice collection and, in 1956, lent *The Surf, Dieppe* to an exhibition of Canadian art that we organized for W. Garfield Weston, himself a Canadian, at his famous emporium, Fortnum and Mason in London.

Some years after the First War, Colonel Gault moved to England and bought a Georgian mansion, set in park-like surroundings near the market town of Taunton, Somerset, in southwest England.

In the autumn of 1970, on one of my visits to England, I decided to telephone Mrs. Hamilton Gault, then a widow, to inquire if she still had the Morrice canvas, and if by chance it might be for sale. She said she would be happy to show it to me, but, in answer to the second question, it was definitely not for sale. I got off the train at Taunton to meet my London colleague. We then took a taxi a mile or so into the country and found our way to the impressive Hamilton Gault mansion. A servant answered the door and we introduced ourselves to the gracious Mrs. Gault in her Hepplewhite-furnished drawing room. The Morrice marine canvas was hung in a place of honour over a finely carved mantelpiece. In addition, there were the two small panels of Paris and Venice I mentioned earlier, plus a war-time sketch of Flanders and a 1921 Jamaican watercolour.

Mrs. Gault gently reminded us she was not interested in selling any of her pictures at this time. Soon she extended her hospitality to the garden where she served us afternoon tea with fresh tomato and cucumber sandwiches. During tea she remarked that if she ever decided to sell her Morrice canvas, we would be the first to know about it.

It would be nearly two years after this event that my colleagues in London got a telephone call from Mrs. Gault's niece, who said that her aunt had

PLATE 88
La Communicante
c. 1910, Panel 4¼" × 6"

A figure of a small girl dressed entirely in white with a long headdress is walking along a street. To her left a female figure in black is about to walk into the composition of the picture. The artist was fond of painting these "semi-religious subjects." This panel was once owned by the Canadian artist Edwin Holgate who knew Morrice in France in the early 1920s.

PLATE 88

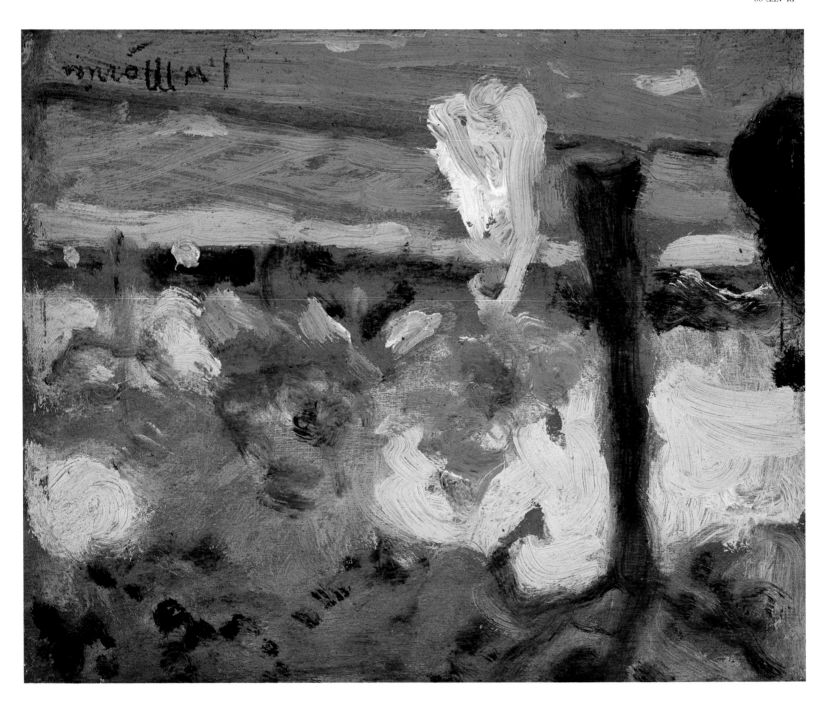

given her *The Surf, Dieppe* picture, with permission to sell it if she wished. It all happened so quickly and quietly. The niece and her husband brought the painting to London, a price was mutually agreed on, and soon another fine Morrice canvas found its way back to Canada.

After the war, I got to know Charles R. Henschel, the personable head of the M. Knoedler Company art firm. Knoedler's operated commercial galleries in New York, London, and Paris. There was an old-time employee who looked after the Knoedler establishment in Paris, and kept it alive during the war years. Her name was Mademoiselle Nicole. She was well aware of my interest in James Morrice, and once, on a visit to Paris, I found a note at my hotel announcing that she had found a Morrice painting she felt sure would be for sale. She then put me in touch with M. Georges Manoury, who had known Morrice more than forty years earlier. M. Manoury lived in an apartment in one of the elegant eighteenth-century buildings on the rue Royale looking towards the great white columns of the Church of the Madeleine.

M. Manoury was a gracious Parisian gentleman who was more than happy to sell me his *Le Porche de l'Église, San Marco, Venice*, which he had bought from the artist many years previously. Painted about 1901, it depicts the façade of the famous Venetian building caught in the glow of a sunset. It was one of a series of sunset paintings the artist made in Venice.

Sometimes an agreeable surprise awaits you upon entering an art gallery. You suddenly see a work of art that you own cover. One day in the mid-1950s, I walked into the little gallery of Bernard Lorenceau on the rue La Boétie, Paris. There, sitting on a chair-easel, was a lovely small Morrice canvas depicting a yacht race at St. Malo; the sea in deep blues and jade greens and the boats with their white sails skimming over the water. The picture was signed with the artist's usual flourish, but I don't believe M. Lorenceau was actually acquainted with the Canadian's work, as he was happy to sell it to me for a modest price.

Among the James Morrice canvases I discovered that was owned by Morrice's art supplier M. Guichardaz was *Fishing Boats*. We had acquired earlier the small panel sketch for it in New York. The owner had written Léa Cadoret to enquire if she knew where it was painted. She replied: "Off the Finistère coast in Brittany." In a sunset at sea the sails of the fishing boats have taken on a colourful sculptural quality. What heightened its interest for me was that the canvas had at one time belonged to M. Guichardaz. He must have received it direct from the artist by barter for artist's supplies. This was not an unusual business arrangement between an artist and his colour supplier in Paris.

PLATE 89
The Fruit Market, Tangiers
c. 1912, Canvas 19¼" × 23½"

A richly coloured work painted on one of Morrice's winter trips to North Africa. A turbanned figure wearing a long blue-striped robe is negotiating a purchase from the blue-garbed fruit seller. An Arab boy in a loose white garment with a basket in his hand stands looking towards the spectator. There is an awning on either side of the counter which is piled high with oranges and other fruits. The awning is textured with flower-like forms and the tiled floor in the foreground is broken by diagonal lines which give depth to the scene. The picture is done in the artist's thin painting technique with the warm preparatory surface of the canvas showing through.

PLATE 89

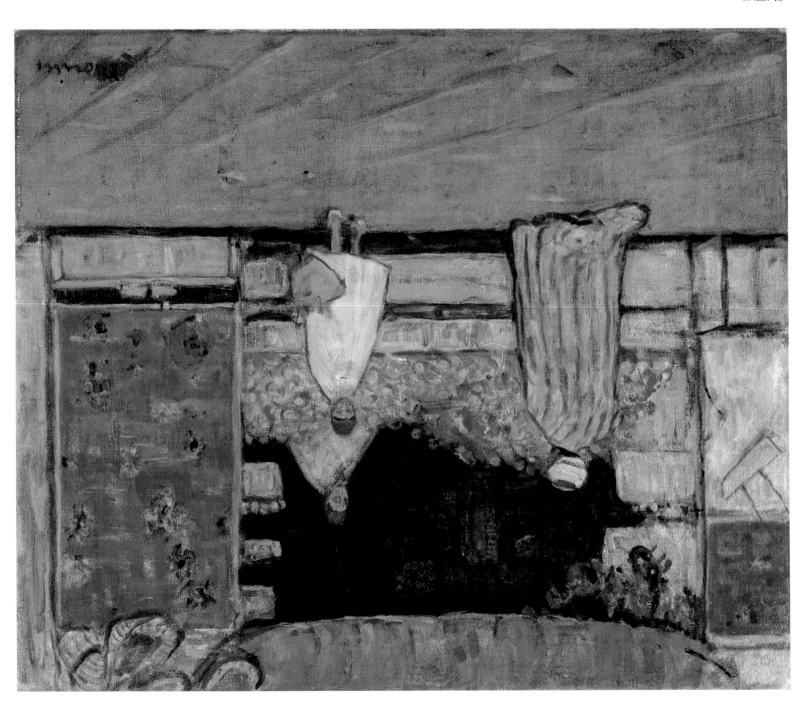

For years I have followed the trail taken by James W. Morrice, both by the man and his art. I have learned to watch for clues, hints, and to listen to rumours and gossip. Sometimes I found I was close, but the quarry had already slipped away. And now and then, when success was least expected, I found I had won a victory.

My desire has been to tell something about the life and times of the artist, sharing with the reader some of my experiences during my search for his paintings and the study of his art. Also I have tried to illuminate the paths that have led me to a greater understanding of this multi-faceted man.

The ninety colour plates in this book superbly reveal the style and progress of the painter over the years. Not only was James W. Morrice the most distinguished artist that Canada has produced, he also established himself internationally as one of the twentieth century's most talented and lyrical Post Impressionists.

PLATE 90
The Quai, Dieppe
c. 1908, Canvas 23¾" × 28¾"

It is mid-June, the poppies and other wild flowers are blooming in a grassy meadow. Women in large bonnets are walking along a promenade, separated by a simple wooden barricade from the seashore. Two-thirds of the composition is filled with sky and white cloud, and the picture evokes the feeling of high summer on the Normandy coast.

PLATE 90

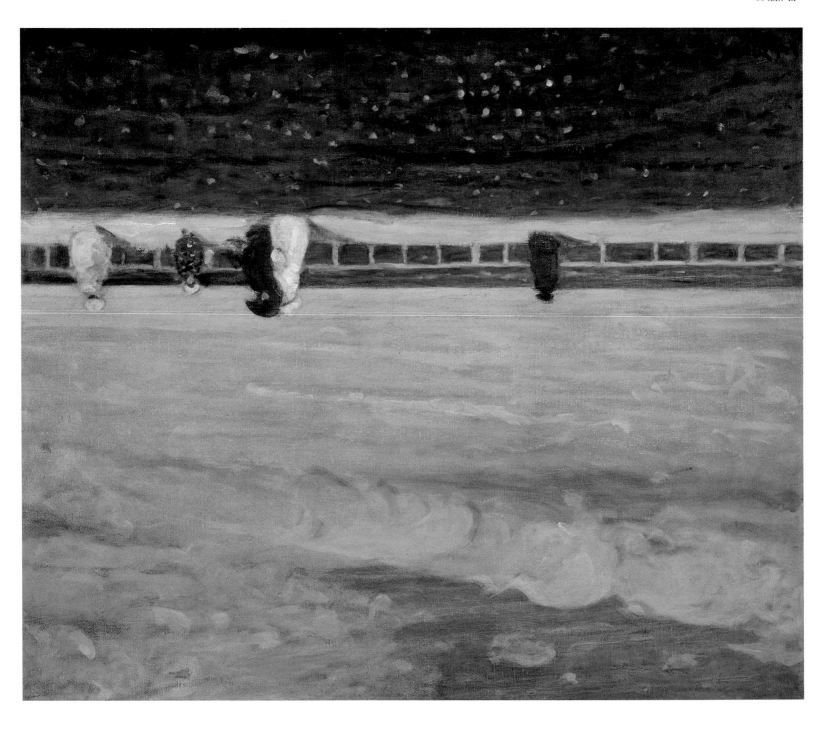

LIST OF COLOUR PLATES

PLATE 1
Prow of a Gondola, *c. 1897*
Panel 12¹/₂" × 9"
Private collection

PLATE 2
The Flower Market, St. Malo, *c. 1901*
Panel 9³/₄" × 7"
Private collection

PLATE 3
Winter, Quebec City, *c. 1908*
Panel 4³/₄" × 6"
Private collection

PLATE 4
Winter Street with Horses and
Sleighs, *c. 1905*
Panel 6" × 4⁷/₈"
Art Gallery of Ontario, Toronto
Gift from J.S. McLean,
Canadian Fund, 1955

PLATE 5
Lady in Brown, *c. 1895*
Canvas 34" × 20"
Private collection

PLATE 6
The Old Holton House, *c. 1909*
Canvas 24" × 29"
Montreal Museum of Fine Arts

PLATE 7
Winter Scene, Quebec, *c. 1905*
Panel 4³/₄" × 6"
Art Gallery of Ontario, Toronto
Gift of Mr. and Mrs. R.W. Finlayson,
1957

PLATE 8
Quebec Farmhouse, *c. 1910*
Canvas 32" × 24"
Montreal Museum of Fine Arts

PLATE 9
Le Pavillon de Flore, *c. 1902*
Panel 5" × 6"
Private collection

PLATE 10
Overlooking a Lagoon in Venice,
c. 1902
Panel 7" × 9³/₄"
Private collection

PLATE 11
A Brittany Girl Knitting, *c. 1898*
Canvas 21¹/₈" × 13¹/₈"
Private collection

PLATE 12
The Surf, Dieppe, *c. 1904*
Canvas 23³/₄" × 28¹/₄"
Private collection

PLATE 13
The Flower Seller, *c. 1901*
Panel 5" × 6"
Private collection

PLATE 14
A Town in Brittany, *c. 1896*
Panel 9¹/₄" × 13"
Private collection

PLATE 15
Boat Building, Brittany, *c. 1896*
Canvas 15" × 18"
Private collection

PLATE 16
A View of Tangiers, *c. 1913*
Canvas-covered board 9¹/₄" × 12¹/₂"
Private collection

PLATE 17
Les Jardins du Luxembourg, *c. 1906*
Panel 6" × 5"
Private collection

PLATE 18
A Café, Paris, *c. 1900*
Panel 5¹/₈" × 6¹/₂"
Private collection

PLATE 19
Wet Day on the Boulevard
St. Germain, *c. 1896*
Panel 7¹/₄" × 8³/₄"
Private collection

PLATE 20
Entrance to the Village of Ste. Anne
de Beaupré, *c. 1900*
Canvas 16" × 22"
Private collection

PLATE 21
Early Snow on the Quai des Grands
Augustins, *c. 1905*
Canvas 18" × 14¹/₂"
Private collection

PLATE 22
View of Paramé from the Beach,
c. 1901
Canvas 24" × 32"
Private collection

PLATE 23
Venetian Girl, *c. 1900*
Canvas 18³/₄" × 13⁷/₈"
National Gallery of Canada, Ottawa

PLATE 24
View of the Beach and Ramparts,
St. Malo, *c. 1899*
Panel 5" × 6"
Private collection

PLATE 25
The Grand Canal, Venice, *c. 1904*
Panel 5" × 6"
Private collection

PLATE 26
Girl in Bonnet, *c. 1900*
Panel 9" × 9"
Private collection

PLATE 27
Rowboats on the Seine, *c. 1898*
Panel 4" × 6"
Private collection

PLATE 28
A Street Scene, Paris, *c. 1902*
Panel 5¹/₂" × 6³/₈"
Private collection

PLATE 29
Blanche in Blue and Green, *c. 1912*
Canvas 24" × 20"
Private collection

PLATE 30
Barge on the Seine, *c. 1896*
Panel 9¹/₄" × 6¹/₂"
Private collection

PLATE 31
Brittany Girl in White and Green
Headdress, *c. 1896*
Panel 13" × 9¹/₂"
Private collection

PLATE 32
The Promenade, Dieppe, *c. 1904*
Canvas 19³/₄" × 24¹/₄"
Private collection

PLATE 33
A Procession, Marrakesh, *c. 1910*
Panel 5" × 6"
Private collection

PLATE 34
Henri Matisse, *c. 1912*
Panel 4³/₄" × 6"
Private collection

PLATE 35
Environs of Tangiers, *c. 1912*
Canvas 25" × 32"
National Gallery of Canada, Ottawa

PLATE 36
Figures in a Café, Dieppe, *c. 1905*
Panel 6" × 4"
Private collection

PLATE 37
St. Mark's and the Doges' Palace,
c. 1899
Panel 10¹/₂" × 12³/₄"
Private collection

PLATE 38
A Marabout, Morocco, *c. 1912*
Panel 6¹/₂" × 5¹/₄"
Private collection

PLATE 39
Pont Louis Philippe, *c. 1902*
Canvas 15" × 21³/₄"
Private collection

PLATE 40
Near Charenton, *c. 1903*
Panel 5¹/₄" × 6¹/₄"
Private collection

PLATE 41
The Sugar Camp, *c. 1897*
Canvas 20" × 16"
Private collection

PLATE 42
Café, Venice, *c. 1904*
Panel 5" × 6"
Private collection

PLATE 43
The Circus, Montmartre, *c. 1903*
Canvas 19" × 23¹/₂"
National Gallery of Canada, Ottawa

PLATE 44
On the Shore, Brittany, *c. 1902*
Panel 8¹/₂" × 11¹/₂"
Private collection

PLATE 45
On the Cliff, Normandy, *c. 1902*
Canvas 19" × 23¹/₂"
Private collection

PLATE 46
Carting Sand, Brittany, *c. 1904*
Canvas 19³/₄" × 24¹/₈"
Private collection

PLATE 47
Capri, *c. 1910*
Panel 9" × 16³/₄"
Private collection

PLATE 48
Nude With Fan, *c. 1914*
Canvas 26" × 20"
Private collection

PLATE 49
Corner of a Village, Jamaica, *c. 1915*
Panel 5" × 6³/₄"
Private collection

PLATE 50
In Picardy, *c. 1918*
Panel 9¹/₂" × 13"
Private collection

PLATE 51
Fruit Boat, Trinidad, *c. 1921*
Canvas 15" × 18"
Private collection

PLATE 52
Outside the Mosque, *c. 1913*
Canvas 23³/₄" × 32"
Private collection

PLATE 53
Marie Louise (Léa) Cadoret, *c. 1896*
Pencil drawing 6¹/₄" × 5"
Private collection

PLATE 54
Femme au Lit, *c. 1896*
Canvas 16" × 13"
Private collection

PLATE 55
Léa in the Garden, Dennemont,
c. 1900
Panel 12³/₄" × 9¹/₂"
Private collection

PLATE 56
Léa in a Tall Hat, *c. 1896*
Canvas 22¹/₂" × 15¹/₄"
Private collection

PLATE 57
A Lake in the South of France,
c. 1909
Panel 5" × 6"
Private collection

PLATE 58
Landscape, Trinidad, *c. 1921*
Canvas 29¹/₈" × 36¹/₂"
Art Gallery of Ontario, Toronto

PLATE 59
Venice, *c. 1903*
Canvas 21³/₄" × 18¹/₄"
Private collection

PLATE 60
In a Paris Park, *c. 1905*
Panel 5" × 6"
Private collection

PLATE 61
The Bull Ring, Marseilles, *c. 1904*
Panel 9¹/₄" × 13"
Private collection

PLATE 62
On the Beach, Tangiers, *c. 1913*
Canvas 23³/₄" × 28³/₄"
Private collection

PLATE 63
Pink Clouds Above the Boulevard,
c. 1908
Panel 5" × 6"
Private collection

PLATE 64
The Place St. Michel, *c. 1905*
Panel 5" × 6"
Private collection

PLATE 65
A Roadway, Barbados, *1921*
Watercolour 8" × 13"
Private collection

PLATE 66
A Brittany Estuary, *c. 1905*
Panel 9¹/₄" × 13"
Private collection

PLATE 67
In Brittany, *c. 1905*
Panel 9¹/₄" × 12³/₄"
Private collection

PLATE 68
Fishing Boats, Concarneau, *c. 1910*
Panel 5" × 6"
Private collection

PLATE 69
The Portal, Marrakesh, *c. 1910*
Panel 5" × 6"
Private collection

PLATE 70
The Beach, St. Malo, *c. 1900*
Canvas 15³/₁₆" × 21⁷/₈"
Art Gallery of Ontario, Toronto
Bequest of David R. Morrice,
Montreal, 1981

PLATE 71
Yachting Near St. Malo, *c. 1902*
Canvas 15" × 18"
Private collection

PLATE 72
The Beach, St. Malo, *c. 1901*
Panel 5" × 6"
Private collection

PLATE 73
Le Pouldu, *c. 1910*
Panel 4³/₄" × 5⁷/₈"
Private collection

PLATE 74
The Prows of Three Gondolas,
c. 1903
Panel 5" × 6"
Private collection

PLATE 75
The Ferry, Quebec, *c. 1909*
Panel 7" × 10"
Private collection

PLATE 76
Horse and Sleigh, Quebec, *c. 1900*
Canvas 16" × 20"
Montreal Museum of Fine Arts

PLATE 77
The Sea Jetty, *c. 1908*
Panel 4⁷/₈" × 6"
Private collection

PLATE 78
A Brittany Town, *c. 1906*
Panel 5" × 6"
Private collection

PLATE 79
The Circus, Concarneau, *c. 1908*
Panel 5¹/₄" × 6⁵/₈"
Private collection

PLATE 80
Campo San Giovanni Nuova, Venice,
c. 1901
Canvas 19³/₄" × 21¹/₄"
Private collection

PLATE 81
Umbrellas on the Beach, St. Malo,
c. 1902
Panel 5" × 6"
Private collection

PLATE 82
Fishing Boats, Concarneau, *c. 1908*
Panel 6" × 5"
Private collection

PLATE 83
Olympia, *c. 1914*
Canvas 32" × 24"
National Gallery of Canada, Ottawa

PLATE 84
Café el Pasaje, Havana, *1915*
Canvas 25" × 26"
Private collection

PLATE 85
Fishing Boats off the Finistère,
c. 1902
Panel 5" × 6"
Private collection

PLATE 86
Woman in a Wicker Chair, *c. 1895*
Oil on canvas 32¹/₄" × 18¹/₈"
Gift of Lord Beaverbrook,
Beaverbrook Art Gallery,
Fredericton, N.B., Canada

PLATE 87
The Market Place, Concarneau,
c. 1910
Canvas 23³/₄" × 28³/₄"
Art Gallery of Ontario, Toronto

PLATE 88
La Communicante, *c. 1910*
Panel 4³/₄" × 6"
Private collection

PLATE 89
The Fruit Market, Tangiers, *c. 1912*
Canvas 19¹/₄" × 23¹/₂"
Montreal Museum of Fine Arts

PLATE 90
The Quai, Dieppe, *c. 1908*
Canvas 23³/₄" × 28³/₄"
Private collection

Buchanan, Donald W. *James Wilson Morrice; A Biography.* Toronto: Ryerson Press, 1936.

Dorais, Lucie, "Deux moments dans la vie et l'oeuvre de James Wilson Morrice." Bulletin 30/1977, National Gallery of Canada, Ottawa (1978): 19-35.

Johnston, William R. "James Wilson Morrice: A Canadian Abroad." *Apollo* (June 1968): 452-7.

MacTavish, Newton. *The Fine Arts in Canada*. Toronto: Macmillan Co. of Canada Ltd., 1925.

Sutton, Denys and Reid, Dennis. "J.W. Morrice." Catalogue of a loan exhibition arranged by the National Gallery of Canada (Holburne of Menstrie Museum, Bath) (May-June 1968).

Vauxcelles, Louis. "The Art of J.W. Morrice." *The Canadian Magazine* XXXIV, No. 2 (1909): 169-176.

Letters between James W. Morrice and Edmund Morris are on file at the Art Gallery of Ontario, Toronto.

Letters between James W. Morrice and Newton MacTavish are housed in the North York Library, Toronto, Ontario.

Facts about the artist's family history were obtained from the Archives of the Montreal Museum of Fine Arts.

Excerpt from *The Magician* by W. Somerset Maugham is reprinted with permission of the Executors of the Estate of W. Somerset Maugham and William Heinemann Ltd; and, for their edition of the work (copyright © 1956) Doubleday and Company, Inc.

Excerpts from *Old Friends* by Clive Bell are reprinted with permission of the author's Literary Estate and Chatto & Windus, and University of Chicago Press.

Excerpt from the chapter "Evening with Exiles" in *Sketches for an Autobiography*, by Arnold Bennett, is reprinted with permission of the publisher, Allen & Unwin, Ltd.

SOURCES AND ACKNOWL- EDGMENTS

INDEX

223